OVER THE RIVERS

AN AERIAL VIEW OF GEOLOGY

Colorado River at the head of
Westwater Canyon, Utah

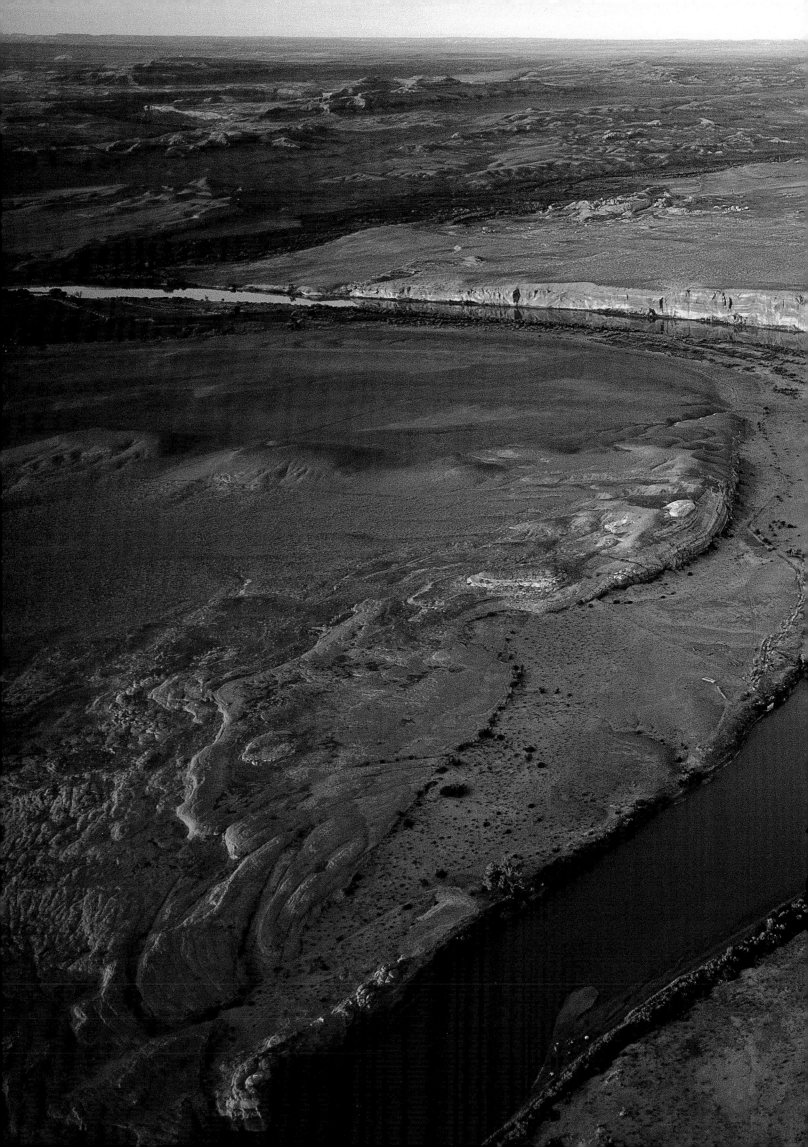

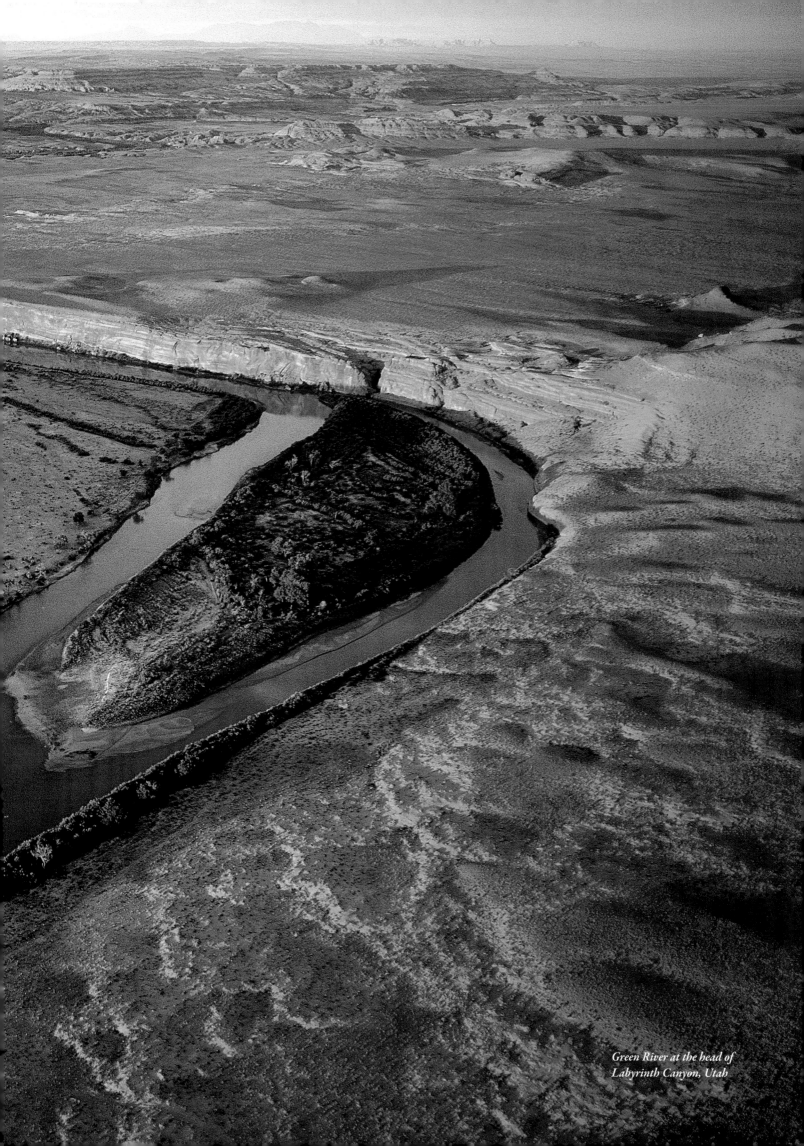

*Green River at the head of
Labyrinth Canyon, Utah*

To Roger Henderson who longed to boat these rivers when we were old men.

EDITORS: STUART WALDMAN AND ELIZABETH MANN
DESIGN & ILLUSTRATION: LESLEY EHLERS DESIGN

ALSO BY MICHAEL COLLIER
OVER THE MOUNTAINS: AN AERIAL VIEW OF GEOLOGY

ALL RIGHTS RESERVED. PUBLISHED BY MIKAYA PRESS INC.

NO PART OF THIS PUBLICATION MAY BE REPRODUCED IN WHOLE OR IN PART OR STORED IN A RETRIEVAL SYSTEM, OR TRANSMITTED IN ANY FORM OR BY ANY MEANS, ELECTRONIC, MECHANICAL, PHOTOCOPYING, RECORDING OR OTHERWISE, WITHOUT WRITTEN PERMISSION OF THE PUBLISHER. FOR INFORMATION REGARDING PERMISSION, WRITE TO: MIKAYA PRESS INC., 12 BEDFORD STREET, NEW YORK, N.Y. 10014. DISTRIBUTED IN NORTH AMERICA BY: FIREFLY BOOKS LTD., 66 LEEK CRESCENT, RICHMOND HILL, ONTARIO, L4B1H1

LIBRARY OF CONGRESS CATALOGING-IN-PUBLICATION DATA

Collier, Michael, 1950-
 Over the rivers / Michael Collier.
 p. cm.— (An aerial view of geology)
 Includes bibliographical references and index.
 ISBN 1-931414-21-1
 1. Geology—United States—Aerial views. 2. Rivers—United States—Aerial Views. 3. Aerial photography in geology—United States. I. Title.
 QE77.C65 2008
 551.48'3097—dc22

 2008060051

PRINTED IN CHINA

OVER THE RIVERS

AN AERIAL VIEW OF GEOLOGY

MICHAEL COLLIER

MIKAYA PRESS

NEW YORK

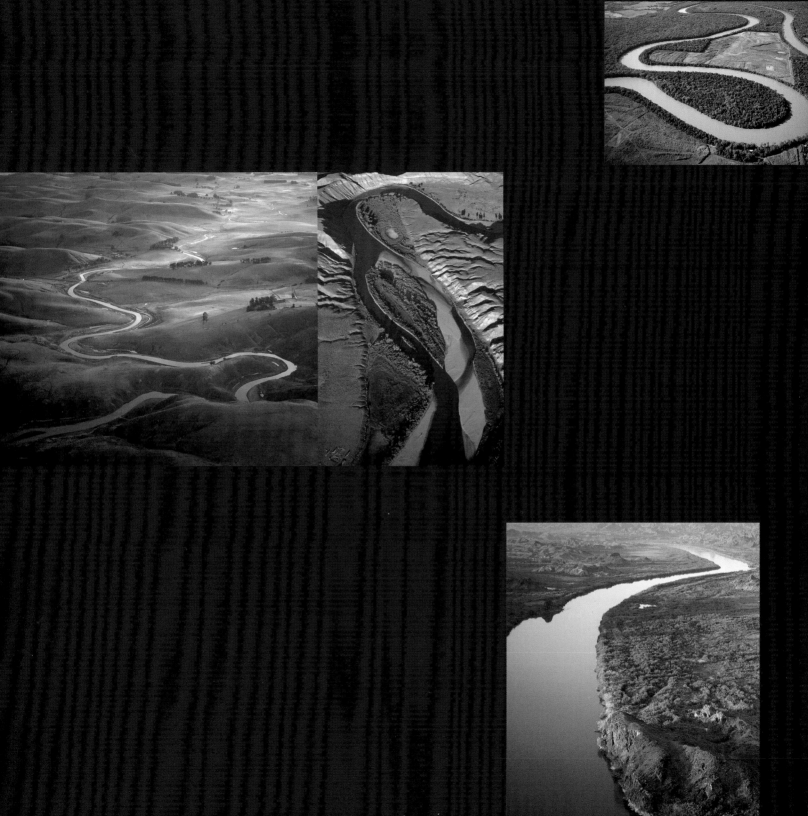

CONTENTS

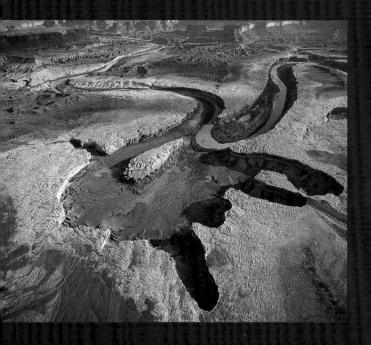

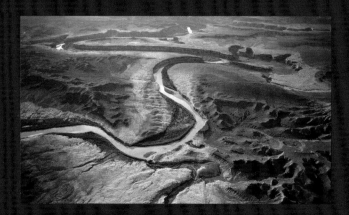

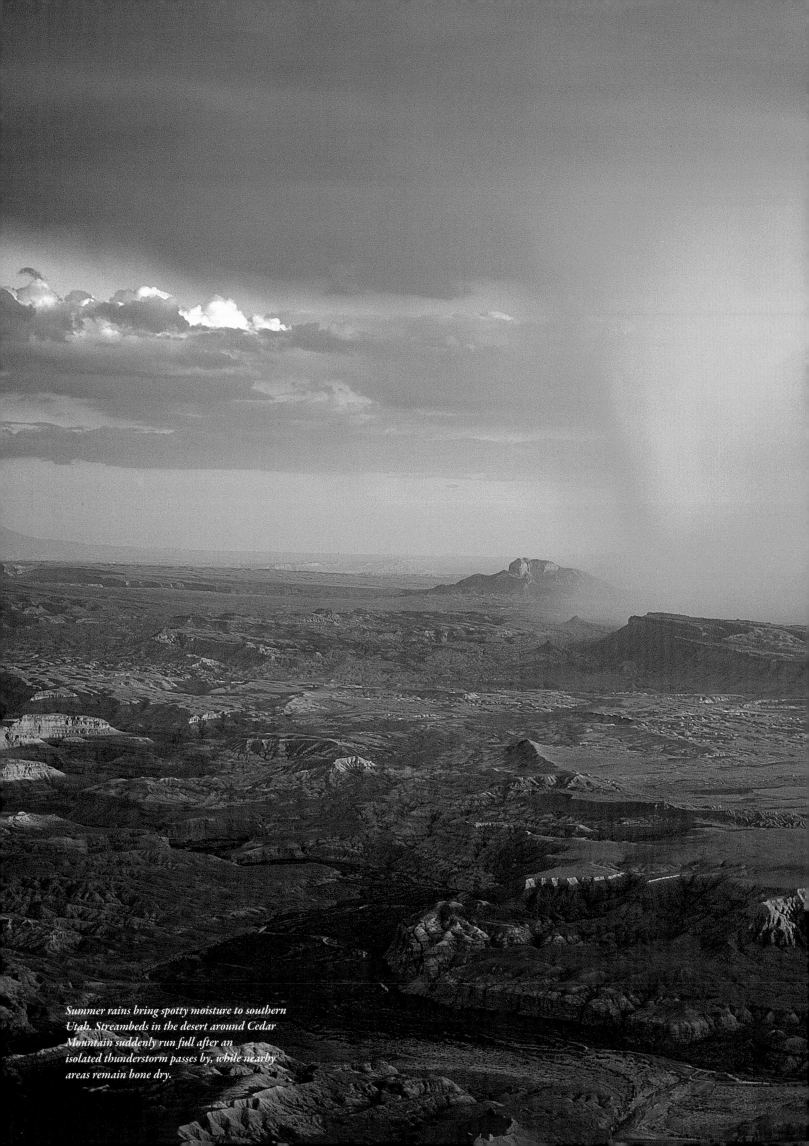

Summer rains bring spotty moisture to southern Utah. Streambeds in the desert around Cedar Mountain suddenly run full after an isolated thunderstorm passes by, while nearby areas remain bone dry.

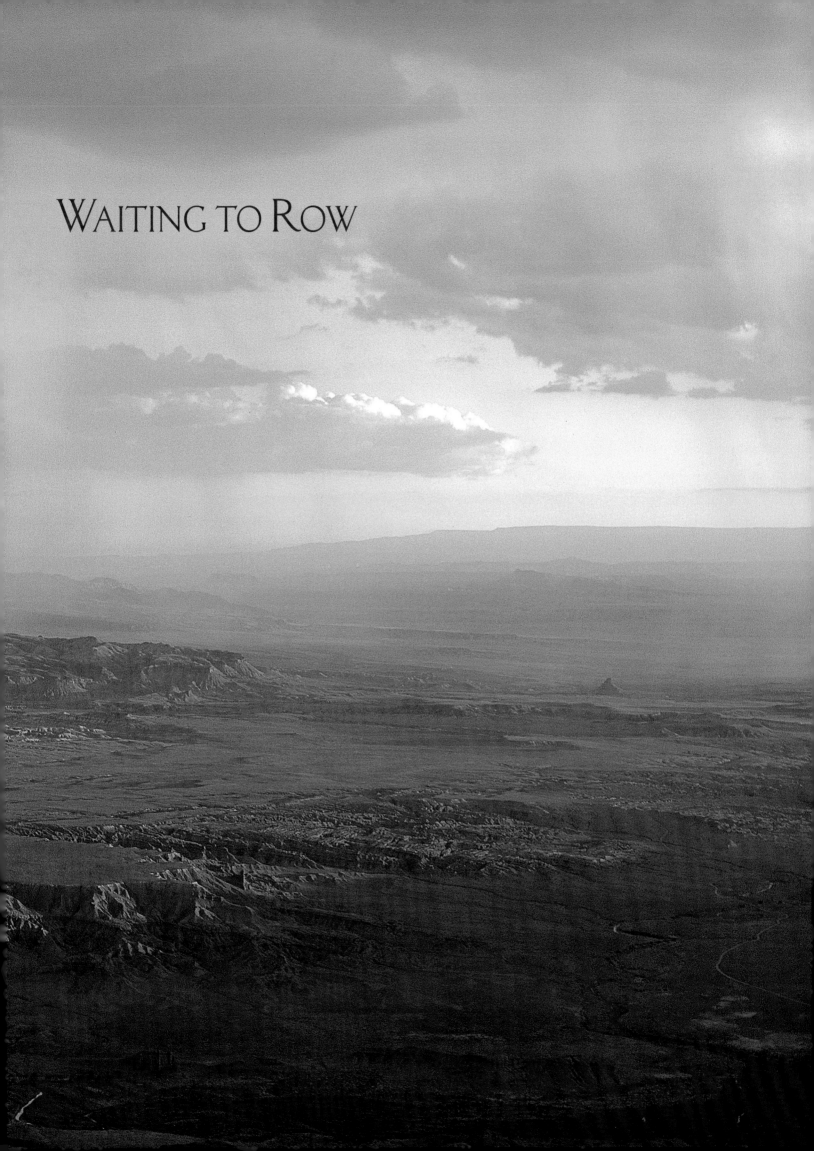

WAITING TO ROW

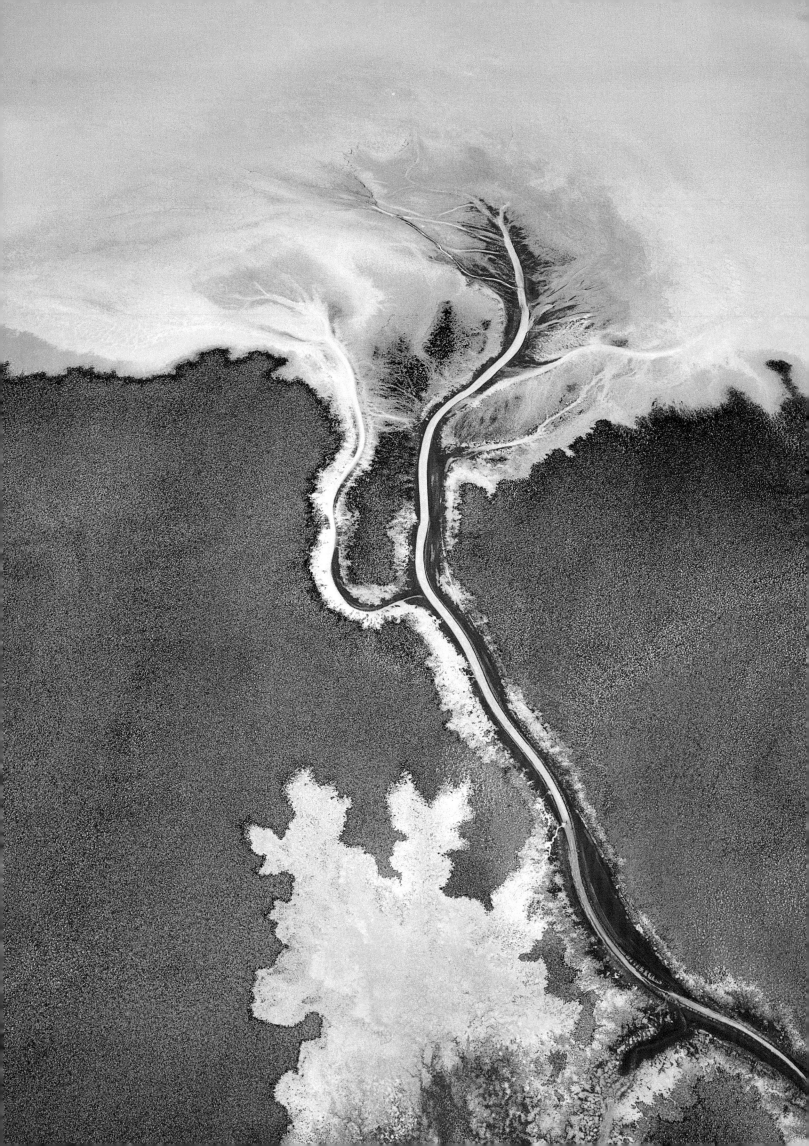

Rivers flow from the mountains to the sea. Nothing could be simpler; nothing could be more complex.

To understand rivers, we should start at the beginning, in the oceans. Ours is a blue planet where water covers almost three-quarters of the surface. If seawater, all 326 million cubic miles of it, simply stayed in the oceans, there would be no rainfall, no rivers. But the sun's heat evaporates seawater, every year lifting something like 77 thousand cubic miles of water into the atmosphere. Most condenses nearby and just falls back into the oceans. But a third of that evaporated water rises high enough and is carried far enough to fall on land. And with that rain, our story begins.

Earth's atmosphere is capable of transporting prodigious quantities of water. Forty weeks of intense rainfall throughout the American Midwest set the stage for the Mississippi River's great flood of 1993—a volume of rainfall equivalent to twice the size of Lake Erie. On the other hand, parts of California's Death Valley can be bone dry for a year or more. On average, that region of the Mojave Desert receives only an inch and three-quarters of rain annually.

If precipitation were equally distributed, every place on earth would receive thirty-one inches of rain each year. But local conditions wring variable amounts of moisture from the air. As any frustrated farmer knows, water vapor can remain suspended within clouds as they blow on by, perhaps to fall downwind on some other farmer's field. Proximity to an ocean can increase rainfall. For instance, the Pacific aims its moisture squarely at Yakutat, an Alaskan coastal town that receives more than 150 inches of rain—ten feet—each year. Precipitation is also likely to be higher near mountains like the Sierra Nevada, where the atmosphere is lifted and cooled as it flows inland. Finally, rain can be wrung from the skies when air masses collide. This occurred in the 1993 Mississippi River flood when cold Canadian air repeatedly encountered moist warm Gulf air over the Midwest.

Death Valley and Yakutat highlight meteorologic extremes. Perhaps it's more useful to squint at a map of the United States and try to see generalized precipitation patterns. The first and most obvious observation is that rainfall increases from west to east across the country. Eastern seaboard states typically receive 40 to 50 inches of rain a year. Farmers across the Great Plains can reasonably hope for 30 to 40 inches each year. But west of the 100th Meridian, in Kansas, annual rainfall steadily decreases—14 inches in Denver, and seven or eight in Phoenix.

Salt Creek in California's Death Valley National Park is more salt than creek. Briny spring water from surrounding mountains carries minerals on a one-way trip into this dead-end basin. The water evaporates, but salt, gypsum, and trona are left behind to form the valley's white floor, called a playa.

Rain may fall, but we still don't have a river. Once it strikes the earth, precipitation can follow one of three paths: water can evaporate and rise back into the atmosphere, it can flow along the surface, or it can sink into the ground. A surprising amount reenters the atmosphere. Evaporation occurs directly from standing bodies of water like puddles or lakes. In some areas evaporation directly from the leaves of trees or crops can be as high as 30 percent of total rainfall. Additionally, plant roots intercept water that has just begun to soak into the ground. This moisture will be carried upward and released back through leaves—a biologically essential process known as transpiration. Taken together, evaporation and transpiration return as much as 70 percent of a region's rainfall back to the atmosphere.

The remaining fraction of rainfall will either percolate into the ground or flow across the surface. Rates of percolation are highly variable, depending on the texture of the ground: porous soil versus fractured rock, absorbent sand versus watertight clay. Once underground, water flows very slowly—maybe 100 feet a year. Eventually groundwater collects in underground reservoirs called aquifers. During a heavy storm, soil can become saturated with rain that has already fallen. When water can no longer be absorbed, it must flow above ground. Water flowing overland combines with springs bubbling up from below to create first a trickle, a brook, then a stream, and finally a river.

Rivers may be the lifeblood of a landscape, but they represent a surprisingly small fraction of the earth's water. Of all water—within the oceans, floating in the atmosphere, locked up as glacial ice, hiding in underground aquifers, or biding its time in lakes—streams and rivers account for only 0.0001% of the total on earth. But this percentage, tiny as it may be, has shaped the world in which we live. Farms have always sprouted where water is most readily available. Cities, dependent on easy transportation, long ago sprang up on the shores of major waterways.

A river is living water. Stand on the bank, look upstream and down, and savor the sense of living water. Every river is the center of a universe where change is a constant. Is the river rising or falling? Is the surface smooth and glistening, or is it chewed into currents and chopped into waves? Is the river clear today, or still muddy from yesterday's storm? Look upstream for the tenth time this hour—is the boat coming down yet? Look downstream—are the salmon still running? The splash and chuckle of a living river tells a landscape's most vivid stories; a river spawns a landscape's wildest dreams.

I learned about moving water while working on the Colorado River, rowing in the 1970s and 1980s through Arizona's Grand Canyon. If that river didn't teach me everything that I know, at least it put it all into perspective. I grew out of adolescence and into manhood on the Colorado, an oar in each hand. I'd tuck those oars under my knees and lean back against the raft's load. I was intoxicated, watching sun-spangled canyon

walls spin circles around an impossibly blue sky. Sometimes my passengers would self-consciously clear their throats as we bore down on a rapid—they seemed more comfortable when I paid attention to the ominous growl of waves beating against rocks.

My pulse quickened whenever we slid into Hance or Horn, Serpentine or Sockdolager Rapids. Ninety-eight miles into the Grand Canyon, the Colorado's muscular surface flexed and freshened as it rolled over the debris fan that forms Crystal Rapid. I'd already memorized every rock and wave that loomed downstream. We swept quickly past the last point where I might have rowed to shore and reconsidered this madness. Accelerating into the turmoil, I waited. There was absolutely nothing to be done for the next ten seconds—agonizing moments that stretched into infinity. On Crystal's tongue, the smooth surface of the river began to heave and shudder, but still I took no strokes. To start rowing even a second too soon, to strike a rock instead of sliding behind it, was to court disaster. Wait. Listen.

Wait.

NOW!

With all my strength I pulled downstream and to the right. The boat slid off the current and cut into the slack water directly behind a granite boulder. The passengers didn't know it, but we'd already run the real rapid. The titillation of waves and rough water would follow soon enough. But for me, the most breathtaking part of river running was always that moment out on a rapid's tongue, oars suspended, waiting for the precise instant when I could take that first strategic stroke.

I've since moved downstream—studied geology, learned to fly, survived medical school. But I haven't forgotten those lessons learned on the water, those prayers offered to the river. I never nose my airplane over into stormy turbulence, never walk into a medical maelstrom without remembering how it was once to slide down the tongue, oars motionless, waiting to row.

This book examines the ways in which rivers rise and flow, the means with which they erode and shape landscapes, and the ways in which landscapes in turn mold rivers. I learned rivers from water level, but I tell their stories now from the air. From the cockpit of my plane I can sometimes see most of a river basin from a single vantage point—its headwaters in the distance, valley below, and mouth at sea level. More often, this aerial perspective provides brief and intimate glimpses of parts of a river, vignettes of the riparian landscape as I pass overhead—a hidden canyon, an unheralded waterfall, a roadless meadow. Being airborne provides new coordinates to a fresh perspective on the world. Up here, geologic stories expand into the fullness of three dimensions. Aloft, I can see the rivers running from the mountains to the sea.

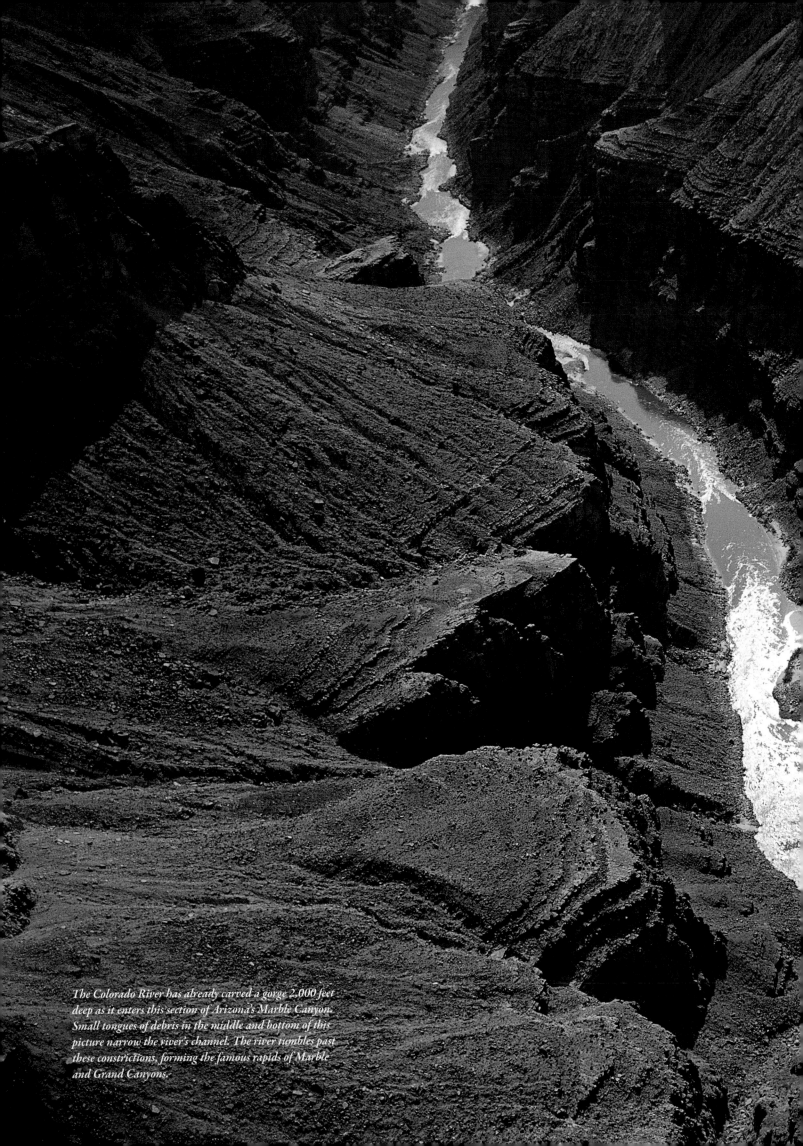

The Colorado River has already carved a gorge 2,000 feet deep as it enters this section of Arizona's Marble Canyon. Small tongues of debris in the middle and bottom of this picture narrow the river's channel. The river tumbles past these constrictions, forming the famous rapids of Marble and Grand Canyons.

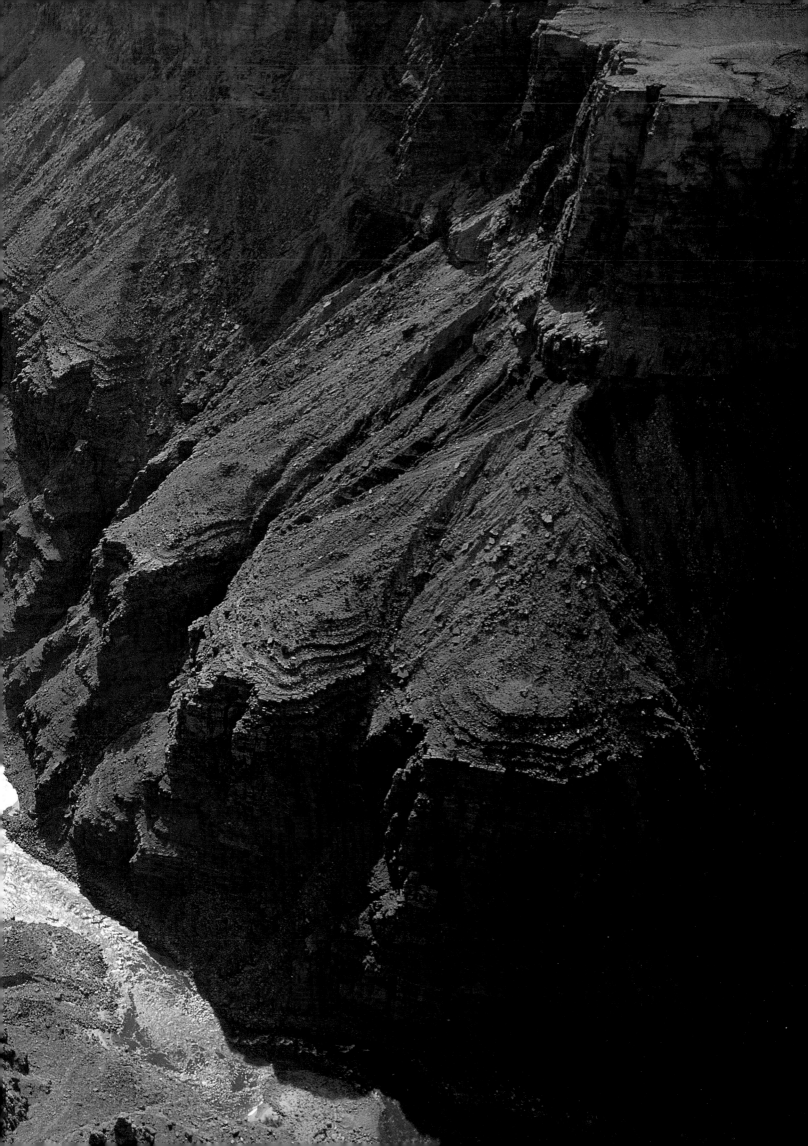

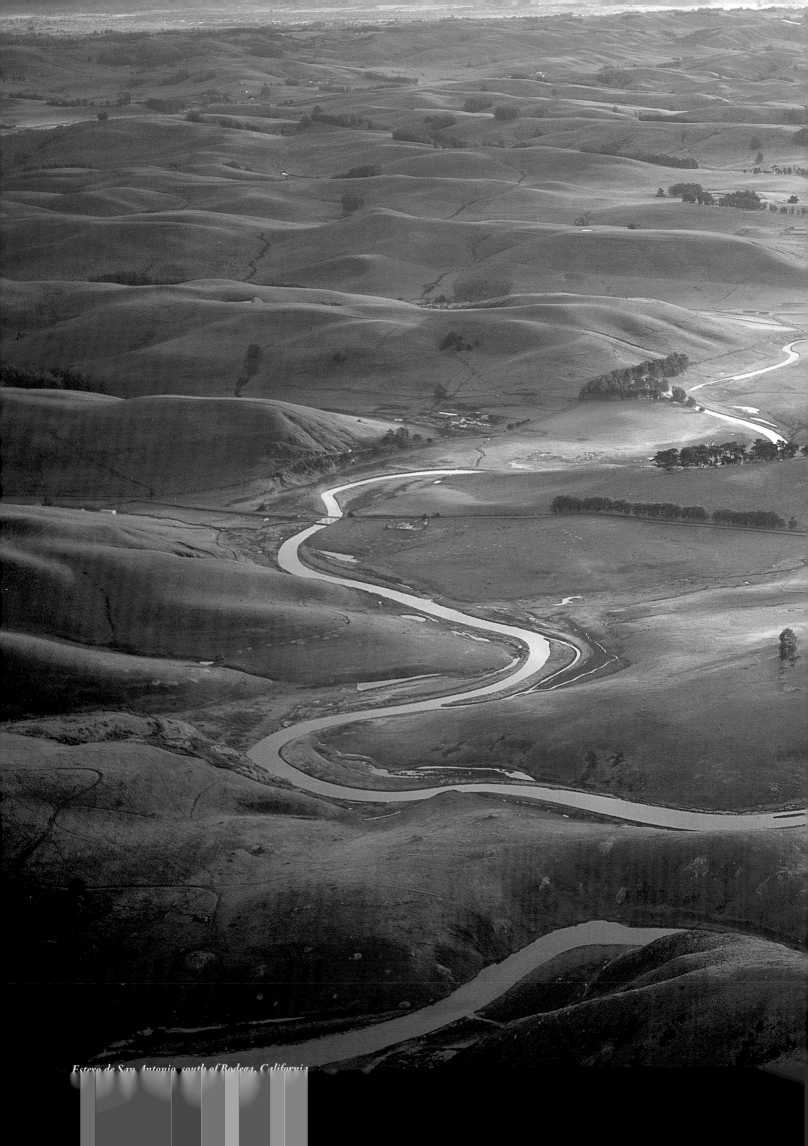

Estero de San Antonio, south of Bodega, California

LIVING WATER

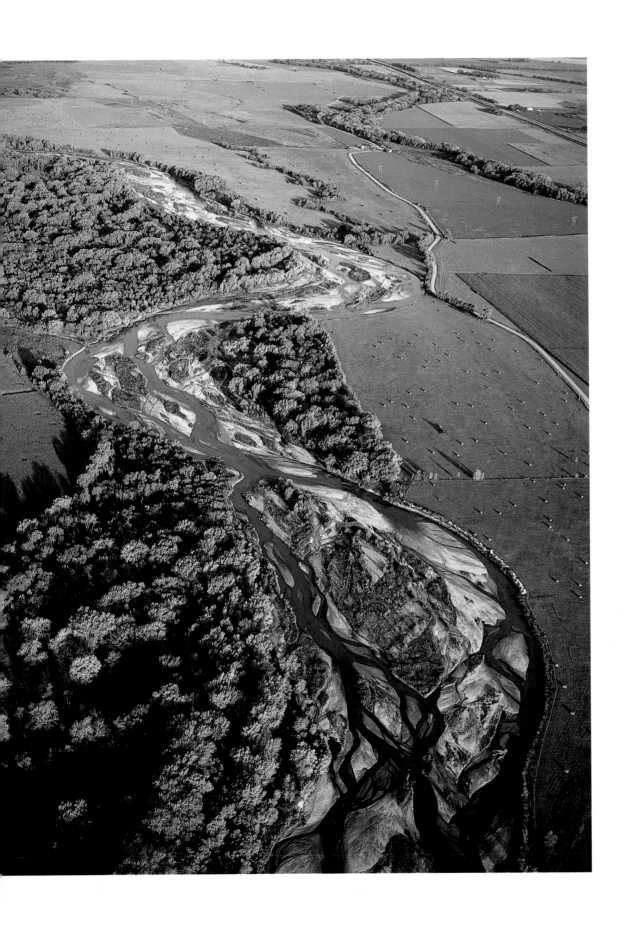

The Platte River above Kearney, Nebraska, is a classic waterway of the Great Plains—flat, wide, and shallow. Its bed is braided, woven with multiple channel strands, and its banks are lined with trees that buffer any flood that might flow downstream.

When a storm rages against Colorado's Rocky Mountains, precipitation has only just begun its long journey back to the ocean. Snow may linger in the high country for months, waiting to melt. Rainfall can soak into the ground and then flow slowly and silently downhill beneath the surface. In places, this groundwater will reemerge at the surface to form springs farther down a mountainside. But for now let's follow water that stays on the surface.

Water initially flows as disorganized sheetwash, an unconfined pulse that rushes downslope. Soon enough that moving water incises little depressions called rills. As one rill joins another, more and more runoff is concentrated into a larger channel. Once a storm passes, these high rills and early channels are likely to dry up until the next rainfall arrives. But eventually a dominant stream will emerge with enough water to keep it flowing. Springs contribute groundwater back to the surface, thus helping to insure that this fledgling stream will continue to flow. As more side streams join, the channel reaches a size that can safely be called a river.

There are no rules that dictate the requisite physical attributes of a proper river. The Columbia River in the American Northwest delivers an average of 280,000 cubic feet of water to the Pacific Ocean every second, while the well-dammed Colorado River now delivers just about zero water to the Sea of Cortez every second—yet both are major rivers in good standing among hydrologists. The Mississippi River stretches 2,300 miles from the headwaters in Minnesota to its mouth at the Gulf of Mexico; Thunder River in Grand Canyon stretches exactly three-quarters of a mile—and yet both appear as bonafide rivers on topographic maps.

A handful of factors determine the speed and power of a river. Slope and roughness of the riverbed are prime considerations. The steeper the downhill gradient of the channel, the faster the flow. The rougher the bottom, the slower the flow. A broad, thin river, exposed to proportionately more drag along its bed than a deeper narrower channel, will tend to flow more slowly. The volume of water, or discharge, in a river also contributes to both speed and power. If other factors like bed slope and channel roughness are held constant, a given stretch of river will flow faster as discharge increases. During a flood, a river's surface may rise only a few feet while its velocity could easily double.

At one time or another, we've all performed that simple but most elegant of hydrologic experiments: throwing a stick into a river. Lo and behold, the stick usually moves downstream. Now throw two sticks, one farther out in the current than the other. The stick nearest the channel's center is likely to move downstream faster. This may seem trivial, but think about it: the center of a river flows fastest, so erosion is more likely to occur at mid-channel than at the river's edges.

The surface of a river is marvelously complex. Waves of differing shapes signal the narrowing or turning of a current. The channel may be shallow here but deeper over there. The central thread of current, called the thalweg, can quickly swing from one bank to the other. Deep churning waves foam back upstream where the current spills over an underwater ledge or boulder. Water accelerates as it squeezes past an obstruction, and decelerates again once the way is clear. Below an obstruction the current can become confused and even flow upstream in an eddy.

It's exhilarating to stand on the brink of a river in flood. The current roars with life. The air is pungent with the smell of muddy spray. Leaves, branches, even whole trees flash past faster than you could hope to run. The overwhelming sensation is one of speed. As always, though, perspective is everything. If, instead of standing on that bank, you could ride the flood, the impression of speed would be replaced with a primal sense of raw power. Moving water is among the most forceful agents on earth. A mountain river in flood can shake the ground as it tumbles boulders along the bottom. The river's surface roils with waves that spring up like genies and disappear again as suddenly. In flood, the lower Mississippi River can flow at nine miles an hour. That may not sound so fast, but at high stages, the Mississippi is pushing three million cubic feet of water—that's 187,000,000 pounds—through its channel every second.

Rivers are in the business of moving two things: water and sediment. We've seen how rivers gather water, but where does the sediment come from? Wind occasionally blows some sand and dust into a river, but far more sediment is picked up by water flowing overland. Rock exposed alongside a river can weather, breaking down into smaller particles that are carried away by moving water. When a river undermines its banks, entire shelves of rock and mud collapse into the current. In flood, a river scoops up sand that has accumulated along its bed during quieter times, and flushes that sediment downstream. The range of sediment concentrations can be extreme. High mountain streams may be crystal clear most of the year. In its lower reaches during a flood, the muddy Mississippi can deliver several million tons of sediment each day to the Gulf of Mexico.

Sediments are carried downstream by different processes depending on their size. Throughout the world, much of the earth's surface consists of easily eroded rock known as shale which, when wet, quickly disintegrates into tiny particles of clay. Stirred by a flood, this suspended sediment gives a river its muddy character. Sand grains, larger than silt or clay, bounce along a riverbed, hopping downstream in a repeated series of short jumps called saltation. The largest particles, such as cobbles and boulders, usually rest on a stream's bottom, rolling only when the river is in high spirits.

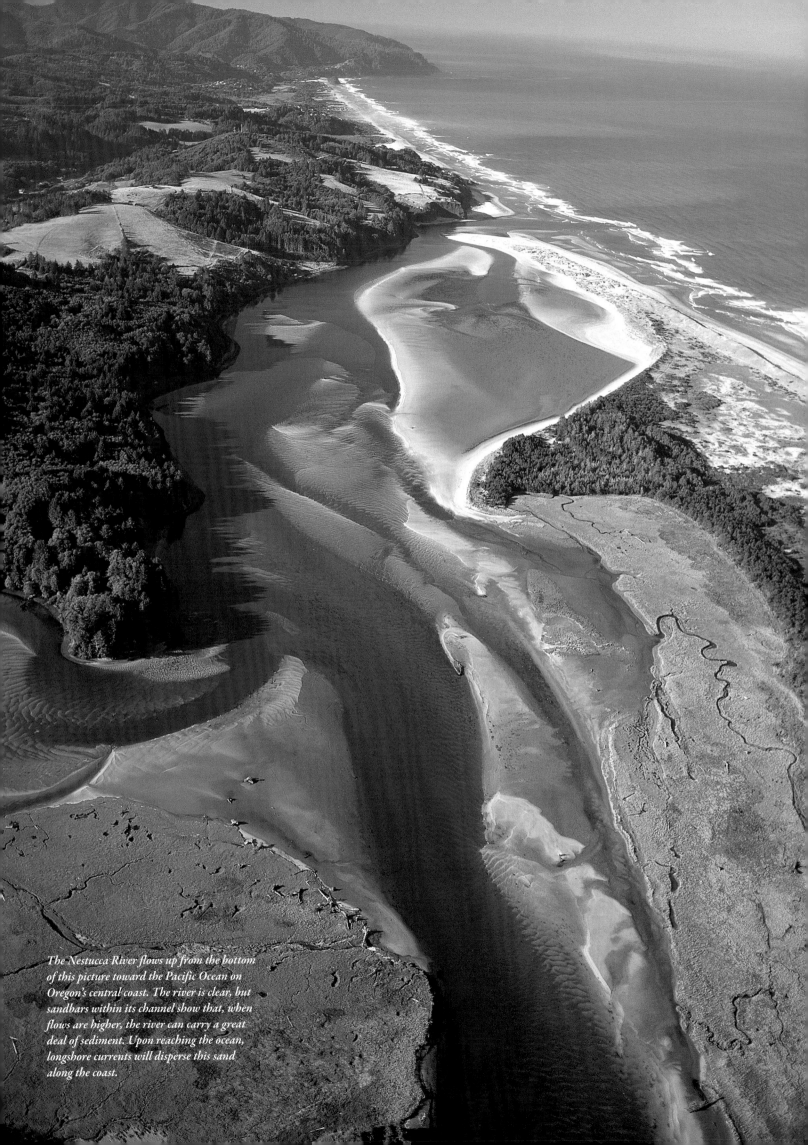

The Nestucca River flows up from the bottom of this picture toward the Pacific Ocean on Oregon's central coast. The river is clear, but sandbars within its channel show that, when flows are higher, the river can carry a great deal of sediment. Upon reaching the ocean, longshore currents will disperse this sand along the coast.

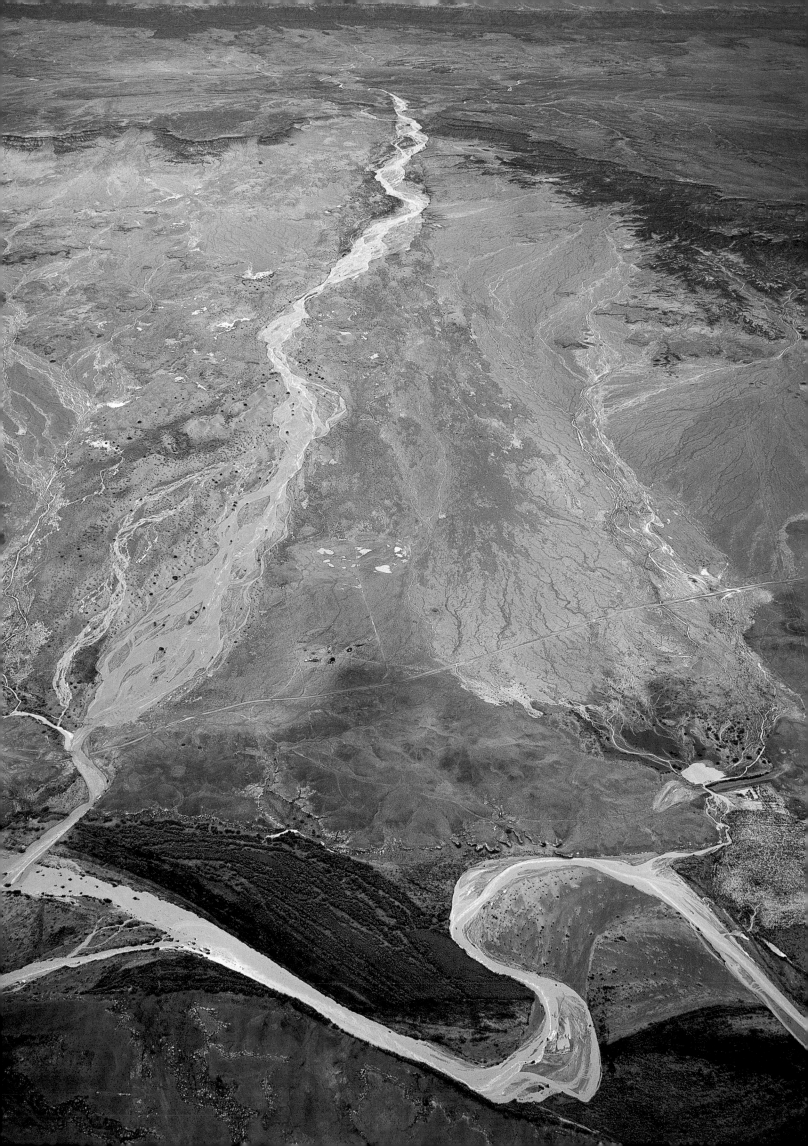

You can never swim in the same river twice. Not only is the actual water constantly being renewed, but specific properties of the river are also always changing—volume, temperature, salinity, acidity, channel shape, sediment content, you name it. For each unique combination of all these parameters, a river will have a given capacity to carry sediment. If that capacity is exceeded, sediment will fall out of the moving water and be deposited on the bottom or sides of a river.

Water flows in one of two states—laminar or turbulent. Laminar flow occurs when adjacent water molecules all move smoothly in a single direction. This accounts for only a tiny percentage of flow within a river, and is usually restricted to within a fraction of an inch of the streambed. For the most part, moving water flows turbulently, even if the bed appears to be smooth, with molecules moving not just downstream, but also up, down, left, right, and back upstream all at the same time. Rivers somehow manage to flow downstream, but all the particles of water sure do find a lot of different paths to get there. They are able to carry sediment because their flow is almost everywhere turbulent, not laminar. Laminar flow, if it were more common, would be lousy at carrying sediment because most particles would just settle through its straight lines of downstream motion. Turbulence keeps silt and sand suspended off the bed like bits of paper lifted skyward by a strong wind. It can lean into cobbles and boulders and force them to roll downstream. Turbulent flow, then, gives rivers their capacity to transport sediment.

Rivers are often compared to conveyor belts, because they move sediment from mountains to the sea. But the analogy limps a little, because the current always moves faster than the sand and gravel that it conveys. Sediments are forever lagging behind, to be chased downstream by the next flood or shift in the channel. A great deal of sand can be stored on the riverbed within eddies—those curlicue currents that flow upstream—because water velocity there is slower than in the main channel. A river's capacity to carry sediment decreases most profoundly upon reaching a base level (such as a lake or the sea) where it soon quits flowing altogether. As motion slows and then stops, progressively smaller particles settle to the bottom of the still water—first pebbles, then sand, then silt, and finally clay.

Rivers exist in their own time, and speak with a voice found nowhere else in nature. If their surface patterns are complex, then their internal currents are infinitely chaotic. The rhythms of a river are those of the larger earth, yielding to the change of climates, the rise of mountains, the fall of the seas. Rivers are neither impatient nor, ultimately, stoppable.

A desert wash is the usually dry bed of an intermittent stream. Washes can suddenly be inundated by water. Here a cloudburst over Moenkopi Plateau in northeast Arizona sent a flood rolling down Landmark Wash. When photographed, the flood was confined to a small channel on the left, but the wide brown triangular stain shows that, at its peak, water had extended over a much broader area. The flood has transported thousands of tons of mud and sand down to the Little Colorado River that flows from right to left at the bottom of the picture.

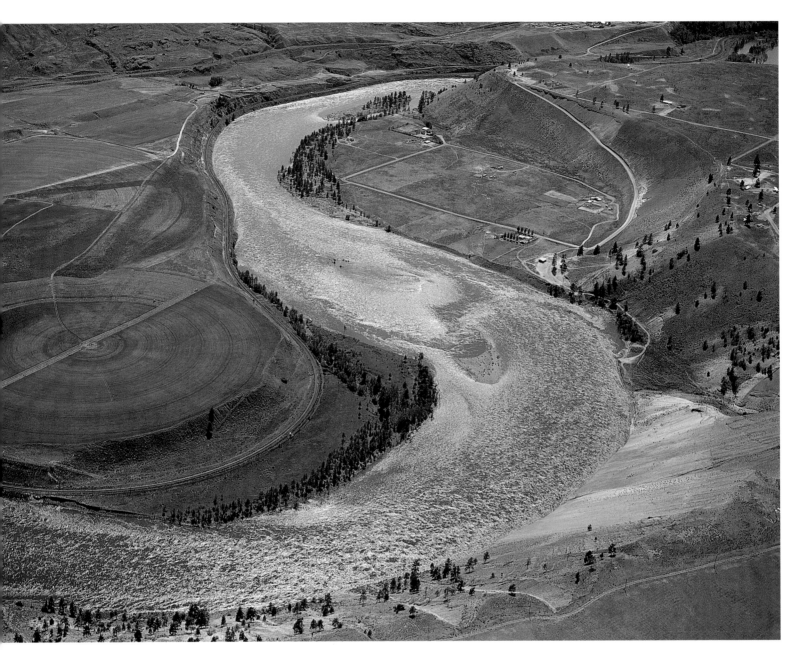

Above: The surface of the Thompson River is choppy as it races through left then right curves below Kamloops, British Columbia. The water swirls turbulently around mid-channel gravel bars that divide the current into fast chutes and slow eddies. It's not hard to imagine that this river is in turbulent flow.

Right: Desert winds and washes deliver a great deal of sand to the Colorado River as it flows along the border between Arizona and California. The sand is swept into underwater dunes which are deposited first on the right side of the channel and then the left as the river's flow naturally swings from one bank to the other.

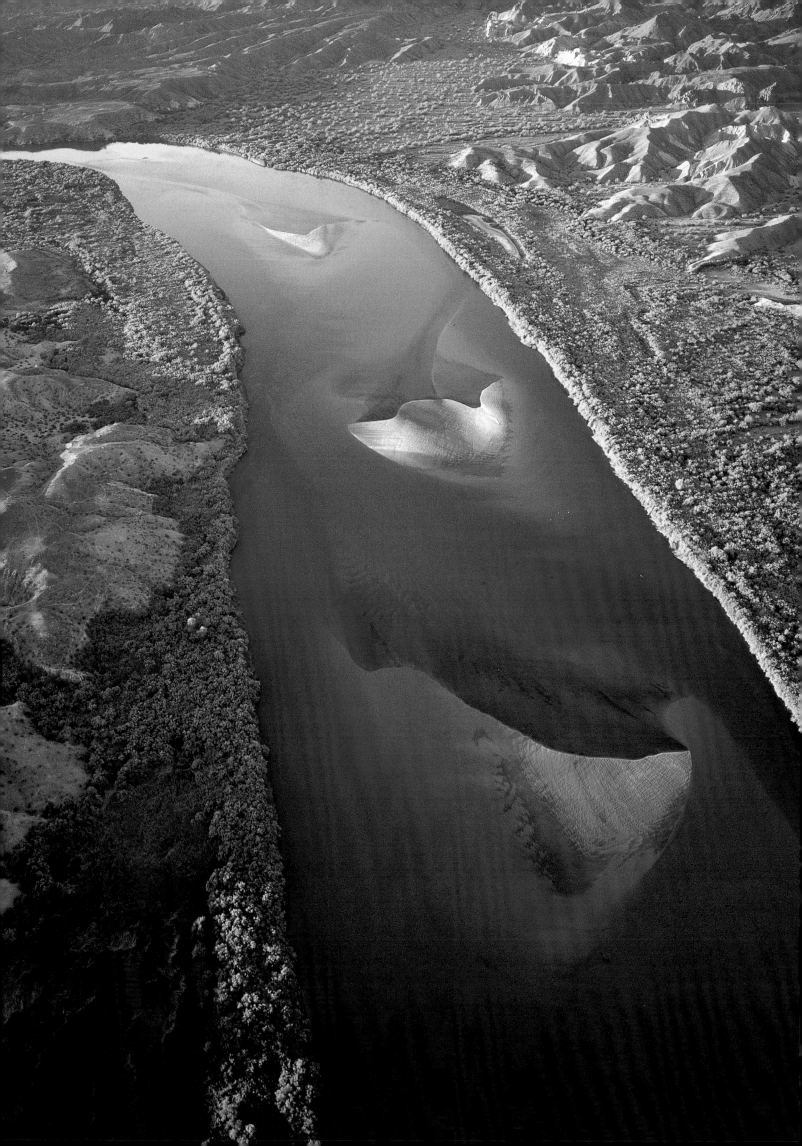

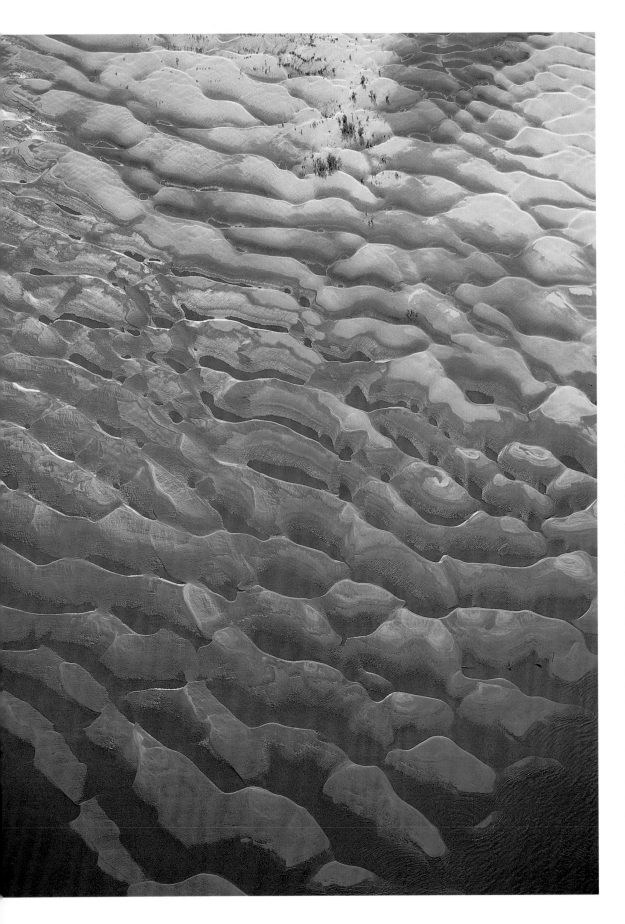

Left: Sand dunes near Caruthersville, Missouri, were created when the Mississippi River was in flood. When submerged by the higher river levels, these dunes marched downstream (toward top of page) as their upstream faces eroded and lee surfaces grew. But for now, stranded above the nearly dry bed, they are static, awaiting the return of high water.

Right: The Paria River is the thin brown stream on the left which joins the darker Colorado River at the head of Marble Canyon in Arizona's Grand Canyon National Park. Historically, the tiny Paria contributed a mere 0.16 % of the larger river's flow but a full 5% of its sediment. Those numbers are now further skewed by Glen Canyon Dam fifteen miles upstream, which traps Colorado River sediment that would have been carried to beaches in Grand Canyon.

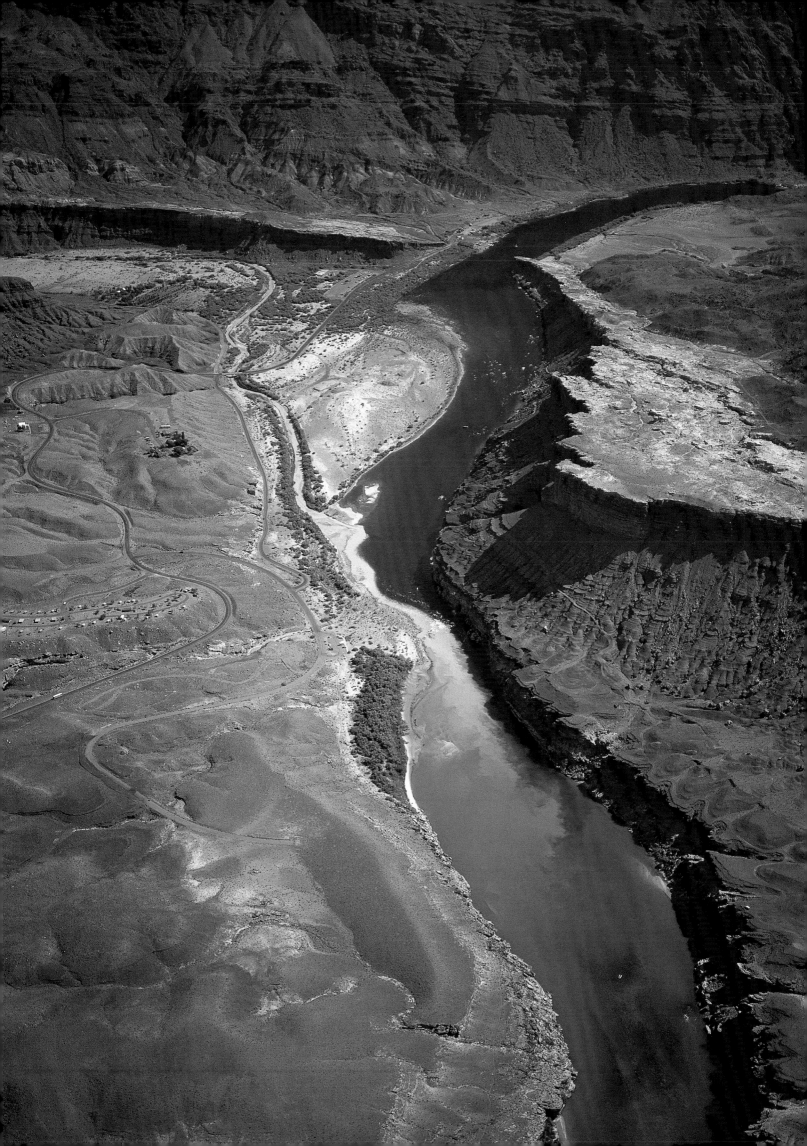

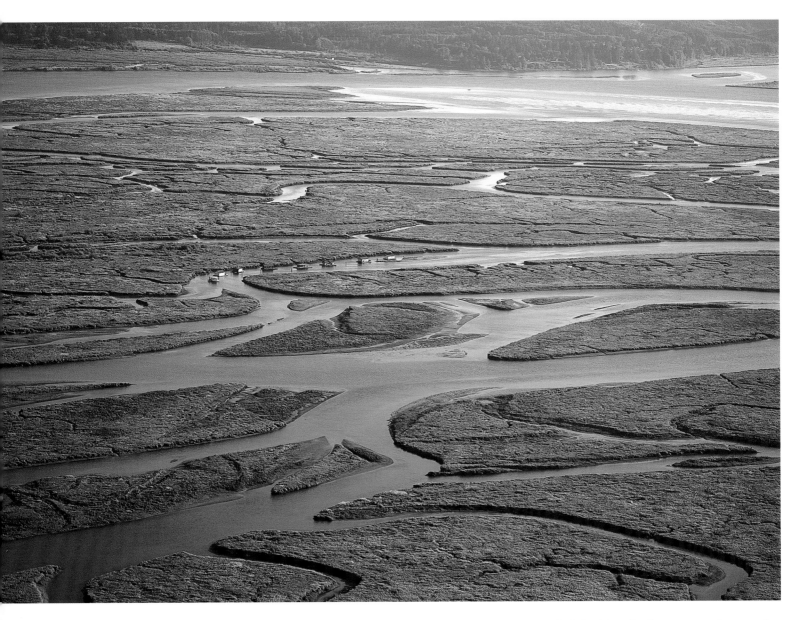

Above: The bulk of the Columbia River, seen here east of Astoria, Oregon, flows from right to left across the top of this picture, skirting the intricate maze of sluggish backwaters that fill the foreground. If the Midwest with its Mississippi River is America's bread basket, then the Northwest with its Columbia River is the nation's water bucket. Rainfall in the Northwest is heavy enough that the Columbia River carries an annual average of 35 million cubic feet of water for every square mile that it drains, a discharge ratio about twice that of the Mississippi.

Right: As the New River barrels around a corner near Hinton, West Virginia, momentum throws its bulk to the outside of the curve where the current will be faster and the channel deeper. It is no surprise that islands have formed on the inside of the curve where the current is slower and sediments are more readily deposited.

Left: Small arroyos—gullies that are usually dry—intermittently deliver sand to the beaches of Bahia San Carlos on the Sea of Cortez, Baja California, in Mexico.

Right: Giant Ice Age floods carried tremendous quantities of sand and other sediments out of Montana into central Washington. Wind now concentrates that sand into dunes near Hanford, before sweeping it grain by grain, back into the Columbia River.

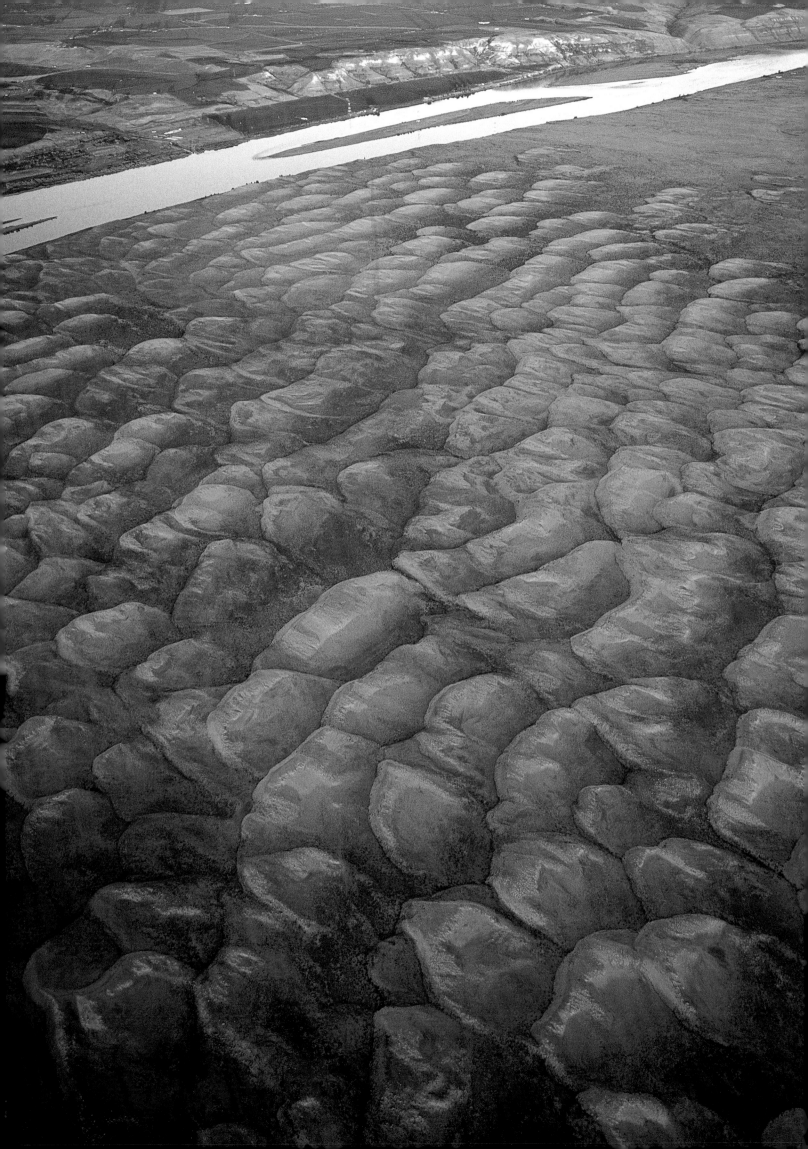

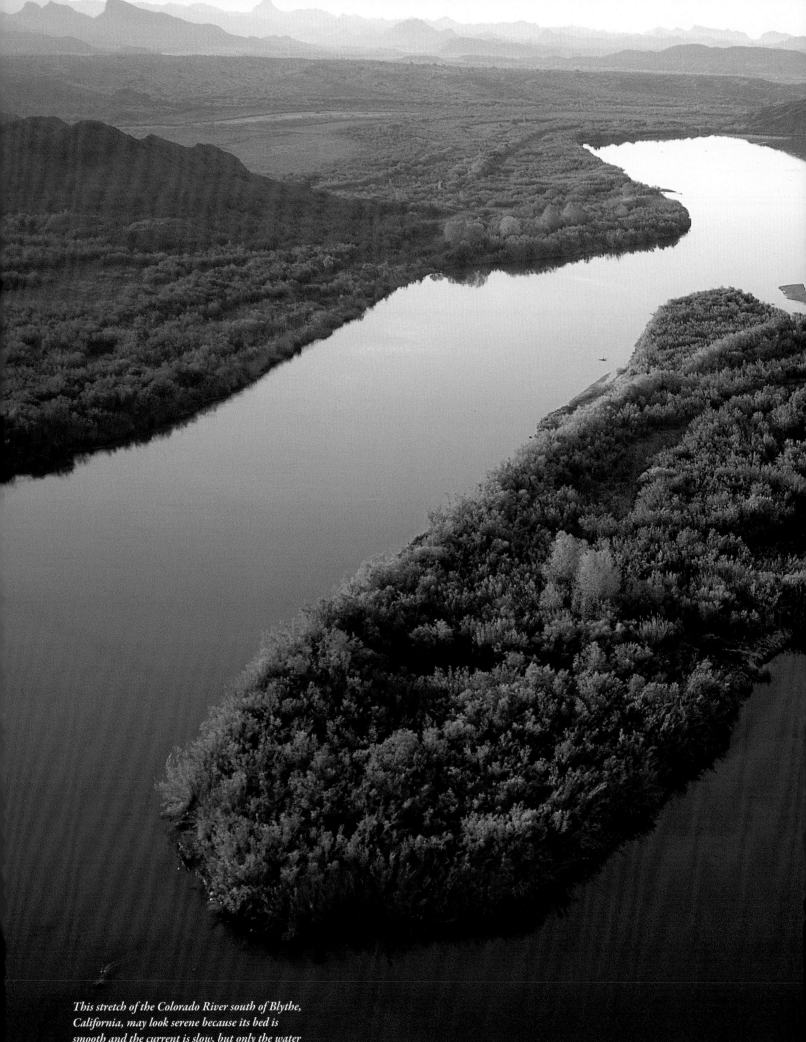

This stretch of the Colorado River south of Blythe, California, may look serene because its bed is smooth and the current is slow, but only the water a fraction of an inch above the riverbed is actually moving in laminar flow.

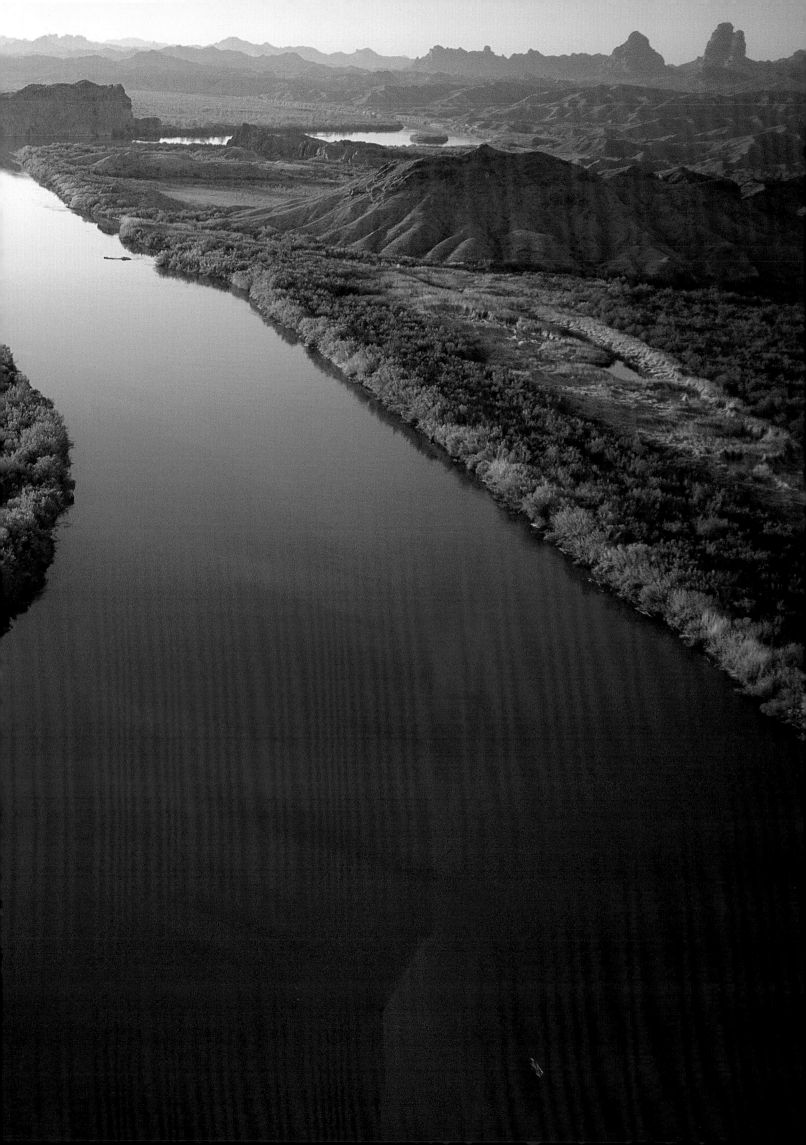

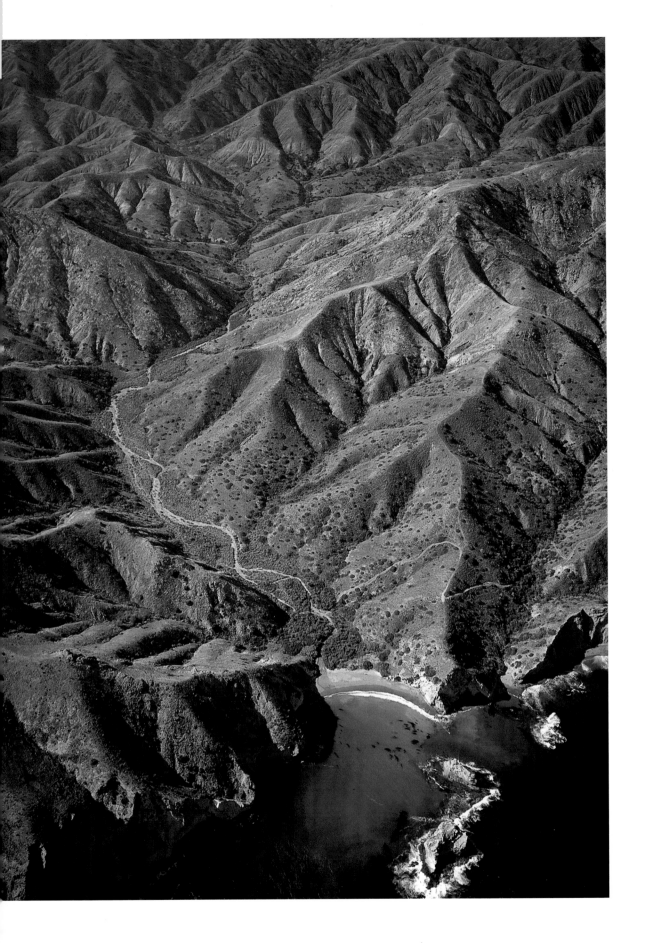

Left: An unnamed arroyo cascades down the south side of Santa Cruz Island within Channel Islands National Park, California.

Right: A small stream near Nelson, in southern British Columbia, brings sand in swirling patterns to the west arm of Kootenay Lake. Currents within the lake redistribute the sand after it has been deposited by the stream.

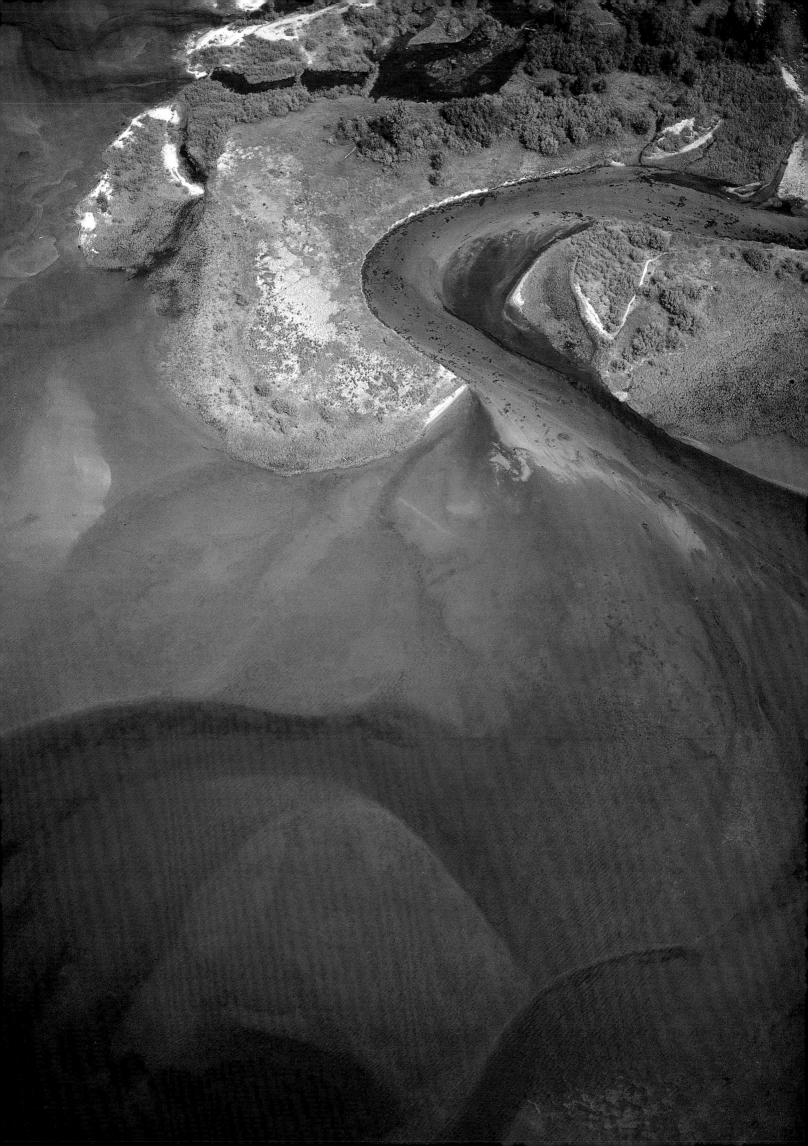

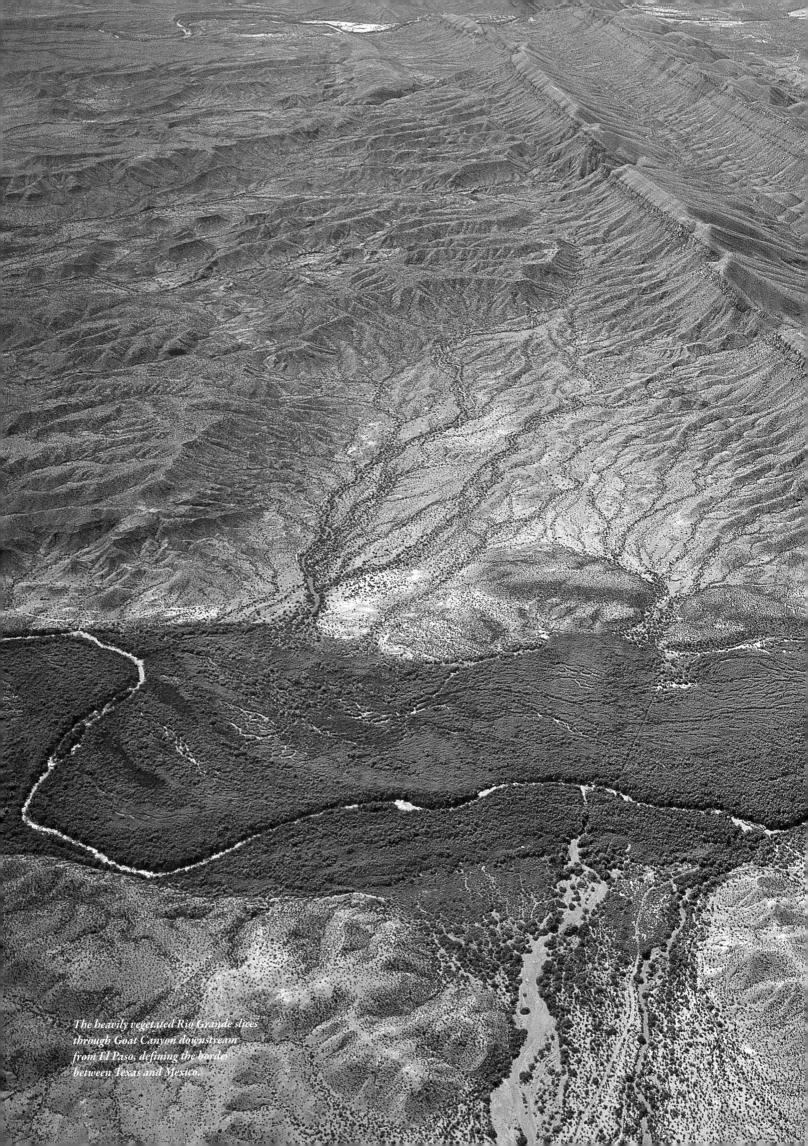

The heavily vegetated Rio Grande slices through Goat Canyon downstream from El Paso, defining the border between Texas and Mexico.

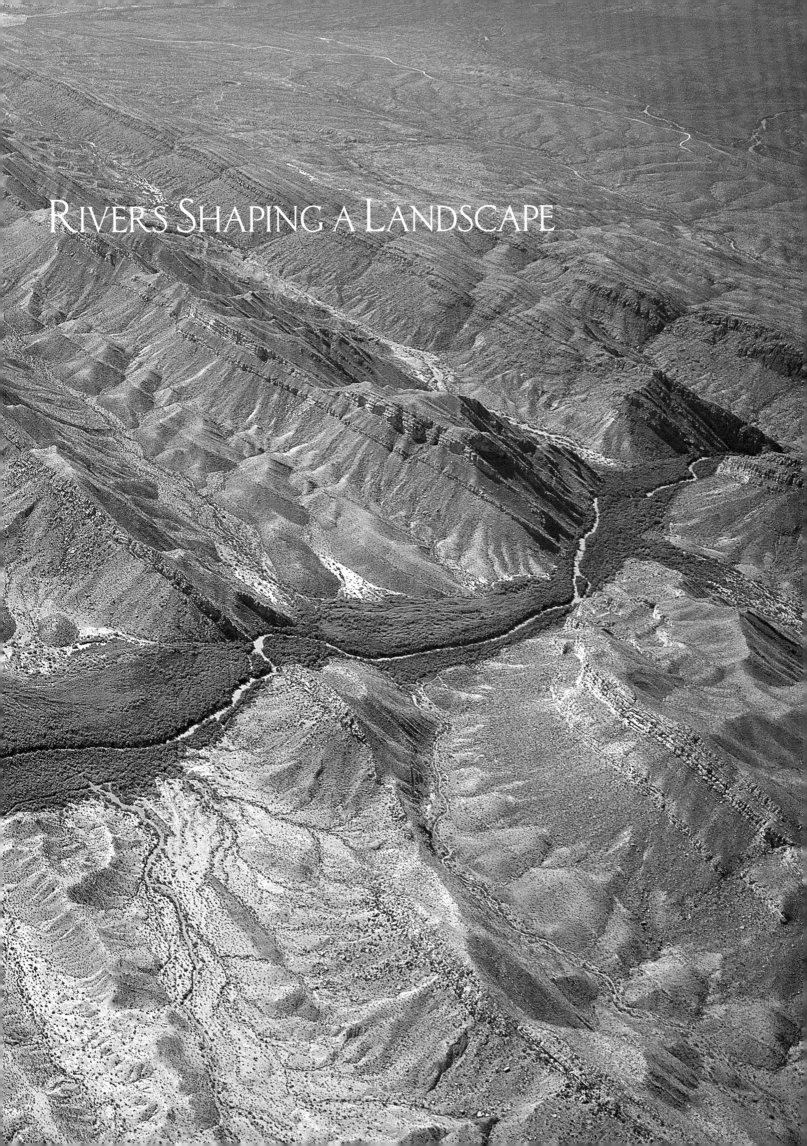

RIVERS SHAPING A LANDSCAPE

Imagine a map of America with its iconic outline: on the right, the East Coast stretches from Maine's craggy chin to the delicate little finger, held down ever so demurely, that is Florida. On the left, the West Coast's blunt brow barges toward the Pacific, while Michigan's thumb is pinched against the forefinger of its Upper Peninsula. That's us: America. Now start erasing. Cities are the first to go. Then eliminate the web of interstate highways. Don't forget to get rid of time zones. Of course state boundaries never really existed in the first place. What's left? A country defined by its rivers. Not a bad map for navigating a great landscape.

If you step back far enough and squint hard enough at this map, you'll see that the United States embraces four great river basins. In the Northwest, the Columbia empties into the Pacific Ocean. In the desert Southwest, the Colorado River drains to the Gulf of California and, just over the Continental Divide, the Rio Grande drains to the Gulf of Mexico. The Mississippi River gathers water from the country's great heartland—all or part of 31 states between the Rocky Mountains and the Appalachians.

Like a grand bouquet, the Mississippi gathers a dazzling array of tributaries, many of which are major rivers in their own right. There are the Ohio, Missouri, Illinois, Arkansas, Minnesota, Iowa, Kentucky, Tennessee, Wisconsin, and Kansas Rivers. The bouquet is colored by the Red, White, Big Blue, Little Blue, Blue Earth, Big Black, Green, Yellow, and Yellowstone Rivers. Listen for the Skunk, Duck, Elk, Beaver, Badger, and Mosquito Rivers. Look for the Rib, Teton, Milk, Tongue, Licking, and Powder Rivers. And the Big Sandy, Wind, Saline, Sweetwater, Cannonball, Smoky Hill, and Loup Rivers. There are the Heart, Knife, Cheat, and Dismal Rivers. You may find the Cheyenne, Little Sioux, Shoshone, Greybull, Ouachita, Des Moines, Wabash, Marias, Miami, Youghiogheny, Monongahela, Allegheny, Cache la Poudre, St. Croix, Popo Agie, and Laramie Rivers. Or maybe you'll see the Canadian, Republican, Madison, and James Rivers. Of course there are also the Platte, Cimarron, Niobrara, Bighorn, Cumberland, Clinch, Gauley, Hiwassee, New, Hocking, Tippecanoe, Musselshell, Wapsipinicon, Walhonding, Tuscarawas, Muskingum, Neosho, Yazoo, Kanawha, and Scioto Rivers. There is a lyrical beauty in their names; the words flow together like notes to form a song that is the Mississippi.

Beyond the Columbia, Colorado, Rio Grande and Mississippi systems are many smaller rivers that nestle between the great drainages—the Sacramento and San Joaquin flow out of the Sierra Nevada and join in California's Great Valley before spilling into the San Francisco Bay. Somehow the Hudson in New York manages to pierce through the Appalachian Mountains on its way to the Atlantic Ocean. A myriad of shorter rivers like the Connecticut, Potomac, and Savannah all flow east from the Appalachian Mountains to the Atlantic Seaboard. To the north, the Great Lakes are laced by short connecting rivers and drain into Canada's St. Lawrence River and Seaway.

Gauley River

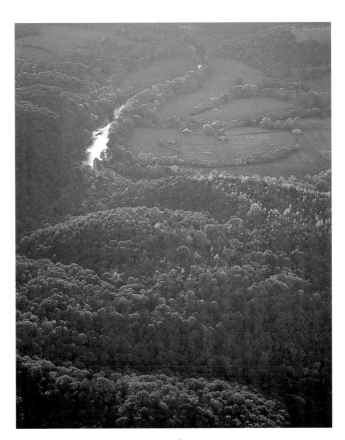

James River

The Mississippi River is an amalgam of many rivers running through a kaleidoscope of landscapes. The Gauley River drains the west flank of the Appalachian Mountains in West Virginia. The James River winds past Springfield, Missouri, and into the Ozark Mountains. To the west, the Niobrara rises in the grasslands of eastern Wyoming and heads across the Great Plains toward the Missouri River on the far side of Nebraska.

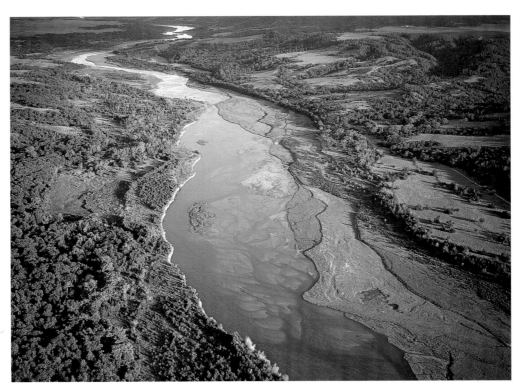

Niobrara River

Rivers continually shape their landscapes. The processes of erosion and deposition operate simultaneously along a river, nibbling away a little land here, redepositing a little sediment there. A river carves canyons and valleys upstream even as it builds terraces, fans, floodplains and deltas downstream. The total area of land drained by a river is called its basin, the fundamental building block of any landscape. Basins are separated from each other by divides, which draw the line between water flowing toward one or another river. The greatest of these is the Continental Divide, which separates waters that flow east to the Atlantic Ocean from those flowing west to the Pacific.

Let's add a bit of complexity to our map by imagining divides between rivers. Now we're looking not only at the isolated blue ink lines of rivers, but also at the basins that each river drains. I find it difficult to think of a river without considering its basin, because rivers and their associated landscapes are intimately connected—each molds the other. Perhaps I take this to extremes when I look at the often dry channel of the Little Colorado north of my home in Arizona, and call it the state's third largest river. But a river is truly more than just moving water. It is the amalgam of the entire basin through which it flows.

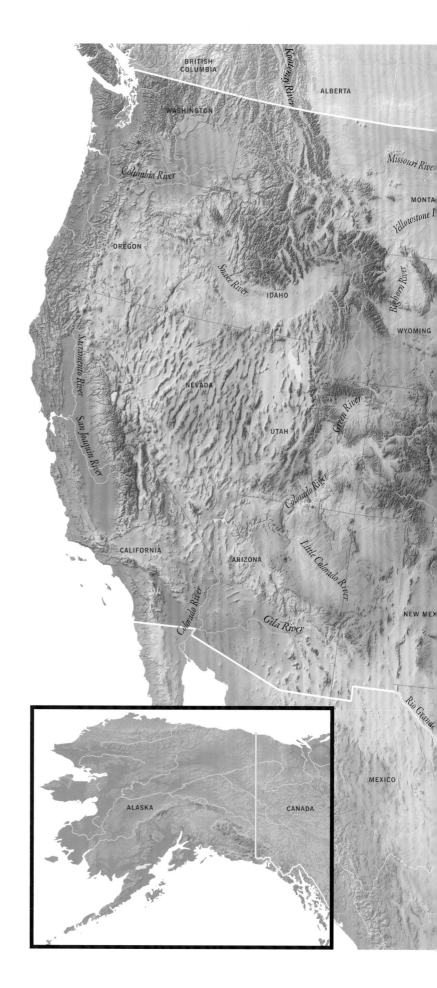

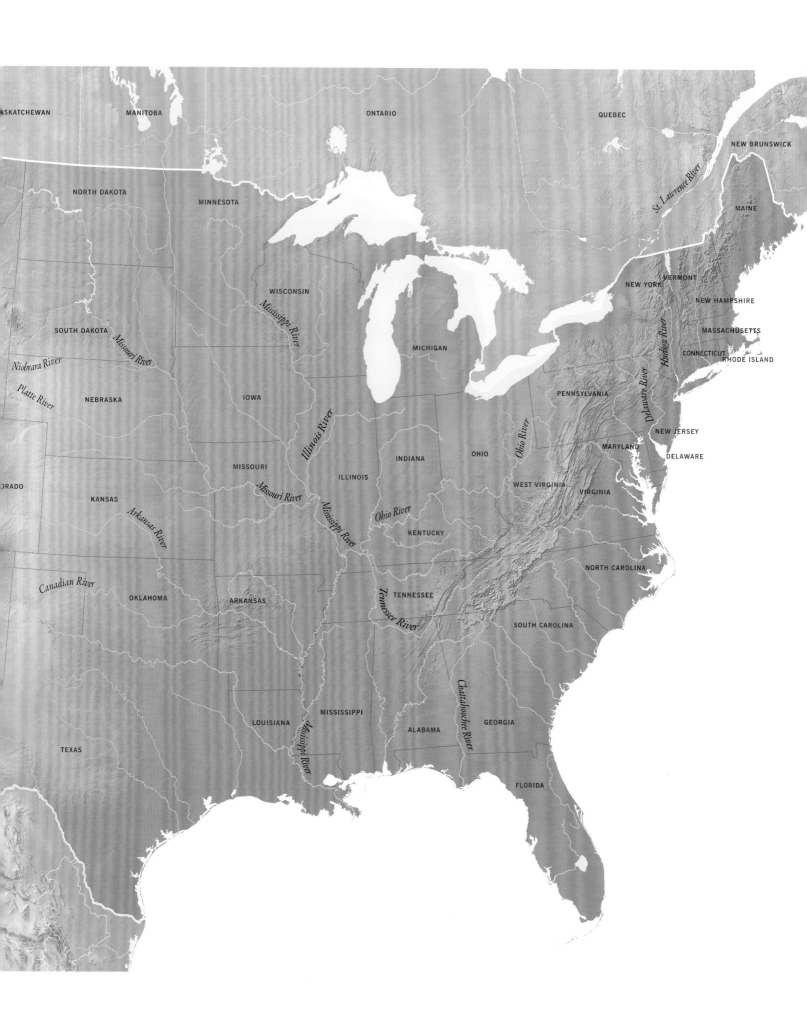

Drainage basins have dimensions—top and bottom, width and breadth. Since the end of a river seems easy to identify as it flows into the ocean, it's not unreasonable to ask where that same river begins. A river "begins," however, not at a single point but everywhere along the upper rim of its drainage basin. The question of origin would be better rephrased: "Which tributary of a river is the longest?" Tributaries of differing length come together to form a larger river, bestowing upon a basin the dendritic appearance of a tree's root system.

At first glance, a river bank seems pretty straightforward. Isn't that the place where, if you take one more step, you'll get wet? But there's more here than first meets the eye. A channel—stretching from one bank across the streambed to the opposite bank—has a unique shape that reflects the river's history. Over time, the channel and its banks assume dimensions that accommodate the river's typical flow and allow it to carry a typical sediment load. During times of flood, flow is greater than normal and the river rises beyond its banks. Floodwaters spread onto the more level ground where flow velocities decrease and sediments drop out, building the surrounding floodplain a little higher.

Weathering and erosion, as we've already seen, wear away at rocks within a basin, gradually lowering uplands, gouging canyons into mountainsides, and sharpening peaks as if they were pencils. Erosion can aggressively extend the upper end of a drainage basin in a process called headward erosion, thereby expanding one basin at the expense of another. In extreme cases, headward erosion might allow one stream to capture a neighboring river in an adjacent basin, a process called stream piracy.

Periodic flooding by the Mississippi River has subtly contoured the land around Perryville, Missouri. On occasion, the river shifts its course, abandoning sections of old channel that become isolated bodies of water called oxbow lakes.

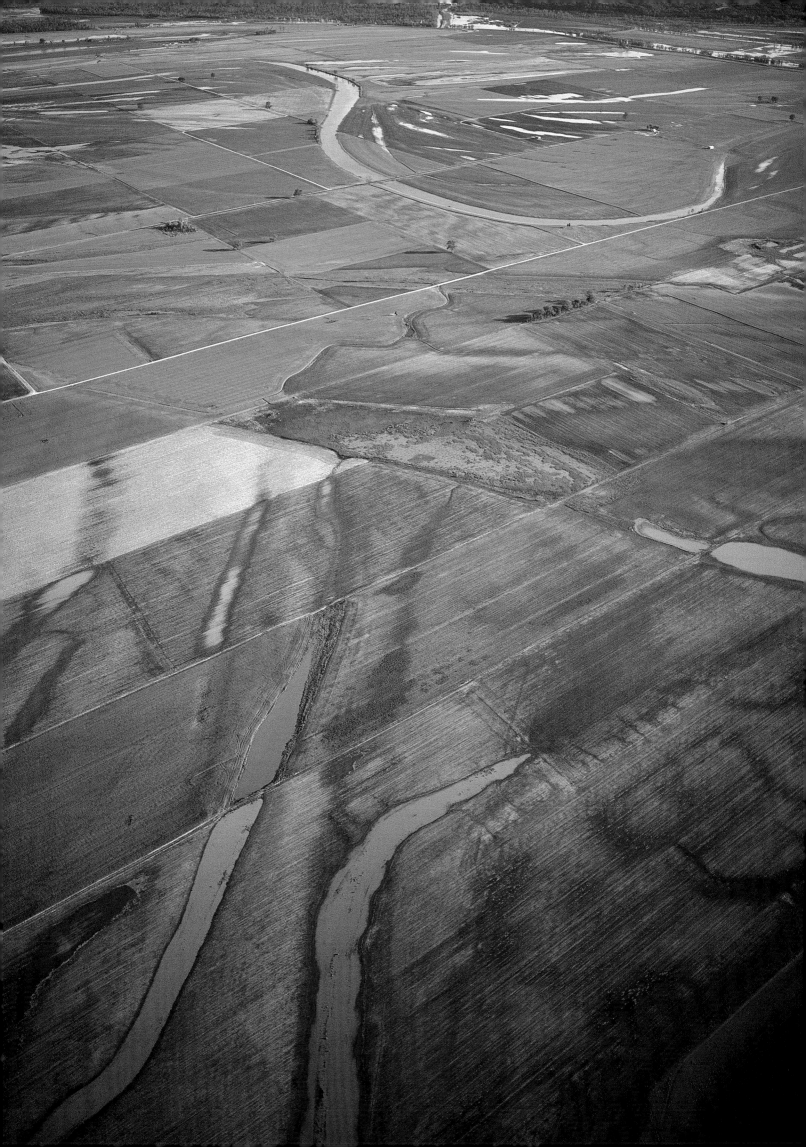

Rivers, strictly adhering to the laws of thermodynamics, are fundamentally lazy, always engaging in the least possible work. A river's job description calls for moving water and sediment from the mountains to the sea, but the contract never stipulates that the work has to be finished by a given date. Flooding may temporarily add an aura of urgency, but under normal conditions Ol' Man River is perfectly content to roll along at his own lazy pace. And a lazy river is one that will set down its burden of sediment the moment it breaks into the least little sweat. A river always maintains a fastidious equilibrium between water and sediment, picking up a little sand here and laying down a little gravel there depending on minute changes in water volume, sediment concentration, and local gradient.

Sometimes a river is asked to transport more sediment than it can handle. The excess sediment can be deposited in mid-channel as a braided tapestry of sand-and-gravel bars that lie between splintered rivulets. Braided conditions are most likely to occur below steep regions with high sediment yield and fitful precipitation. The bars and channels of a braided stream are unstable and will rearrange themselves with every passing flood.

Mountain streams often course within narrow canyons. At the foot of the mountains, streams are suddenly released from the confines of their bedrock channels to spread out across a wider valley below. Leaving the mountains, the stream still has a fairly steep gradient, but because the flow is spread over a wider channel, it is no longer competent to carry as much sediment. Sand, gravel, and boulders then accumulate in a cone-shaped deposit called an alluvial fan. Sometimes fans from neighboring streams coalesce into a broad apron of alluvial sediment called a bajada that can almost bury the mountain from which it originates.

Braided streambeds, alluvial fans, and bajadas are topographic features that tend to exist in the upper reaches of a basin. Farther downriver, as gradient flattens out, other landforms begin to appear. Channels curl into languorous loops called meanders. Floodplains become more extensive, stretching in the case of the lower Mississippi River across multiple states. Swamps form alongside the lowest reaches of some rivers. And finally, deltas are created as rivers roll into the sea. Let's look at these in greater detail.

MEANDERS: Rivers meander because they are irascible. A natural river is unwilling to flow in a straight line for long. Despite the best efforts of the U.S. Army Corps of Engineers to impose rectilinear banks upon a river, moving water within a channel will inevitably sway from side to side like a string of wobbly railroad cars rolling down an uneven track. As a result, the current's momentum bears first against one bank, and then deflects against the other, and back again, all the way to the sea. With each deflection, alternating outside banks are eroded, and the bends become more pronounced. Since a river's velocity is slower on the inside of a bend, sediment is more inclined to settle on the inside of the curve, forming sand spits known as point bars that gradually grow out into the current. Meanders form on rivers of all sizes. Big rivers always have big meanders, and little rivers have little meanders —a consistent balance between flow volume and channel shape.

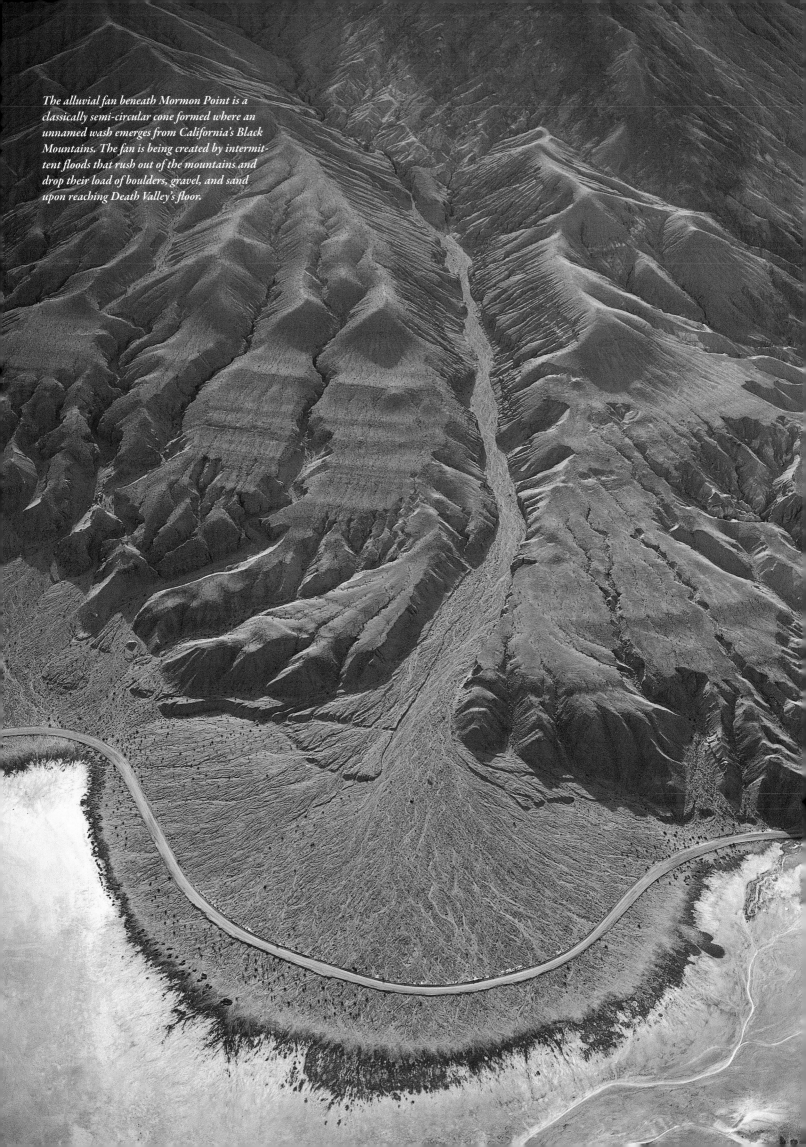

The alluvial fan beneath Mormon Point is a classically semi-circular cone formed where an unnamed wash emerges from California's Black Mountains. The fan is being created by intermittent floods that rush out of the mountains and drop their load of boulders, gravel, and sand upon reaching Death Valley's floor.

FLOODPLAINS AND SWAMPS: In Montana and Wyoming, tributaries of the upper Missouri River fall hundreds of feet in their first mile or two. Farther downstream after joining the Mississippi, that same water must travel 1,500 miles from Kansas City to New Orleans to accomplish the same vertical drop. Near its mouth, rolling through some of the world's flattest land, the Mississippi River falls only two inches for every mile that it flows horizontally.

Below Cape Girardeau, Missouri, the last six hundred miles of the Mississippi River are remarkably flat. The Mississippi's 35,000-square-mile floodplain encompasses parts of Missouri, Illinois, Tennessee, Kentucky, Arkansas, Mississippi and Louisiana. When a river rises beyond its banks, the overflow tends to smear out as a thin sheet of slow water. A great deal of sediment is deposited just beyond the banks where the current first decelerates. Consequently, natural levees often build up close to the river. Around New Orleans, these levees stand twenty feet above the level of the lower Mississippi. Large particles of sand are released from the current near the levees, while floodplain areas farther away are coated in a fine slime of slippery mud. These far reaches of the floodplain, with sluggish flow and poorly defined drainage patterns, are often fated to become swamps. In extreme cases, such as the Yazoo River in Mississippi, a separate, parallel river develops behind the levee to handle overflow draining through such a swamp.

DELTAS: Finally, reaching the sea, a river leaves the land and surrenders its current. Here gravel, sand, and silt sequentially drop out. Sandbars and mudflats choke the channel, repeatedly deflecting the river left and right as water seeks an unobstructed course to the sea. If ocean currents don't immediately whisk these deposits away to deeper waters, a delta will grow, extending some distance out into the sea.

Before reaching the sea, most rivers have been conscientiously gathering tributary streams into their main trunk. But at its delta, a river often fragments into multiple channels called distributaries, each seeking its own final path to the sea. With continued deposition, a river will eventually abandon an entire deltaic system, as has happened many times on the lower Mississippi. Indeed, the Mississippi would have forsaken its course past New Orleans in the mid-twentieth century if the U.S. Army Corps of Engineers hadn't blocked its natural diversion into the parallel Atchafalaya River, a much shorter course that reaches the Gulf of Mexico below Morgan City, 125 miles to the west.

In a flat land rocks can be scarce, so geological attention is often focused on the actions and effects of rivers. Flying over the Midwest, my eye is drawn to the seductive curve of meanders, and to the curtness of cutoffs. Over Arkansas, I trace terraces and follow floodplains. Farther south over the Gulf Coast, terra firma gives way to endless swamps and those beautiful bayous. Rivers determine the final expression of a level landscape. But in the next chapter we will see that when geologic upheaval occurs—when mountains

rise and volcanoes erupt—the playing field is no longer level. Then upthrust is pitted against erosion, and mountains rise even as their rivers seek to wear them down.

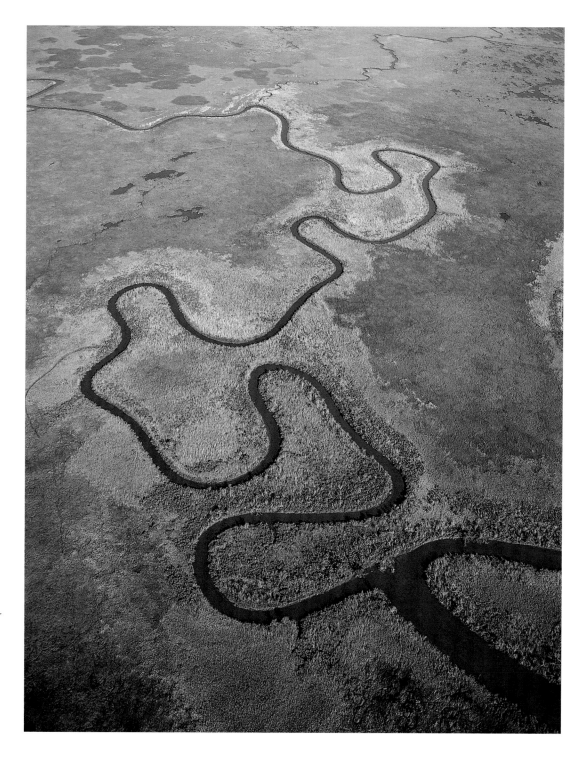

This small stream meanders toward Vermilion Bay south of Abbeville, Louisiana, through low swamps punctuated by many poorly-drained lakes (seen at the top of the photograph).

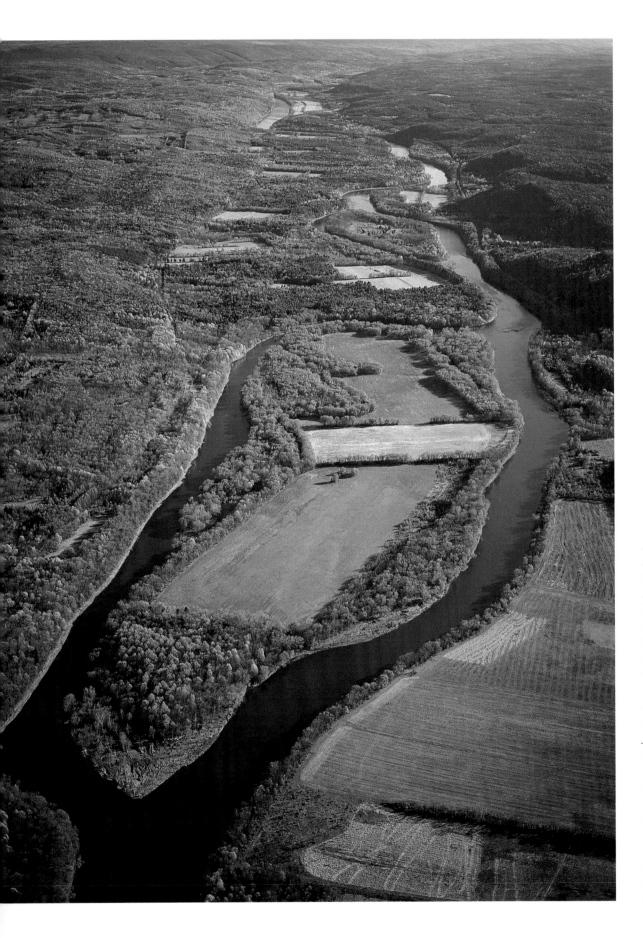

Left: Below Milford, Pennsylvania, the Delaware River splits to flow around Minisink Island toward the Delaware Water Gap. At the Gap, the river abruptly turns and cuts through Kittany Mountain on its way into New Jersey and out to the Atlantic Ocean.

Right: Two large rivers—the Sacramento and San Joaquin— flow from the Sierra Nevada and cross California's Great Valley. Below the rivers' confluence the resulting waterways, seen here, branch into a maze of canals and backwaters that eventually drain into San Francisco Bay. Roads are visible on top of dikes that line both sides of every channel, protecting farmers in this flood- prone lowland.

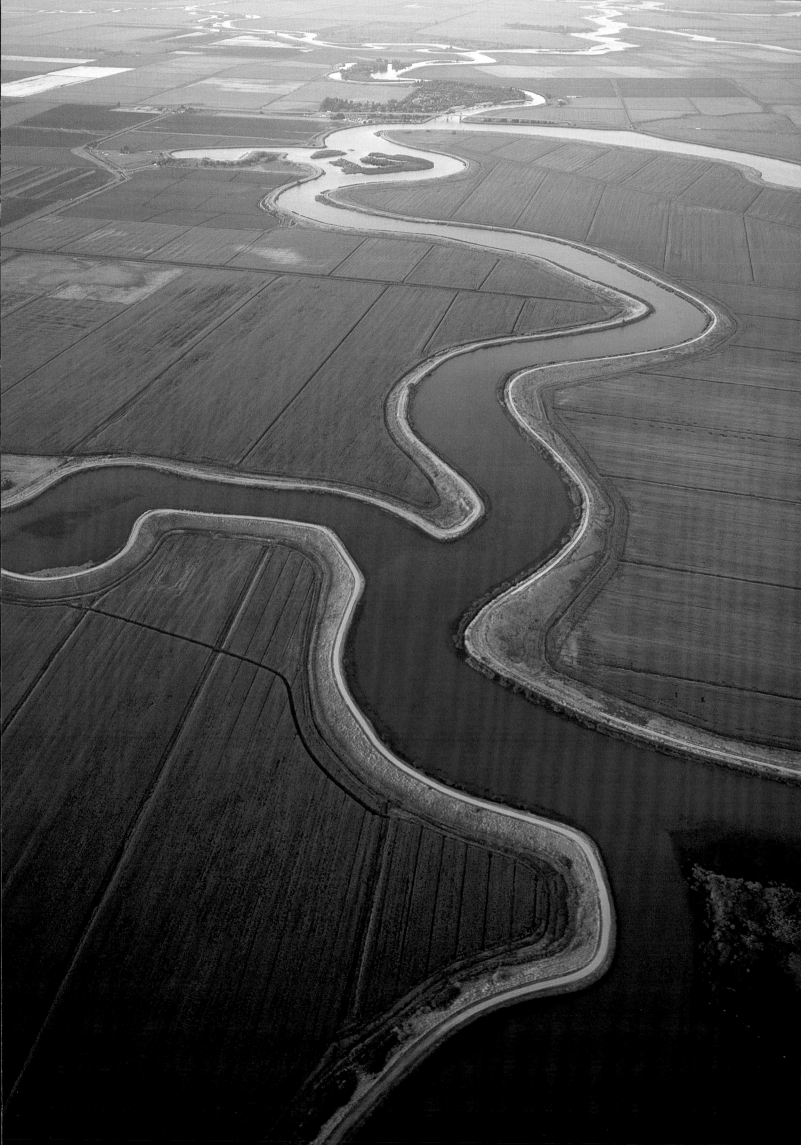

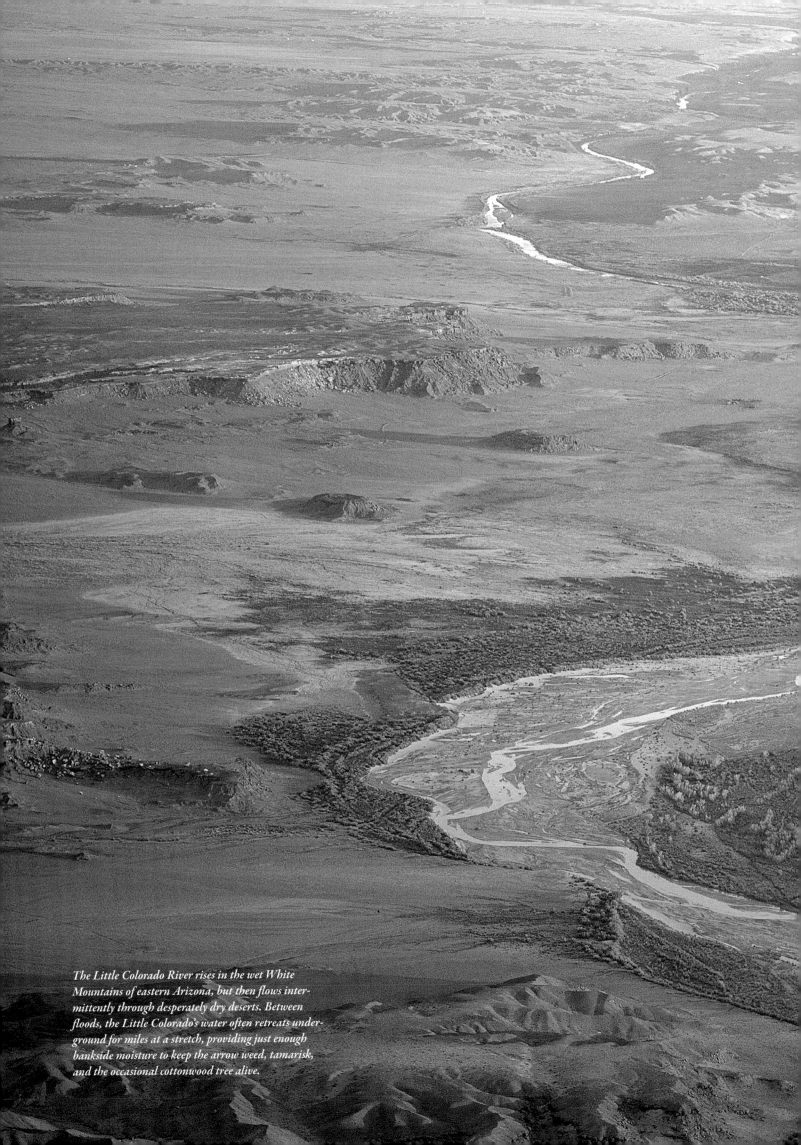

The Little Colorado River rises in the wet White Mountains of eastern Arizona, but then flows intermittently through desperately dry deserts. Between floods, the Little Colorado's water often retreats underground for miles at a stretch, providing just enough bankside moisture to keep the arrow weed, tamarisk, and the occasional cottonwood tree alive.

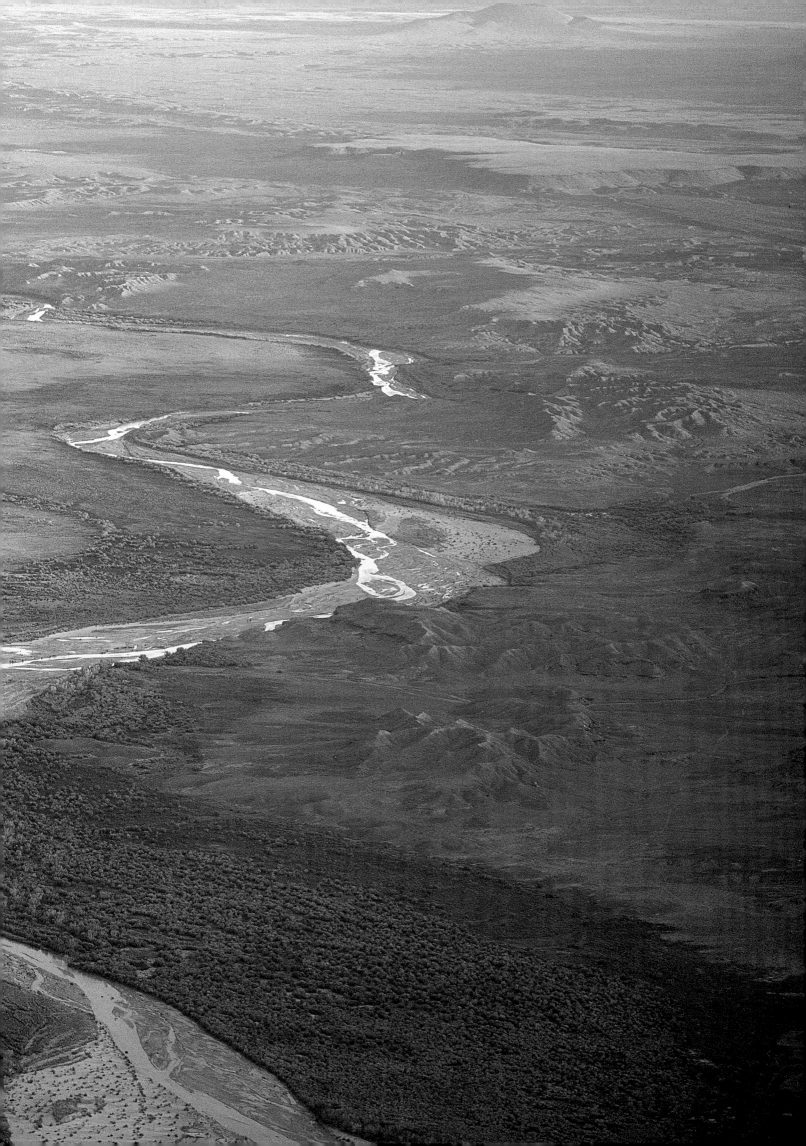

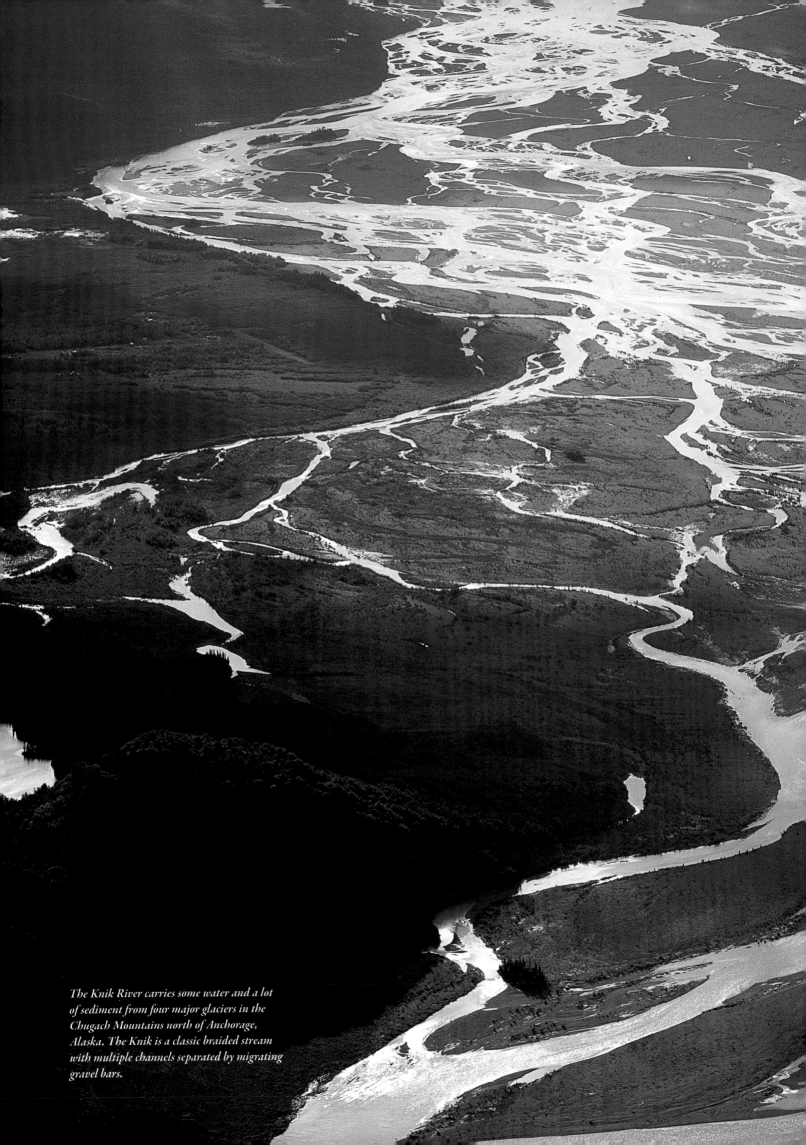

The Knik River carries some water and a lot of sediment from four major glaciers in the Chugach Mountains north of Anchorage, Alaska. The Knik is a classic braided stream with multiple channels separated by migrating gravel bars.

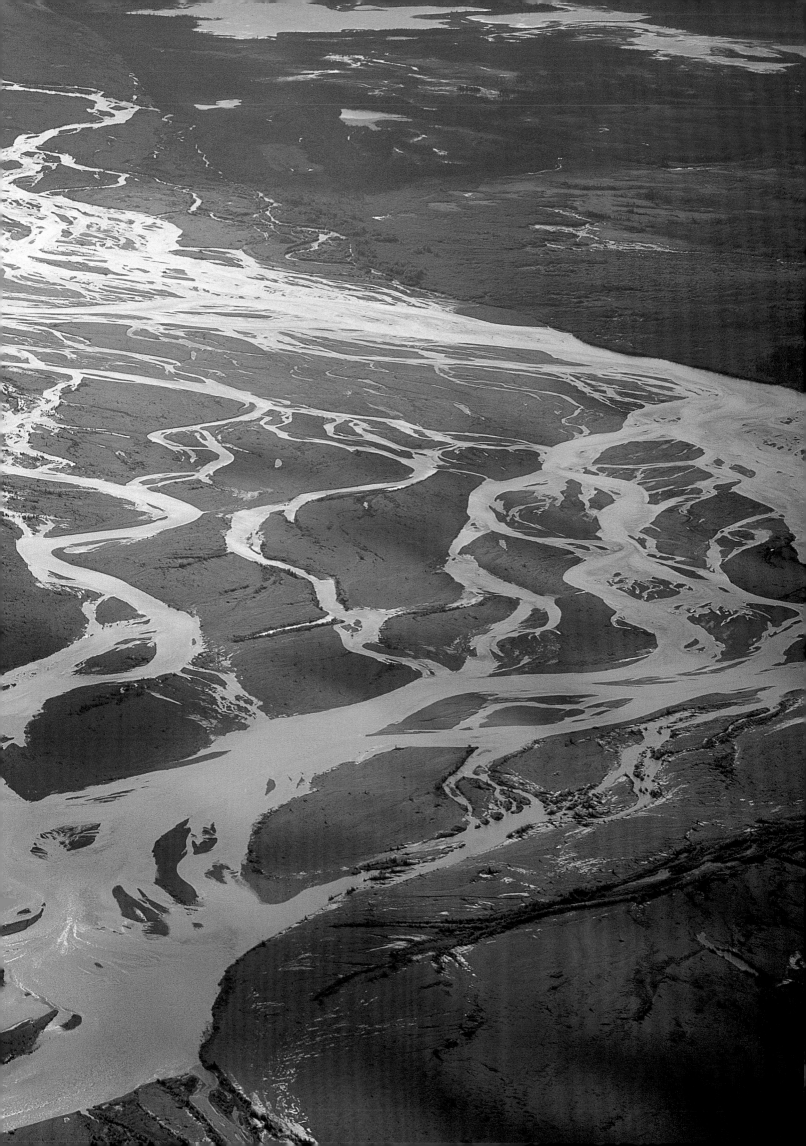

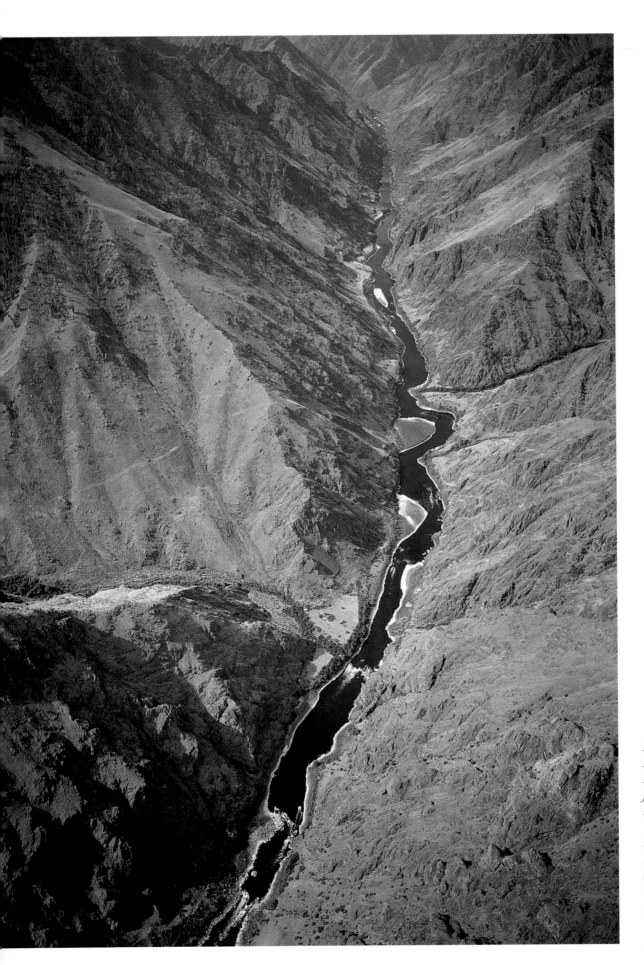

Left: The Snake River has carved Hells Canyon on the border of Idaho and Oregon—a 6,000-foot-deep testament to the fact that rivers shape their landscapes.

Right: Spring rains bring flowers to the otherwise barren slopes of Mancos Shale near Caineville, Utah. The intermittent showers have allowed this unnamed gully to gradually extend its reach into the basin below Ekker Butte.

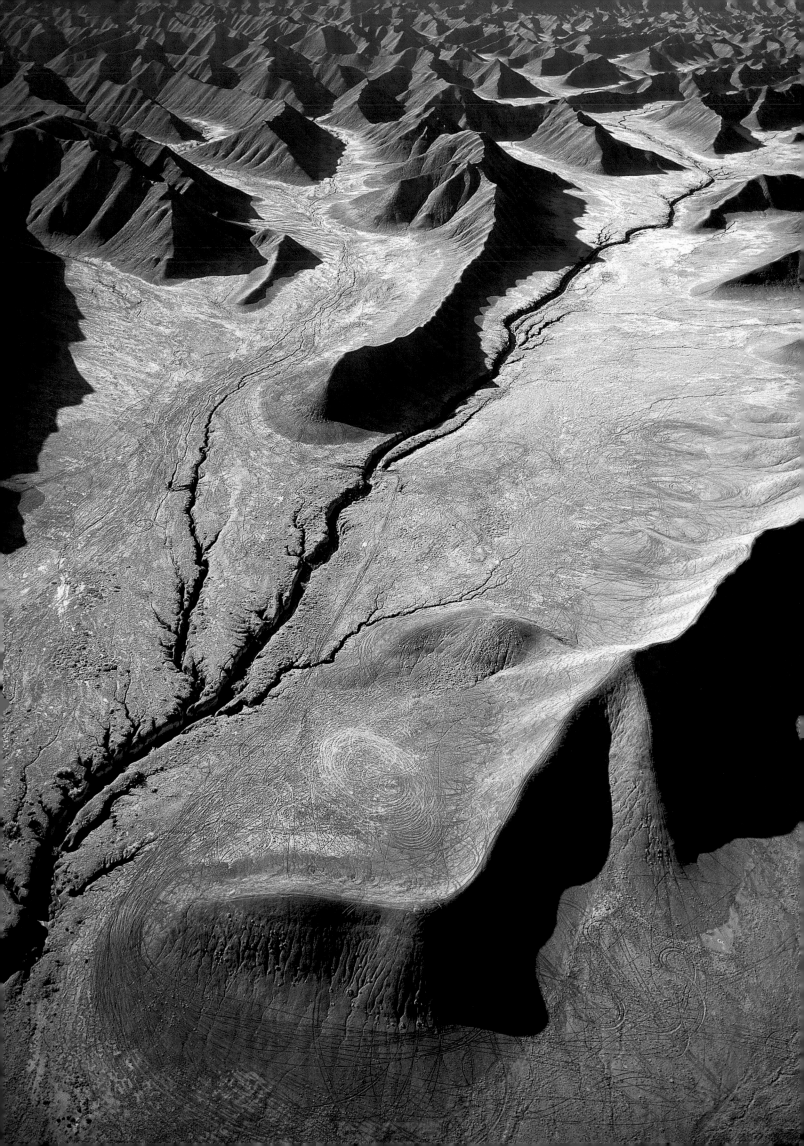

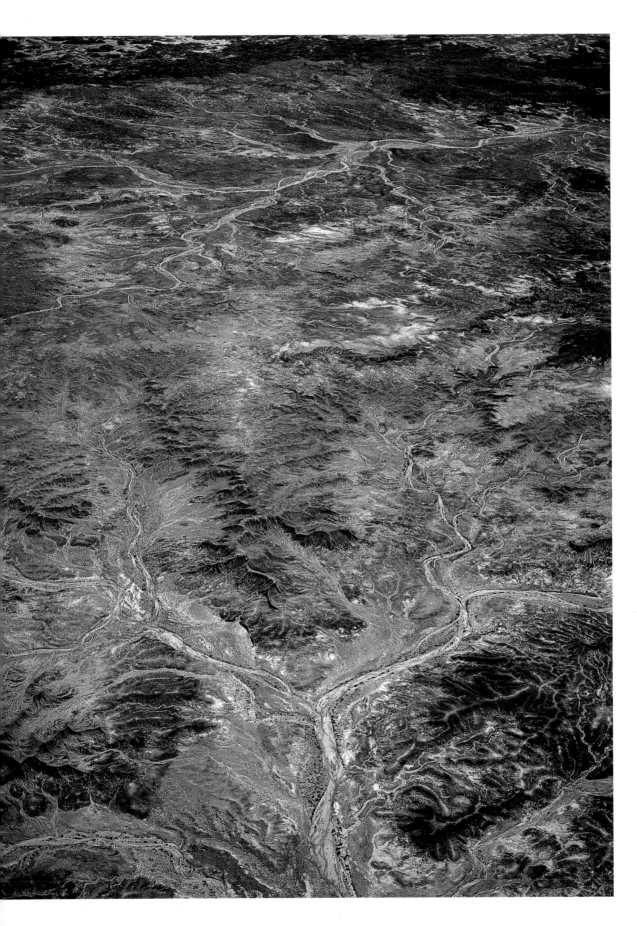

Left: Fingers of the Dead River erode soft hills of Chinle Shale in Arizona's Petrified Forest National Park. Here, two local washes form small basins, one draining down in the picture, and the other to the top right. When rain falls, each finger joins with its neighbors to form a larger stream, all clawing away at the shale. Time will eventually tell which drainage grows larger at the expense of the other.

Right: Wingate Wash cuts between the Panamint and Owlshead Mountains in Death Valley National Park, California. The wash is braided because it has a steep gradient, variable discharge, and abundant coarse sediment. Normally bone dry, Wingate Wash occasionally lights up with yellow blossoms when winter storms bless it with rain.

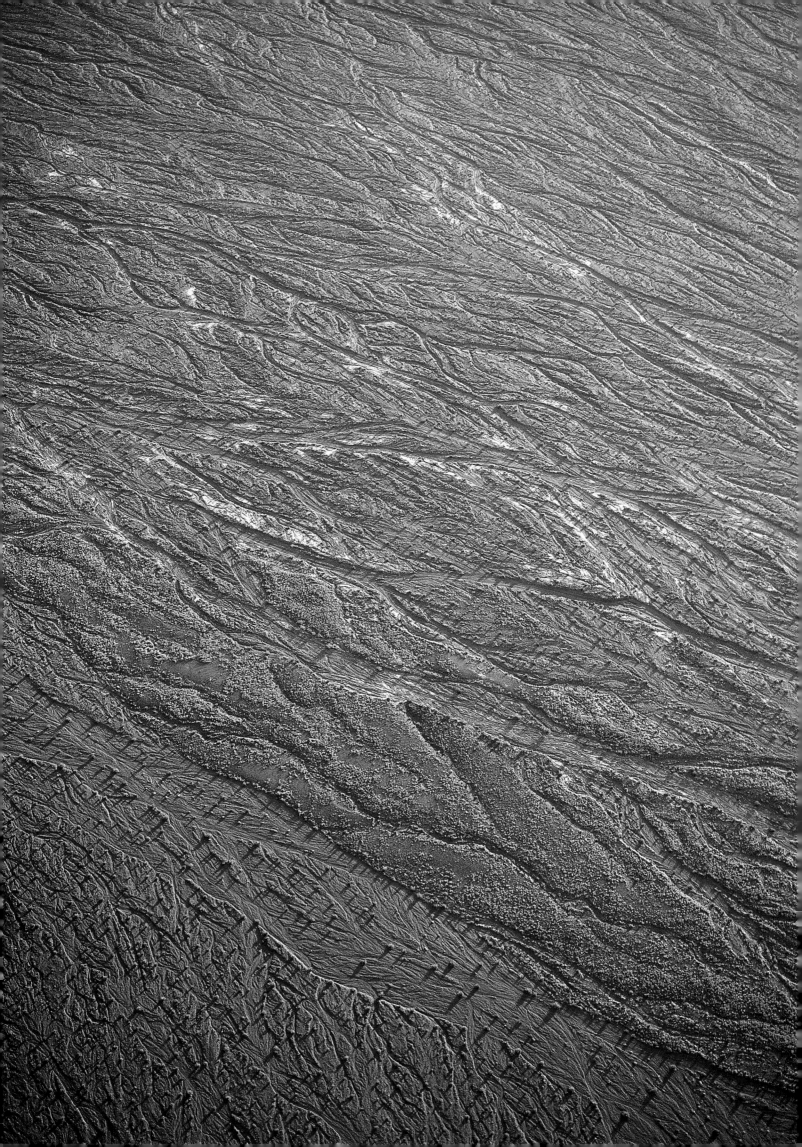

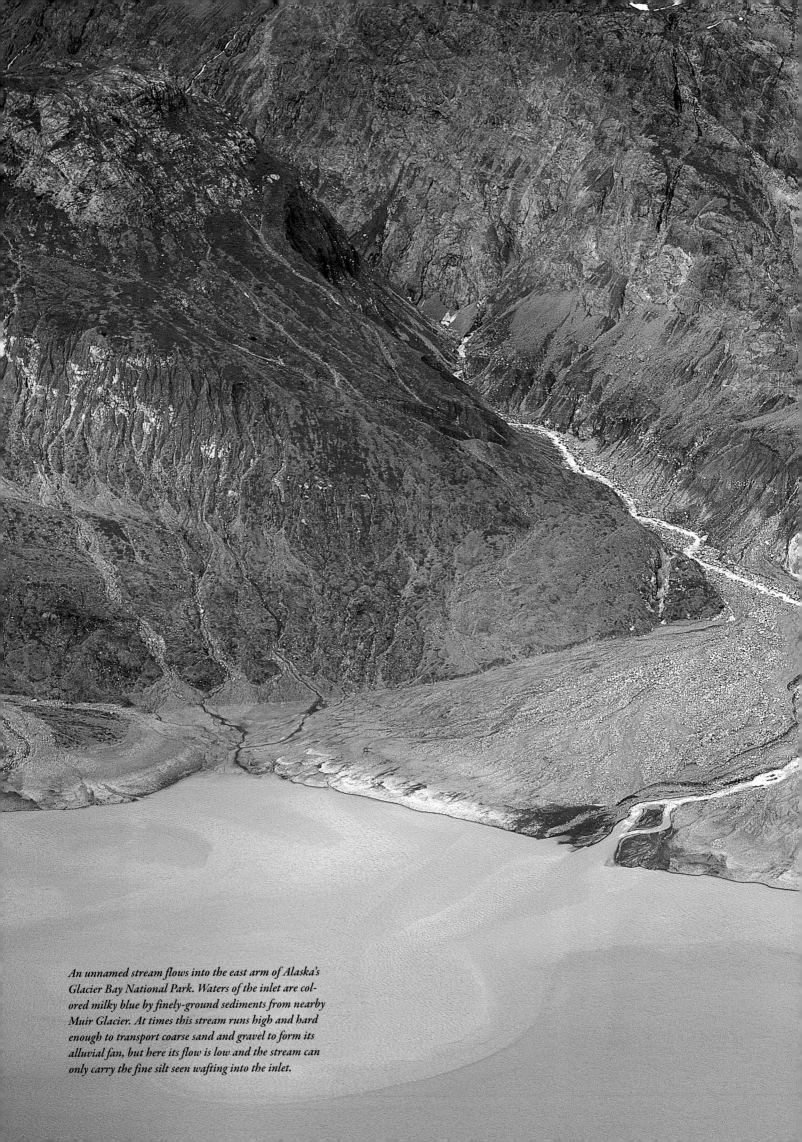

An unnamed stream flows into the east arm of Alaska's Glacier Bay National Park. Waters of the inlet are colored milky blue by finely-ground sediments from nearby Muir Glacier. At times this stream runs high and hard enough to transport coarse sand and gravel to form its alluvial fan, but here its flow is low and the stream can only carry the fine silt seen wafting into the inlet.

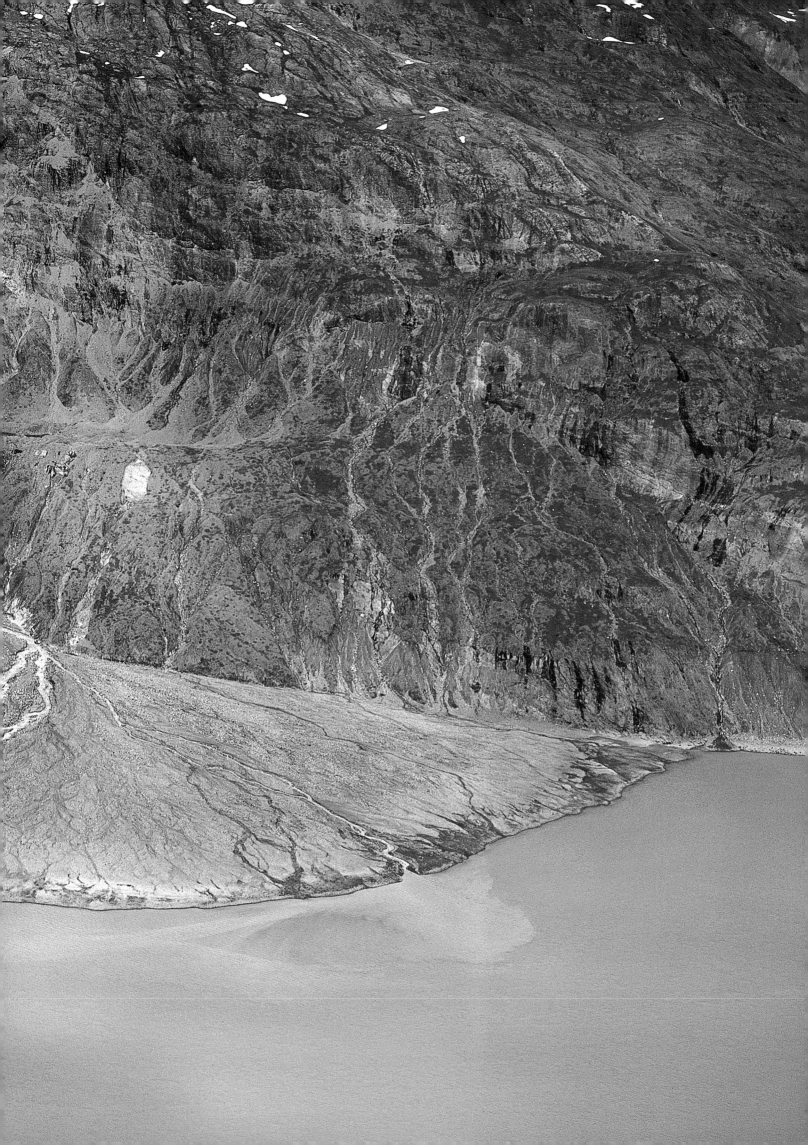

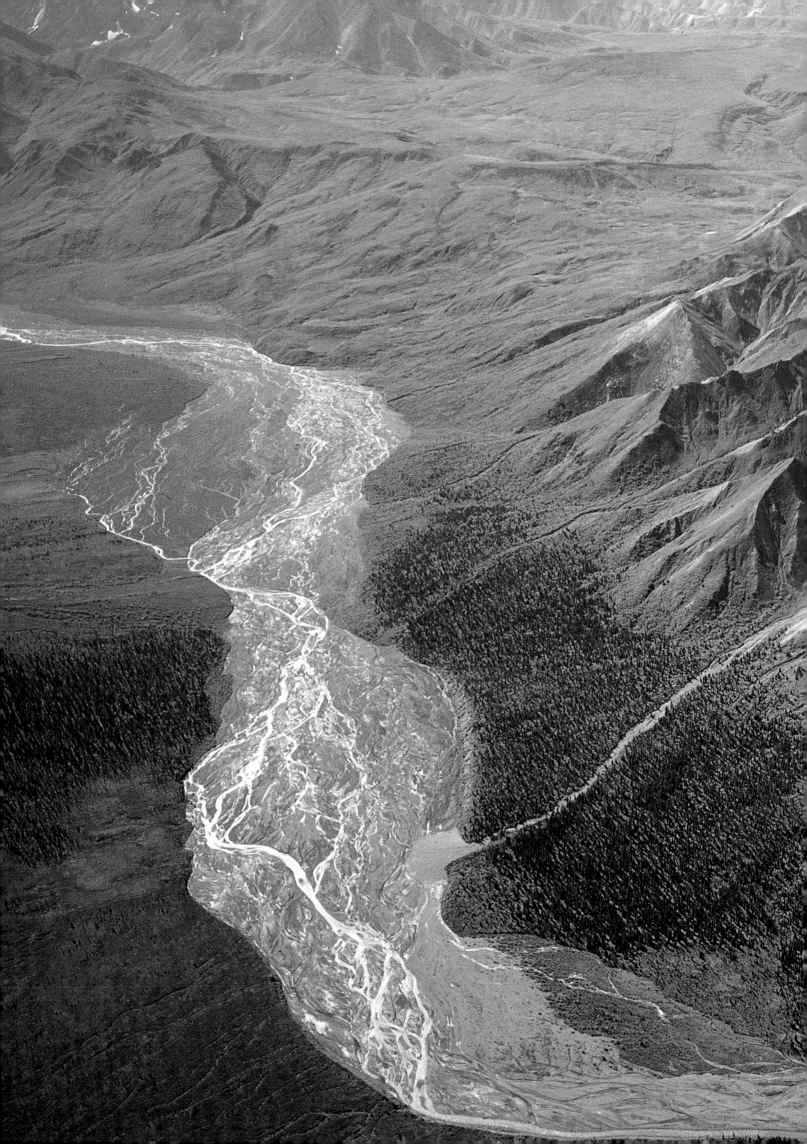

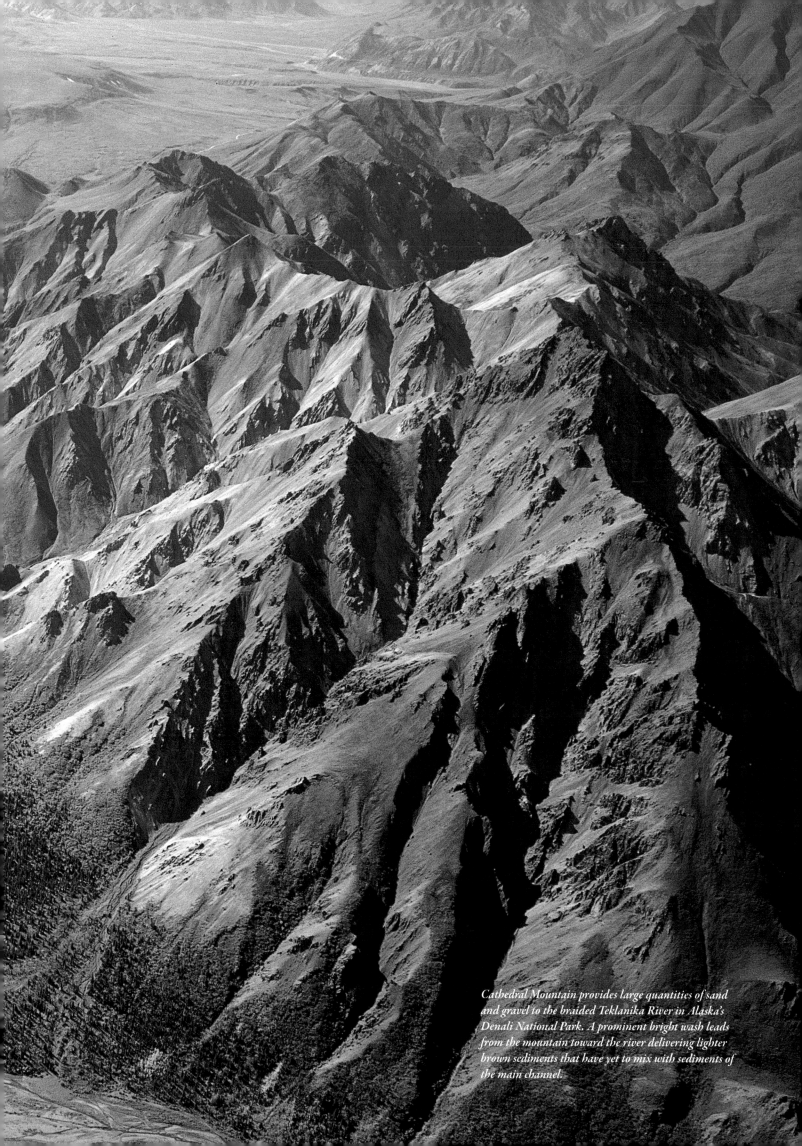

Cathedral Mountain provides large quantities of sand and gravel to the braided Teklanika River in Alaska's Denali National Park. A prominent bright wash leads from the mountain toward the river delivering lighter brown sediments that have yet to mix with sediments of the main channel.

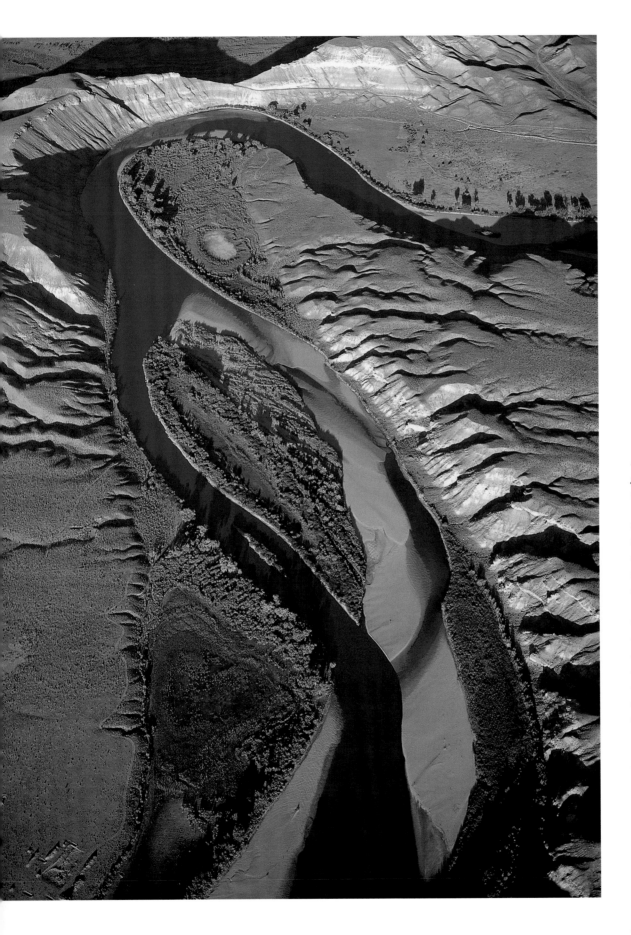

Left: Tamarisk and cottonwood trees grow along the Green River as it heads toward Desolation Canyon in Utah. When the Green was in flood, it flowed around what would have then been a vegetated island in the middle of the picture. Here the flow is lower, and the river is now confined to a single main channel on the left. The remaining small cut-off channel, visible on the right, provides a warm backwater nursery for young fish. Bare sand shows that higher flows swept away bankside vegetation at the bottom of the picture. The water, sand, and plants that comprise the active channel are all confined within terraces and higher cliffs, beyond which the land quickly reverts to desert.

Right: Light green waters of the Green River commingle with darker waters of the Colorado River in the heart of Utah's Canyonlands National Park. The two rivers don't mix immediately. Instead, the boundary between the two bodies of water sloshes left and then right as cliffs force the channel to swing through right and then left curves.

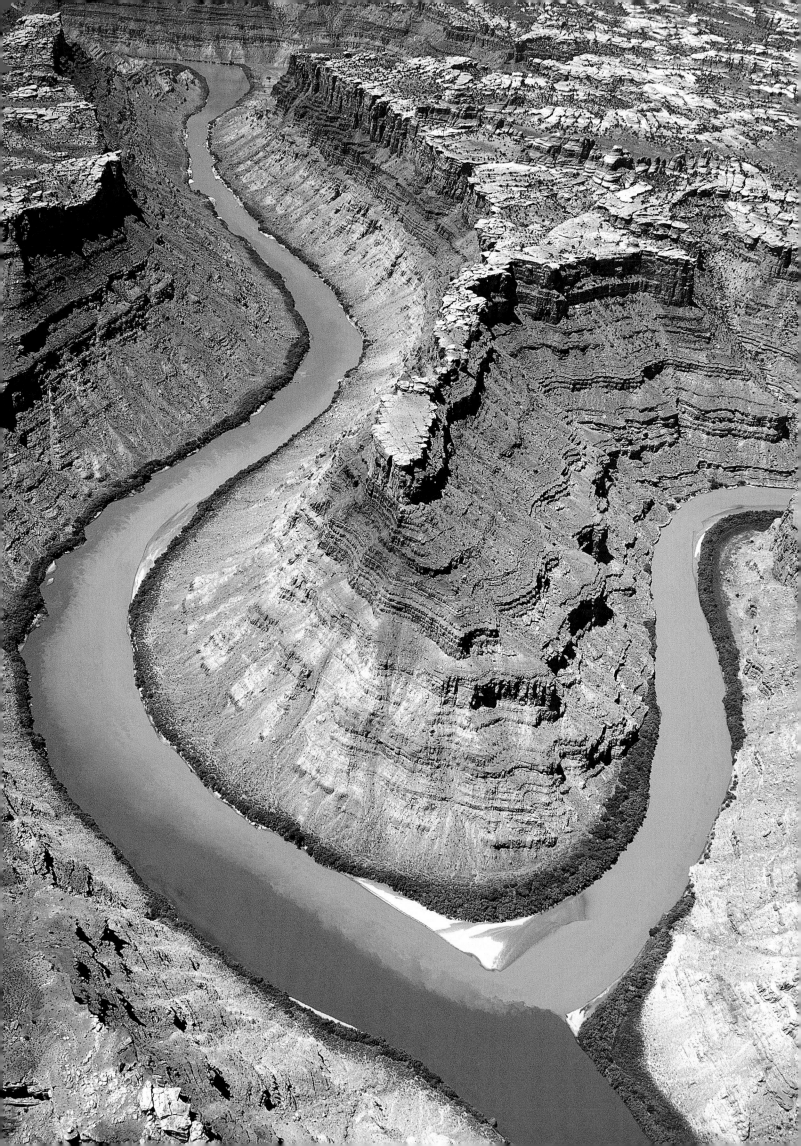

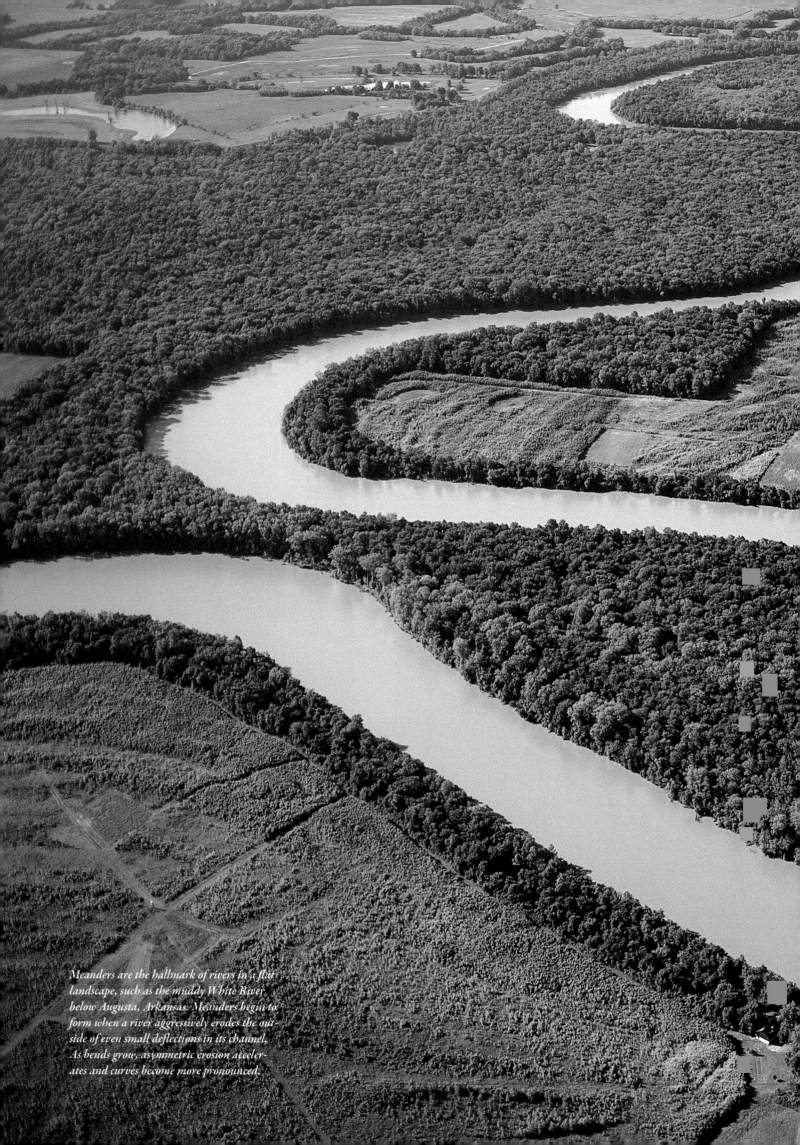

Meanders are the hallmark of rivers in a flat landscape, such as the muddy White River below Augusta, Arkansas. Meanders begin to form when a river aggressively erodes the outside of even small deflections in its channel. As bends grow, asymmetric erosion accelerates and curves become more pronounced.

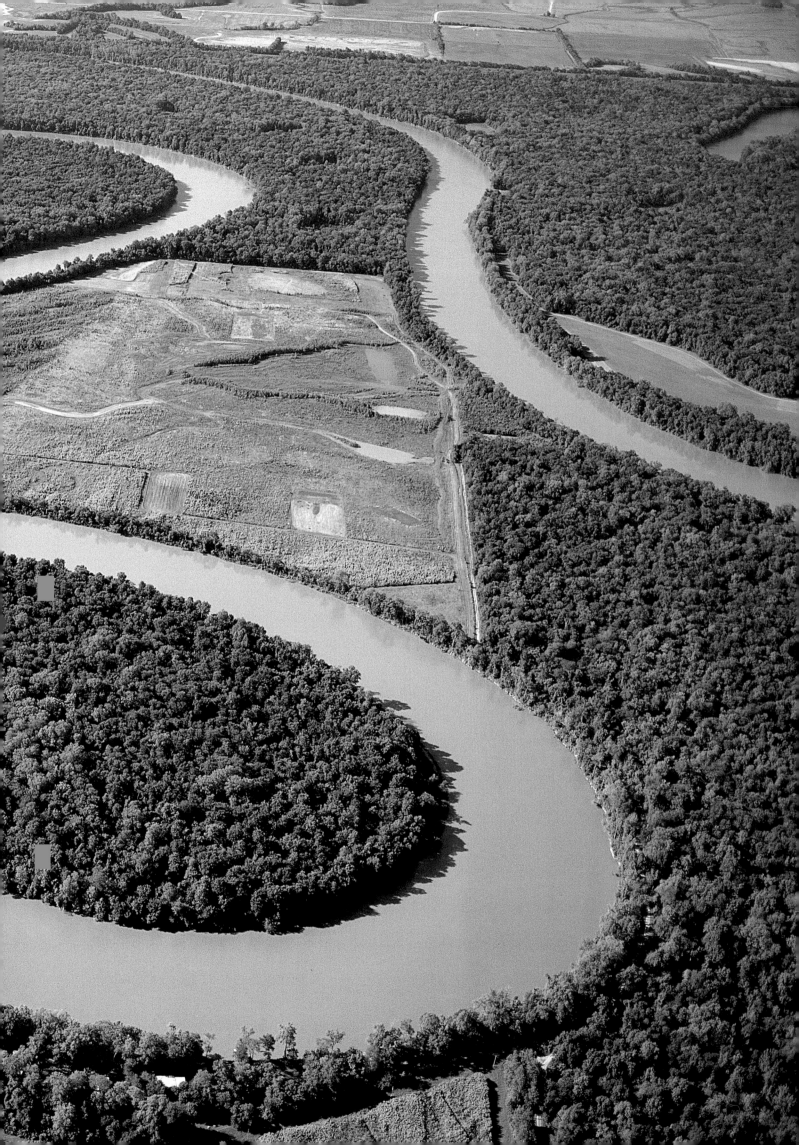

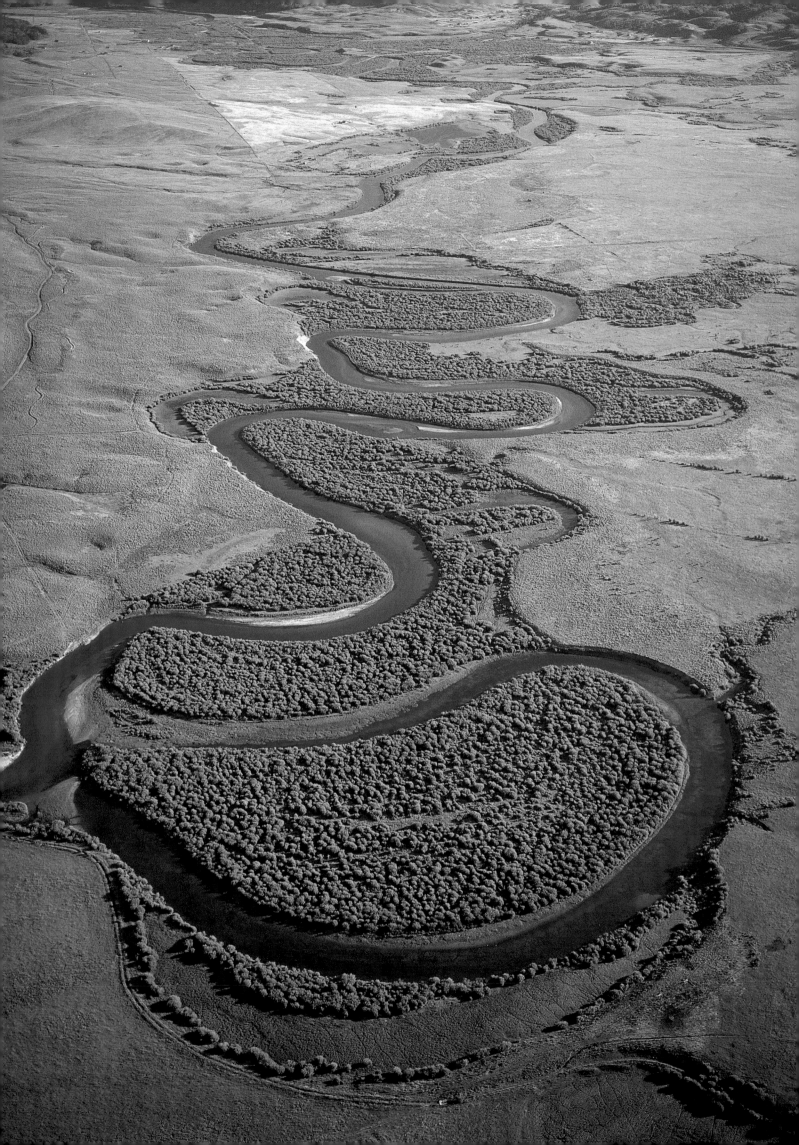

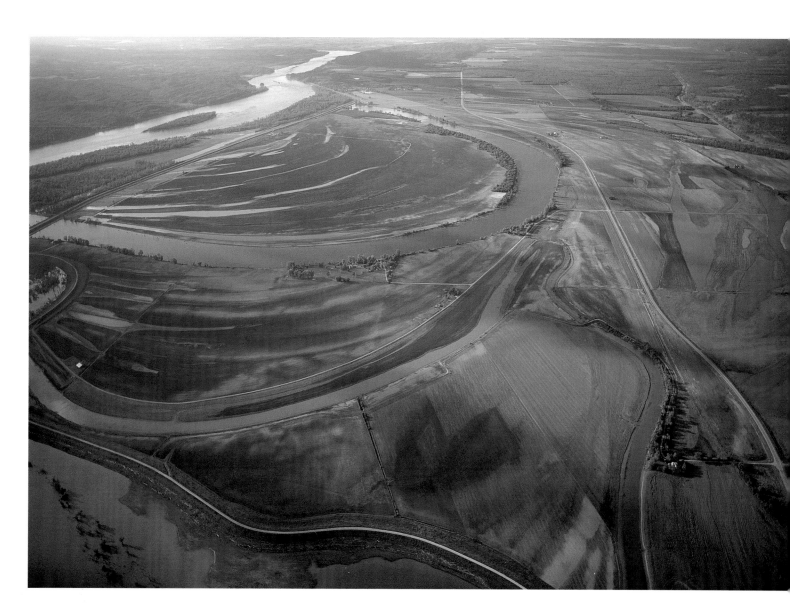

Above: Cutoff meanders can be sealed away from the main river channel by plugs of sediment, thus forming oxbow lakes as seen here along the Mississippi River above Cape Girardeau, Missouri.

Left: The Green River writhes like a snake in slow motion as it twists toward Bronx, Wyoming. The river gradually erodes the outside of bends while depositing bright sand on the inside of bends. At the bottom of this photograph, erosion has cut through a meander's narrow neck, shortening the river's course by abandoning an entire loop of its channel. This abandoned loop has become a backwater known as a cutoff meander.

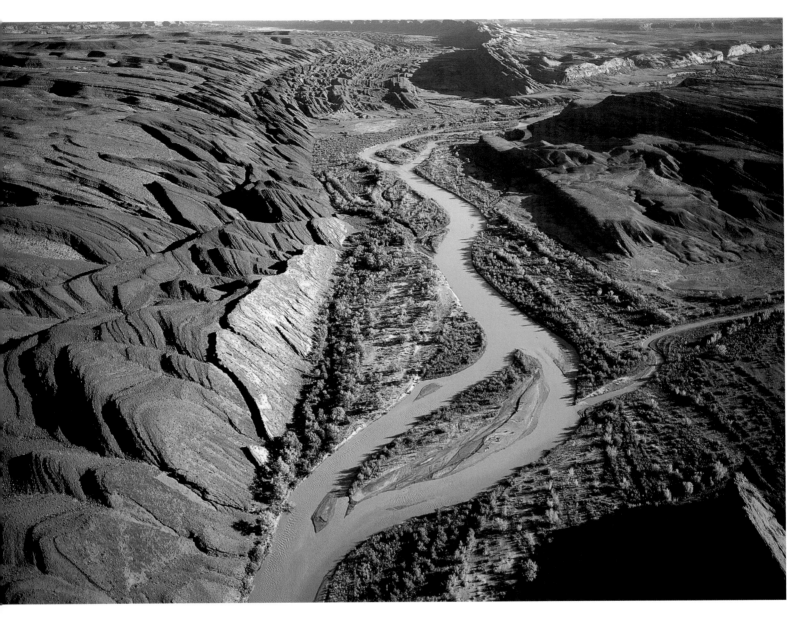

Above: Comb Ridge was tilted 65 million years ago during the Laramide period of mountain-building that jarred much of the mountain west. Utah's San Juan River flows along the base of this ridge, where it has eroded into an exposure of soft shale. The thin red stream of Chinle Wash joins the San Juan from the right.

Right: The Englishman River coyly meanders and dawdles as if it were reluctant to disappear into the sea. This rocky part of the Atlantic coastline near Kennebec, Maine, was gouged by glaciers that left behind small rocky islands seen at the top of the photograph.

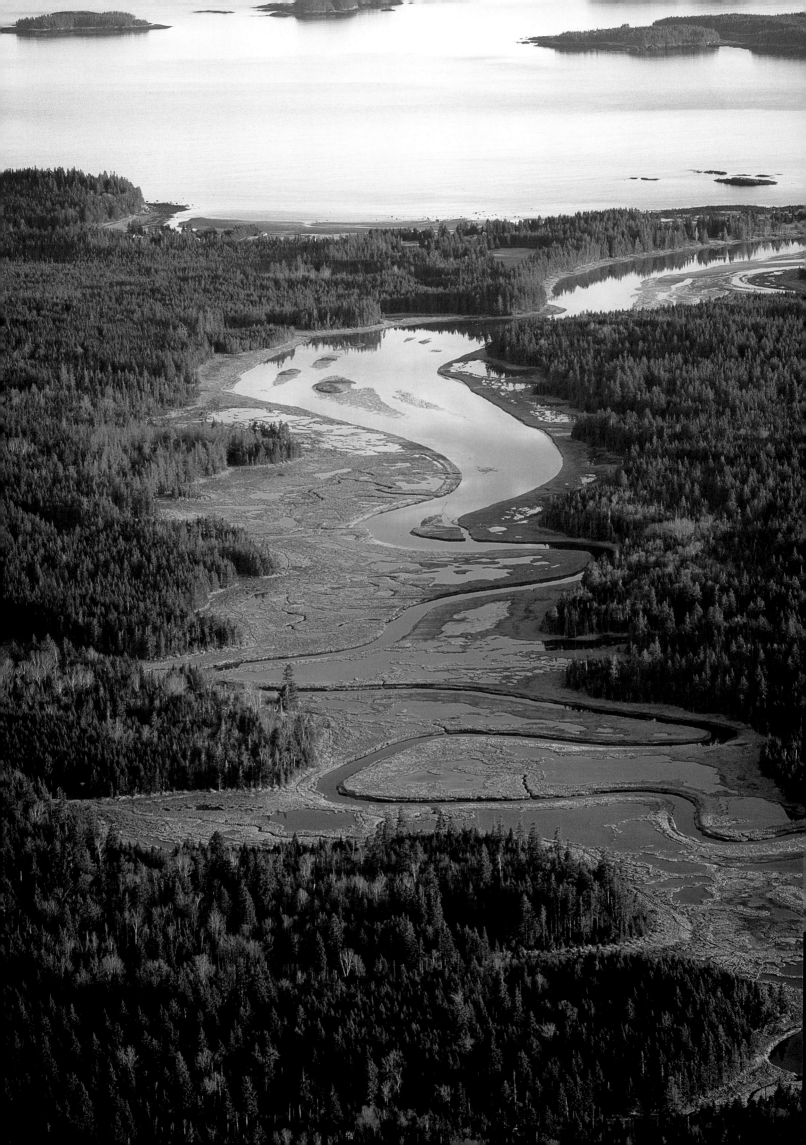

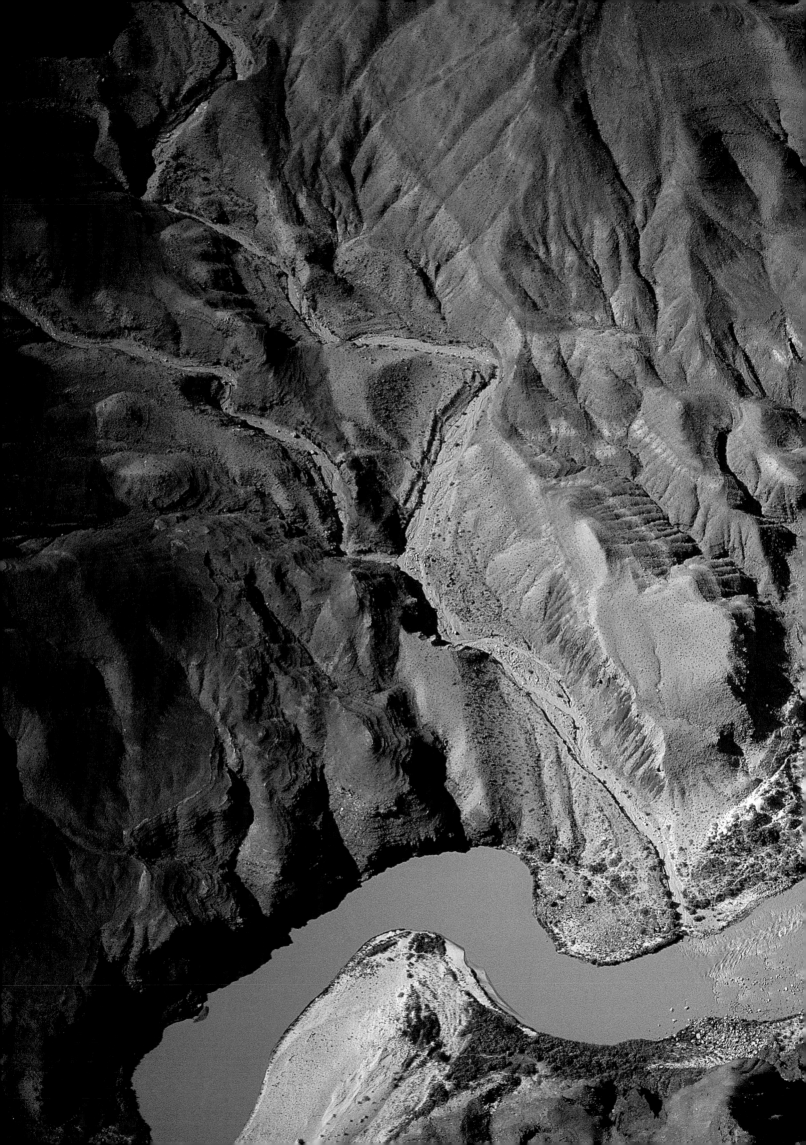

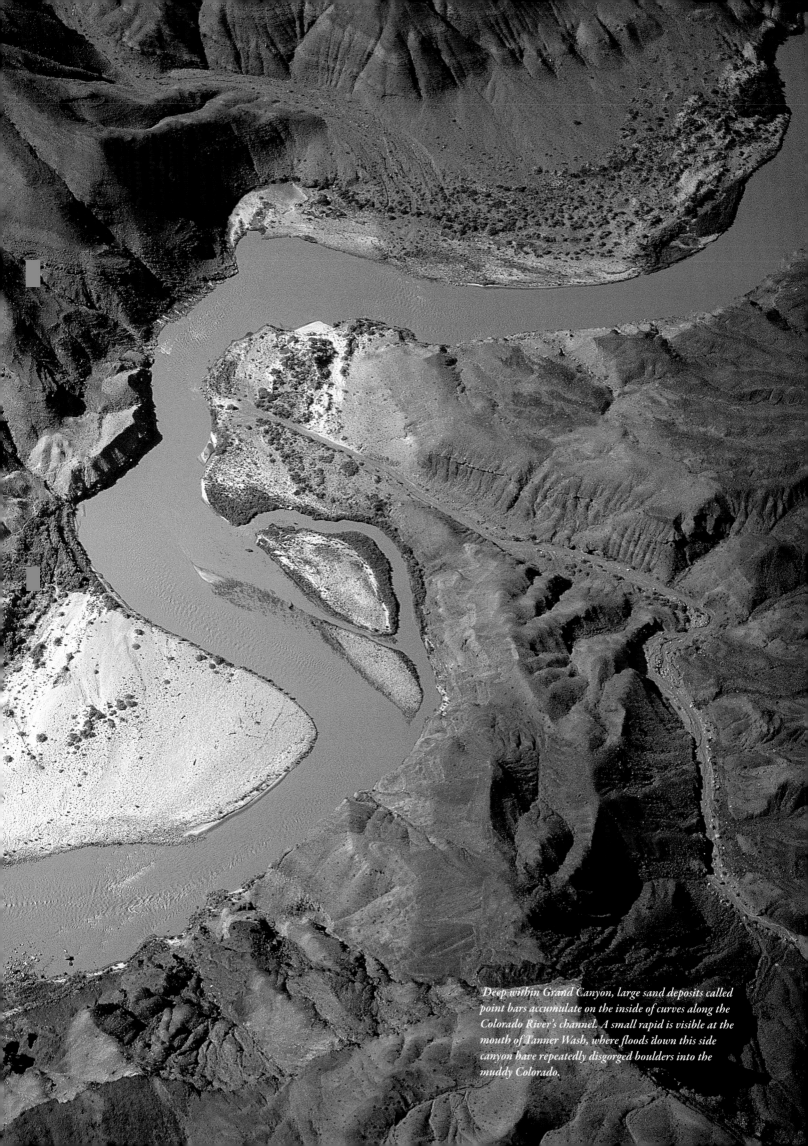

Deep within Grand Canyon, large sand deposits called point bars accumulate on the inside of curves along the Colorado River's channel. A small rapid is visible at the mouth of Tanner Wash, where floods down this side canyon have repeatedly disgorged boulders into the muddy Colorado.

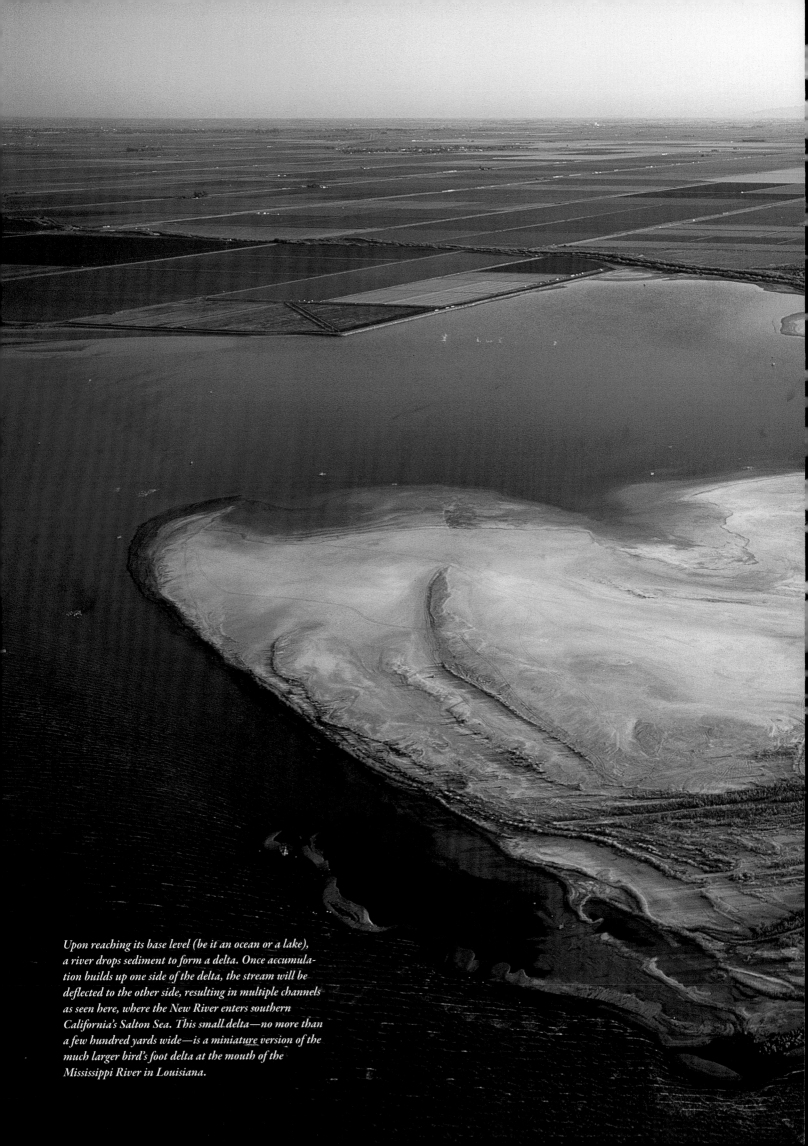

Upon reaching its base level (be it an ocean or a lake), a river drops sediment to form a delta. Once accumulation builds up one side of the delta, the stream will be deflected to the other side, resulting in multiple channels as seen here, where the New River enters southern California's Salton Sea. This small delta—no more than a few hundred yards wide—is a miniature version of the much larger bird's foot delta at the mouth of the Mississippi River in Louisiana.

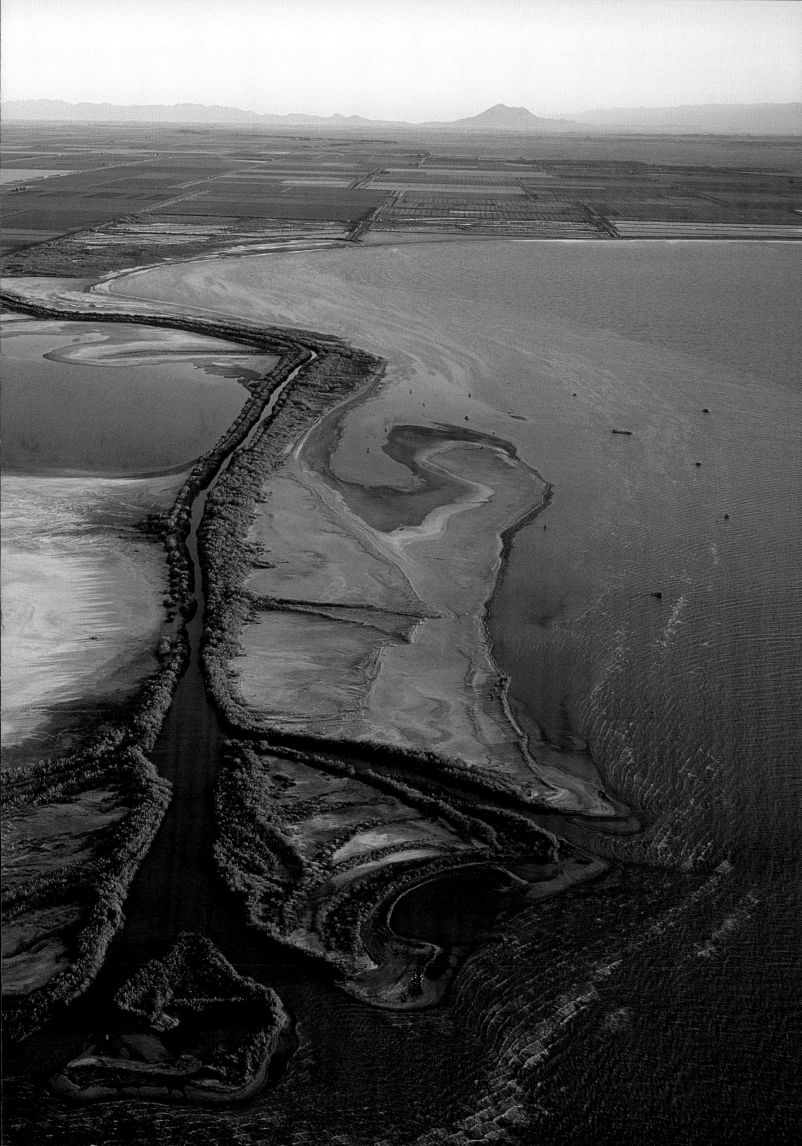

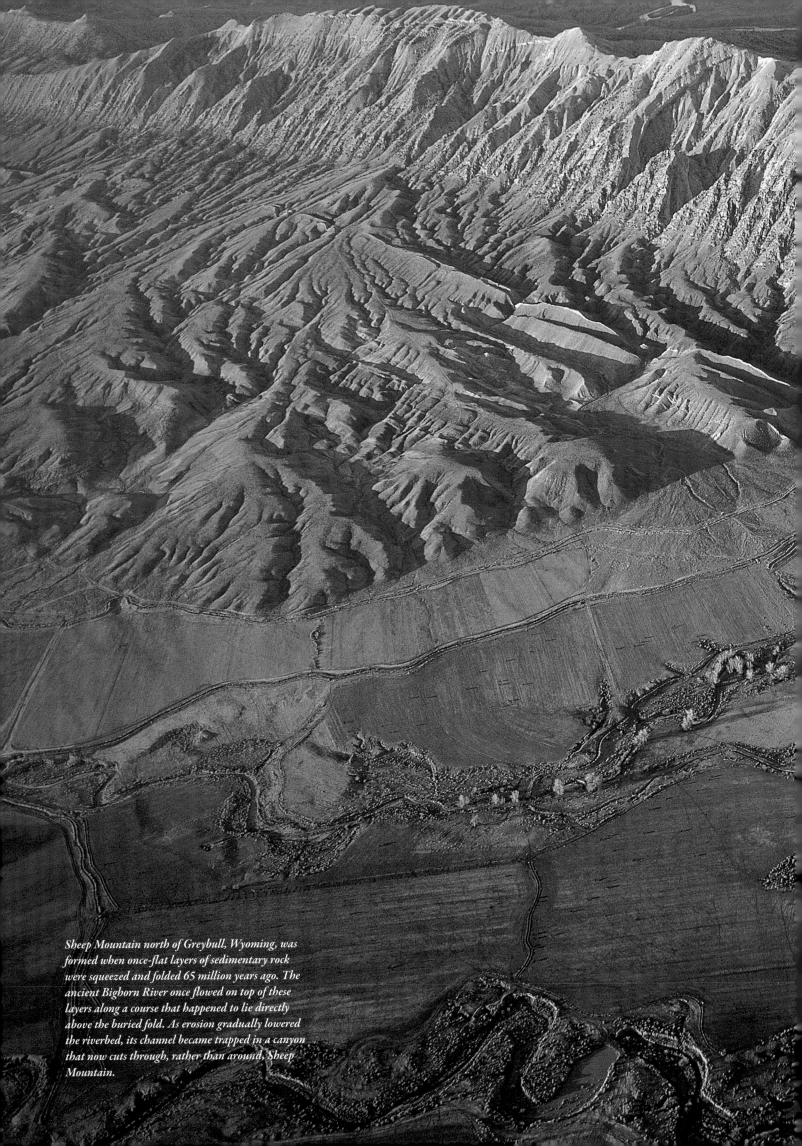

Sheep Mountain north of Greybull, Wyoming, was formed when once-flat layers of sedimentary rock were squeezed and folded 65 million years ago. The ancient Bighorn River once flowed on top of these layers along a course that happened to lie directly above the buried fold. As erosion gradually lowered the riverbed, its channel became trapped in a canyon that now cuts through, rather than around, Sheep Mountain.

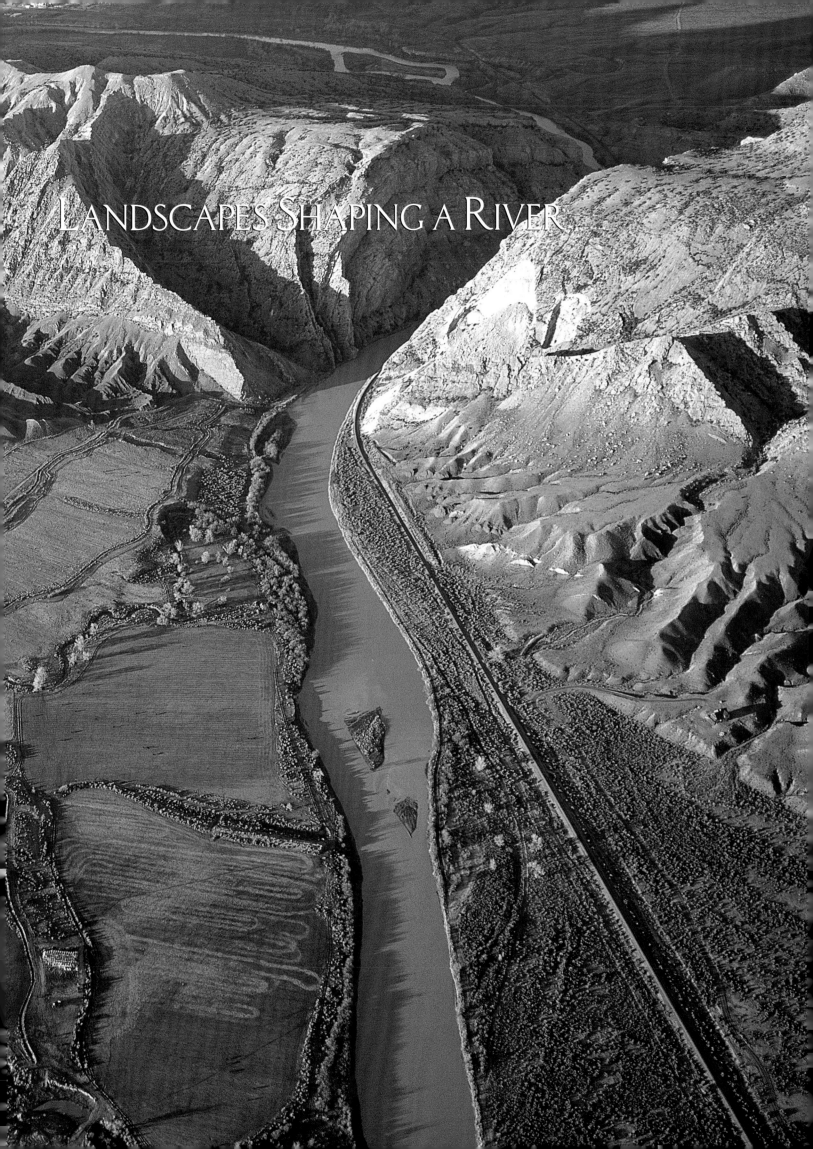

LANDSCAPES SHAPING A RIVER

Three Waters Mountain, at the north end of the Wind River Range, cradles a single point common to three great American rivers. From here, water flowing east joins the Missouri and Mississippi Rivers on their way to the Gulf of Mexico. Westbound water makes its way to the Snake and Columbia Rivers, eventually reaching the Pacific Ocean. And water running south enters the Green and then Colorado Rivers, heading without hope for the Gulf of California. Depending on the smallest puff of wind, a raindrop falling on Three Waters Mountain could end up in oceans 2,200 miles apart. In the ridges and valleys that fan out from Wyoming's Three Waters Mountain, it's perfectly clear that landscapes can shape their rivers.

Western Wyoming was caught up in a mountain-building frenzy 70 million years ago when the Wind River Range was pushed skyward by the inexorable pressure of plate tectonics. Twenty million years later and a hundred miles to the north, volcanic eruptions inundated an area east of Yellowstone with 7,000 cubic miles of andesite and dacite to create the Absaroka Mountains. And now the Teton Range is repeatedly jarred by earthquakes that are going off like a string of firecrackers around Jackson Hole. These mountains, crazily tipped and capriciously torn, still creak and groan as their peaks rise and valleys fall.

Rivers seeking the ocean try to make sense of the mountains whence they flow. You'd think their job would be simple—after all, doesn't water just run downhill? But the geometry of living water in a tortured landscape turns out not to be so simple. The Green River flows north out of the Wind River Mountains before twisting back to the south. The Snake River fusses around the Absarokas and flirts with Jackson Lake before suddenly gouging a path west past the Teton Range. The Wind River empties into the Bighorn which then claws its way north through the Owl Creek and Sheep Mountains. Rivers are supposed to flow around— not through—obstructions like mountains. Something odd, something disturbing, is going on here. Western Wyoming is caught between the uplifting of mountains and the down-cutting of rivers.

Western Wyoming is geographically complex not only because of its tall mountains and deep, river-cut canyons, but also because mountain-building and erosion operate simultaneously here. Each proceeds at its own pace, and each process influences the other. Time, as a fourth dimension, is the key to understanding this landscape. Geologic stories involve not only scenes like mountains and characters like rivers, but also plots— when, and in what sequence, did things happen?

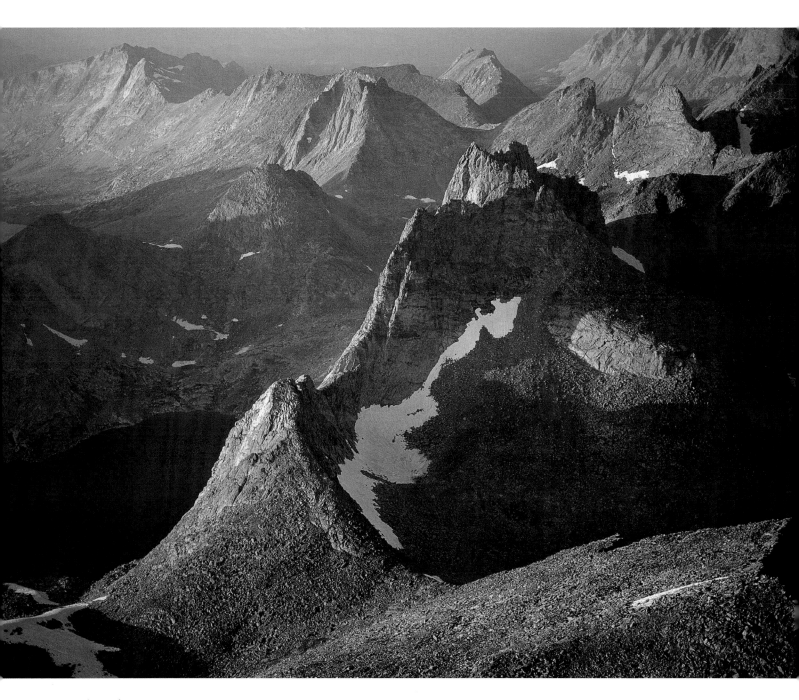

Wyoming's Wind River Mountains, rising 13,700 feet above sea level, were heavily glaciated during the Pleistocene Epoch. The ice chiseled ridges, and carved bowls that now hold lakes. The Continental Divide runs along the sharp crest of these mountains, separating waters that will either flow east or west.

Imagine a river that is minding its own business, flowing peacefully across a lowland countryside. The river curls into meanders, tends its terraces, and dependably deposits its floodplain. But when some drunken tectonic plate crashes into the continent, those flat-lying layers beneath the river are uplifted into a new mountain range. If our river is able to cut down about as fast as the mountain buckles up, the eroding layers will mimic a block of wood being lifted into a stationary sawblade. And the river will end up flowing through, rather than around, a newborn mountain.

Alternatively, imagine a different mountainous region that was heavily faulted and folded in the distant past. After the mountain-building pyrotechnics fizzled out, the rocks ended up looking like a large, well-used wad of chewing gum. Time passed, seas came and went, and this mangled terrain was quietly buried beneath younger, flat-lying sedimentary layers. Along comes a young river, lollygagging across the top of these layers in lazy loops and easy meanders. As the river's course becomes entrenched, it unsuspectingly erodes down into the old mountains that are buried below like the grain inside a block of wood. Now that spinning sawblade (the river) is being lowered down onto the wood, which already contains the roots of those ancient mountains. As erosion proceeds, the river may once again end up flowing through a mountain, but this time by a very different process than our first hypothetical terrain.

In the eighteenth century, bible-brandishing geologists argued that the world was created with all of its cracks and crenulations in merely seven days. On the third day, the oceans were separated from land, and water apparently just ran downhill, hurriedly seeking out the low places. But why were there not more waterfalls in this crinkly world? Not all cracks and crinkles would have had similar depths. Why then, when two rivers run together, are confluences usually level rather than stepped off? Perhaps, since our world isn't spangled with billions of waterfalls, a more even-handed agent like erosion must have gradually fit rivers smoothly to their valley floors. But the processes of erosion would have to have been active for more than seven short days. Places like the mile-deep Grand Canyon in Arizona are monuments to the steady gnawing power of water, spanning not just days, but millions of years.

Of course there are exceptions: some rivers do flow into preexisting lowlands. The Rio Grande runs down a great north-south trough in New Mexico. This thousand-foot-deep Rio Grande Rift exists because the forces of plate tectonics are here prying North America apart and lowering the floor of the trench. Rivers typically erode their own valleys. But in this case, the Rio Grande is following a geologically (rather than hydrologically) ordained depression.

Not all rivers flow in valleys of their own making. The Rio Grande in central New Mexico passively follows a rift that was created when the underlying crust was stretched apart by the inexorable forces of plate tectonics.

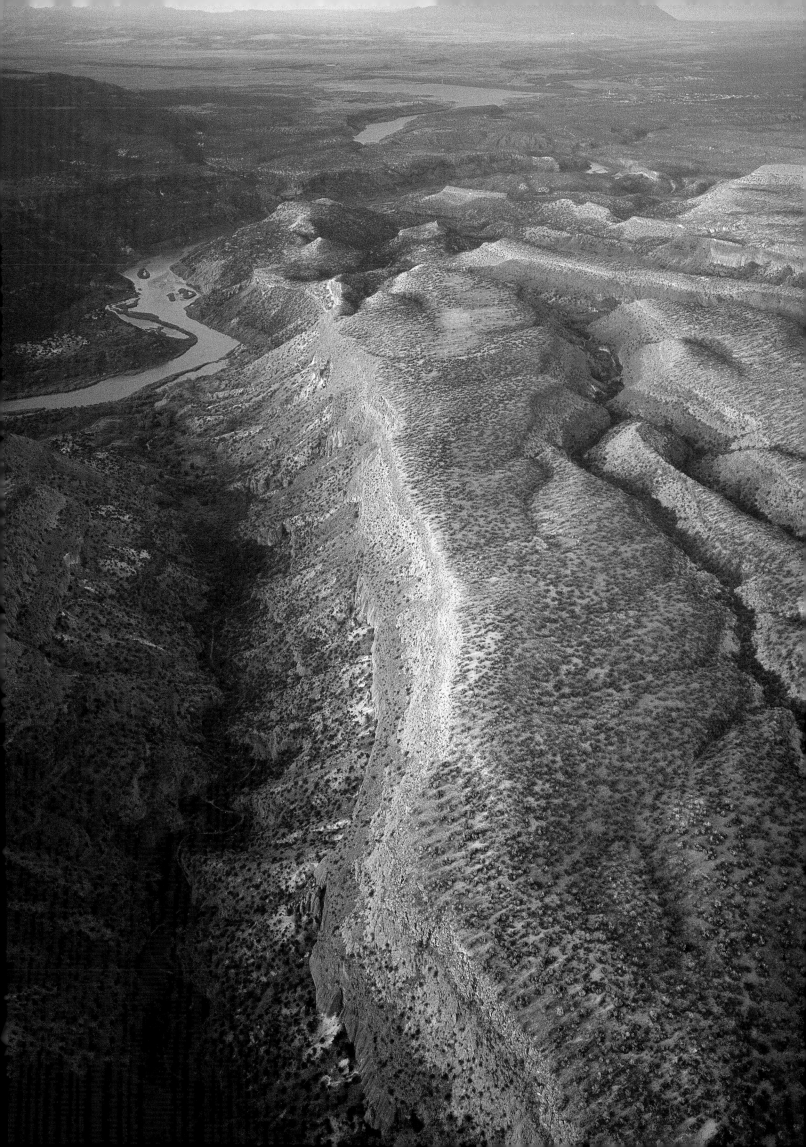

Farther west in California, the Amargosa River pours into another trough called Death Valley. The river ends at Badwater which, at 282 feet below sea level, is the lowest place in the United States. Death Valley and the Amargosa are part of the Great Basin, a quarter-million-square-mile corner of the American West where rivers run, not to the sea, but into oblivion—dry lakebeds and natural evaporation ponds lined with salt flats and sagebrush.

Geology is, more than anything else, a collection of stories about time and the earth's history. The scales of time involved are unimaginably immense. For instance, the Colorado River now peels back layers from Arizona's Grand Canyon. At the bottom, the twisted rocks of the Vishnu Schist record a mountain-building epoch that happened more than one and a half billion years ago. Half a billion years later, another mountain range was superimposed on the first. Another half-billion years passed and seas washed in, draping thousands of feet of sedimentary rocks across the remnants of the mountain roots. The gaps between these three events are eerily silent because most clues of their passage have been erased by erosion. Geologic time is as vast and as soundless as the space between stars.

Rivers have often been shaped by the forces of plate tectonics. Eons ago, Europe, Africa, and North America were jammed together into a single continental block. Then, a hundred and fifty million years ago, these plates began to separate, and the early Atlantic Ocean swirled in to fill the gap between them. Sea level fluctuations carved a notch in the hard crystalline shoulders of the Appalachian Piedmont. This notch would become the Atlantic Fall Line that now has been lifted about three hundred feet above sea level. At the Fall Line, modern rivers tumble over waterfalls that lie consistently inland from the Atlantic Seaboard. It's no accident that early industries that relied on the waterwheel for power were located here, seeding a row of modern cities like Trenton, Philadelphia, Washington, Richmond, Raleigh, and Augusta.

When plates of the earth's crust are stretched, they do not always succeed in fully separating as they did to form the Atlantic Ocean. MidAmerica began to writhe 95 million years ago, first warping up into an arch from southern Louisiana to southeast Missouri, then, ten million years later, dropping below sea level. Geologists propose that this rise and fall was due to the subterranean passage of a hot plume of magma deep within the mantle. Like a blow torch aimed at the bottom of a steel plate, this hot spot first heated and expanded the overlying crust. Then, after the torch had passed, the crust cooled and shrank. The Gulf Coast had begun to tear open, but then it stopped. What could have been an incipient ocean turned out to only be a deep embayment stretching up from the Gulf of Mexico. The resulting lowland became the bed of the Mississippi River. Though most of the fireworks are over, the continent's crust in this region is still tossing and turning as it tries to fall back asleep. The most violent earthquake ever recorded in North America actually occurred here in 1812, rather than along the continent's more notoriously active West Coast.

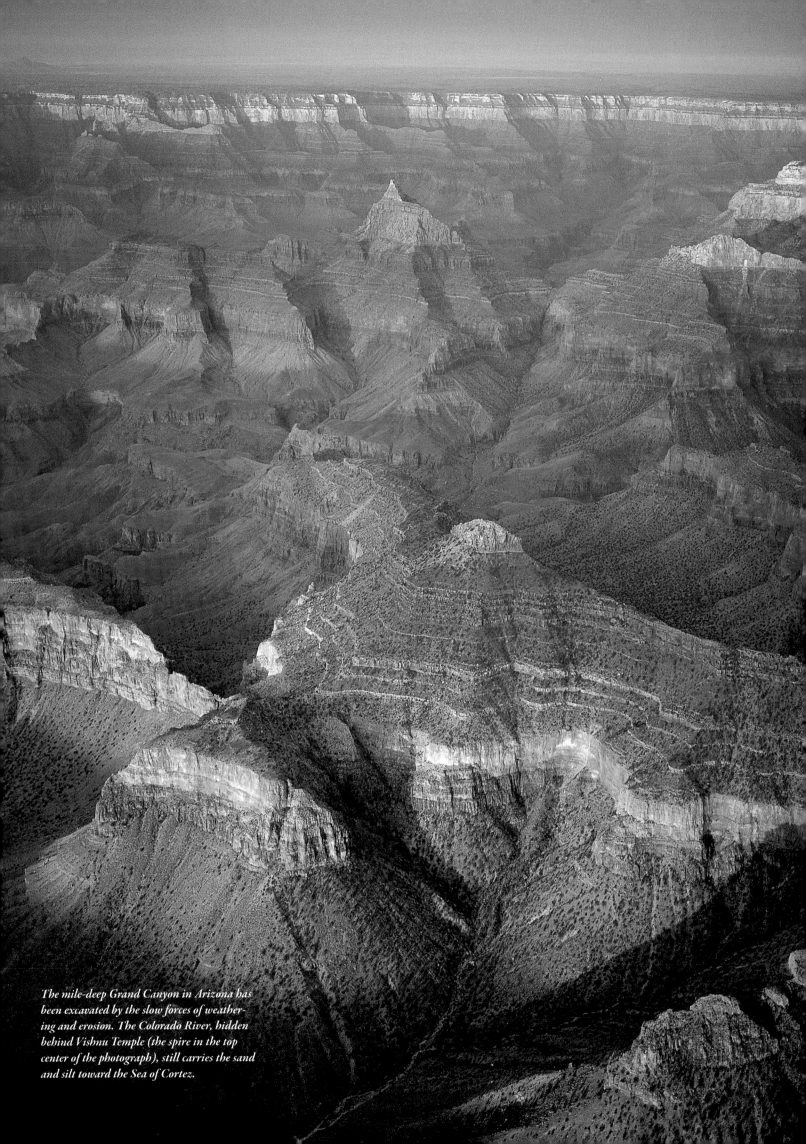

The mile-deep Grand Canyon in Arizona has been excavated by the slow forces of weathering and erosion. The Colorado River, hidden behind Vishnu Temple (the spire in the top center of the photograph), still carries the sand and silt toward the Sea of Cortez.

North America and the Pacific plates are shearing past each other along the San Andreas Fault that slices through California. As a result, Baja California and coastal California from San Diego past San Francisco are lumbering northwestward relative to the rest of North America. The Colorado River takes advantage of this shearing motion where its course defines the boundary between Arizona and California. It drains a quarter-million square miles of the American Southwest, bringing with it prodigious quantities of sediment from the mountains of Colorado and Wyoming, and especially the deserts of Utah and Arizona. Farther downstream, the river looks like an out-of-control fire hose spraying now left, then right across its delta, depositing sediment first to the east, then to the west. But the delta is more than just a passive receptacle for sediment; it remains tectonically active with some areas popping up as mountains and other areas dropping into basins. The Salton Sea in southeast California, pulled 220 feet below sea level by the irresistible urges of plate tectonics, is a natural destination for the Colorado River when it occasionally abandons its present channel and temporarily flows into that basin.

In upper New York state, the Hudson River begins its journey from the Adirondack Mountains at a small elegantly-named lake—Tear of the Clouds. The lower Hudson flows across the Newark Basin, a failed rift where a crustal plate tried but couldn't split apart two hundred million years ago. All rivers have work to do; the Hudson's lot was to carry staggering amounts of meltwater and sediment from the heavily glaciated Northeast during the Pleistocene Ice Ages, 1.6 million to ten thousand years ago.

Glaciers, like plate tectonics, are a geologic force in their own right, both sculpting the earth's surface and steering its rivers. Long Island, near the mouth of the Hudson, is an assemblage of terminal moraines, great gravel piles plowed into position by glaciers that repeatedly swept down from the north. During the coldest parts of the Pleistocene Epoch, sea level dropped by as much as three hundred feet because so much of earth's water was locked up in glaciers. Consequently the Hudson and other nearby rivers like the Connecticut and Delaware were forced to carve deep channels through their moraines to reach the sea.

At their peak, Pleistocene ice sheets covered much of Canada and the northern tier of the United States, to depths of 4,000 feet and more. Across the continent in northern Idaho, one lobe of the great Cordilleran Ice Sheet repeatedly blocked the Clark Fork River, named by Meriwether Lewis for his hiking buddy William Clark. The Clark Fork ice dam created Lake Missoula, which stretched well back into Montana, holding a volume of water equal to both Lakes Ontario and Erie. The barrier catastrophically failed each time the lake rose 2,000 feet up the face of the ice. Flows of almost ten cubic miles per hour would rush westward, draining the lake in a matter of days. We have no evidence that the rivers of earth have ever carried greater floods in all of geologic time.

Eastern Washington preserves the imprint of 40 or more of Lake Missoula's floods in a jumbled landscape

called the Scablands. These Pleistocene deluges, hundreds of feet deep and traveling at speeds up to 50 miles an hour, stripped away all soil in their path and instantly carved the greatest waterfalls our continent has ever known. Entire canyons were jackhammered out of bedrock by the irresistible power of water gone mad. Leaving Lake Missoula, the floods diverged into three wide paths, rejoining near what is now the Washington/Oregon border to sweep through the Columbia River Gorge and past present-day Portland out to the Pacific Ocean. In these Scablands, glaciers had violently shaped a river which in turn instantly reshaped its landscape.

Lower Crab Creek (at bottom), near Othello, tries to make sense of the jumbled landscape left behind by great floods that repeatedly chewed through this part of central Washington during the Pleistocene Ice Ages. These Scablands were instantly stripped of all soil, scored into nonsensical drainages, and pocked with potholes as many hundreds of feet of floodwater hurtled by at speeds approaching 50 miles an hour.

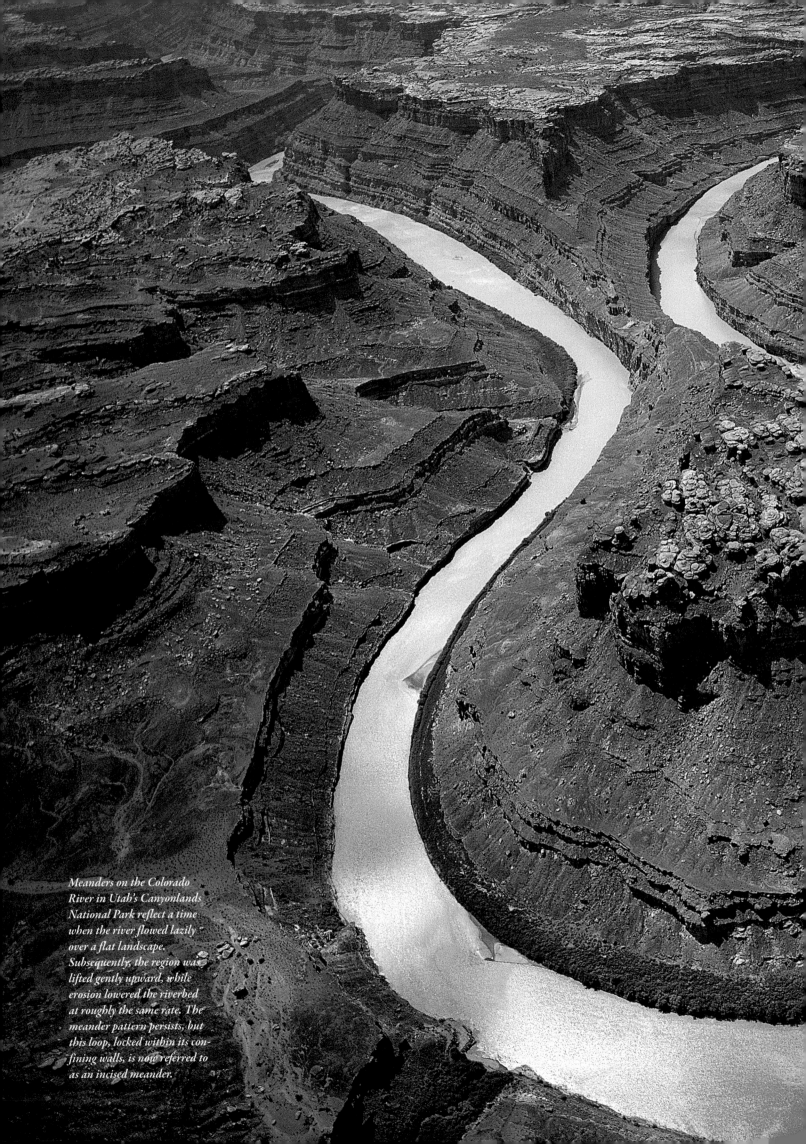

Meanders on the Colorado River in Utah's Canyonlands National Park reflect a time when the river flowed lazily over a flat landscape. Subsequently, the region was lifted gently upward, while erosion lowered the riverbed at roughly the same rate. The meander pattern persists, but this loop, locked within its confining walls, is now referred to as an incised meander.

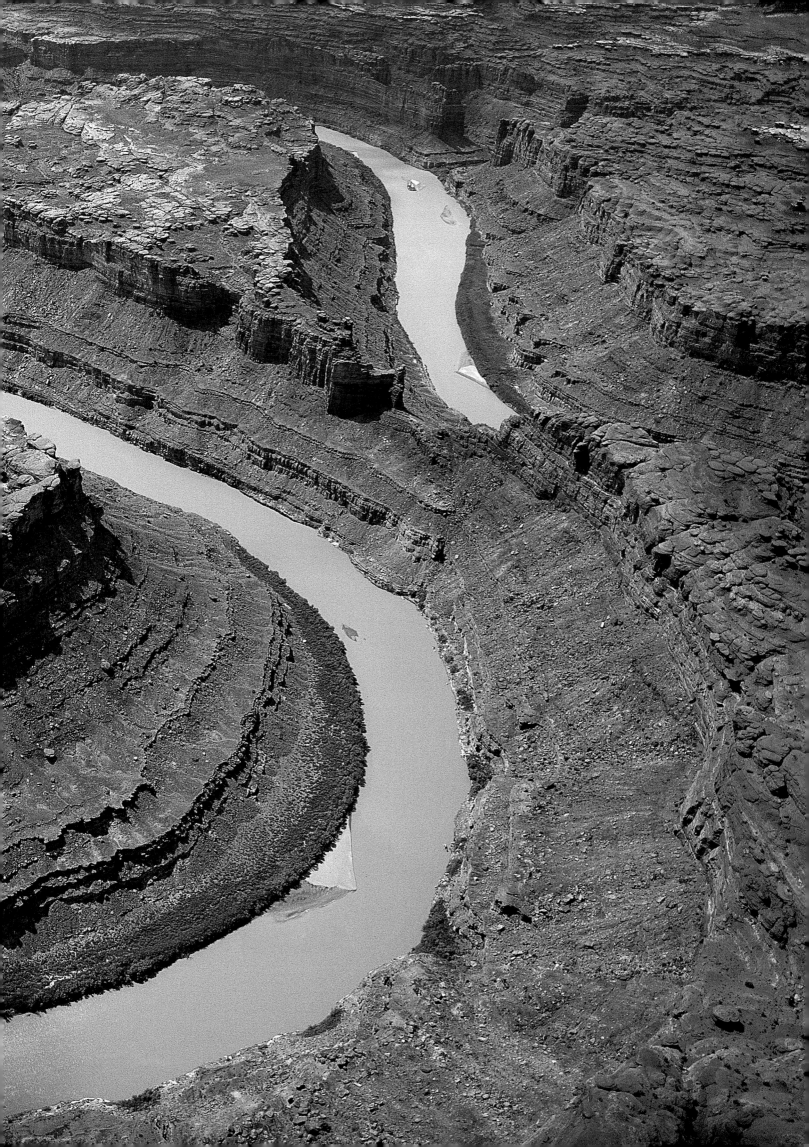

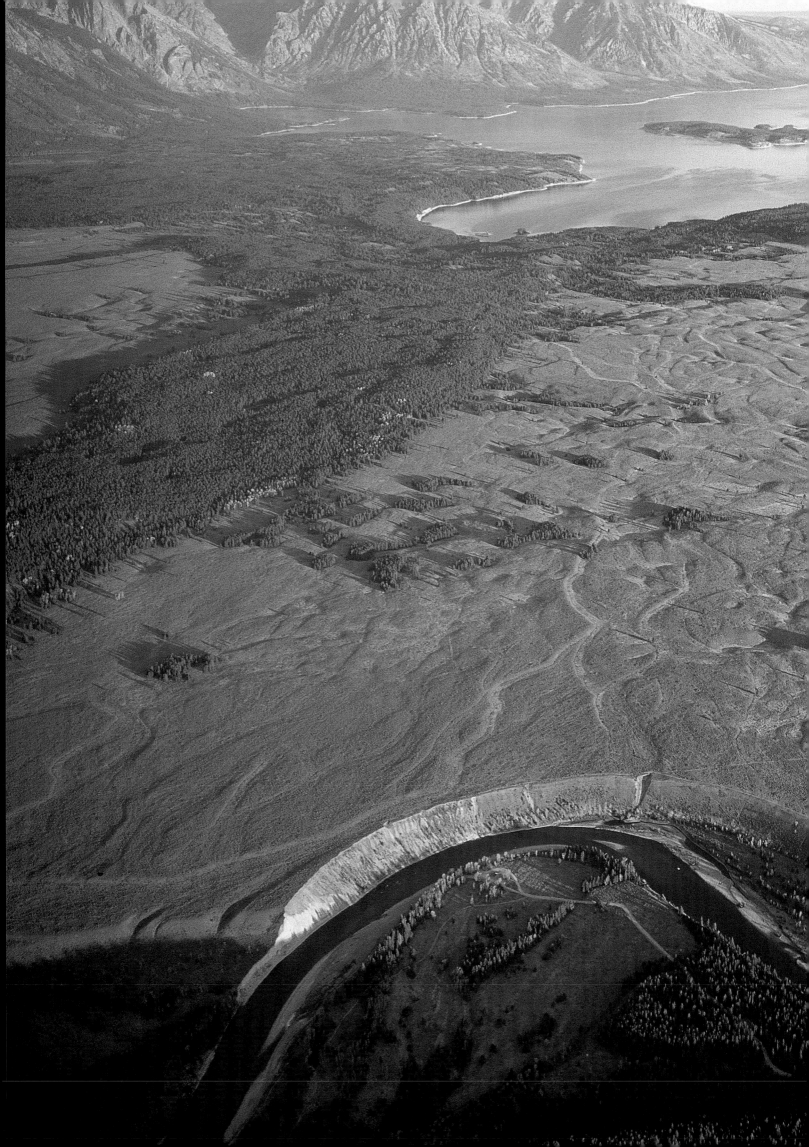

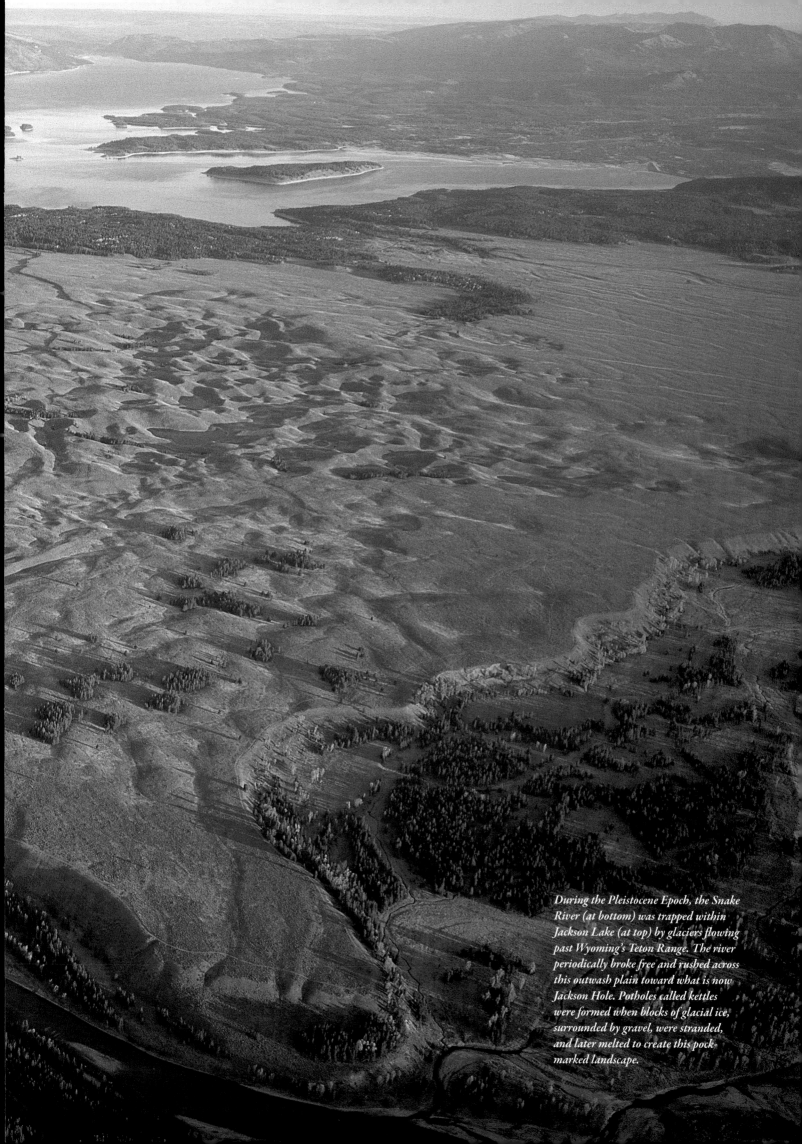

During the Pleistocene Epoch, the Snake River (at bottom) was trapped within Jackson Lake (at top) by glaciers flowing past Wyoming's Teton Range. The river periodically broke free and rushed across this outwash plain toward what is now Jackson Hole. Potholes called kettles were formed when blocks of glacial ice, surrounded by gravel, were stranded, and later melted to create this pockmarked landscape.

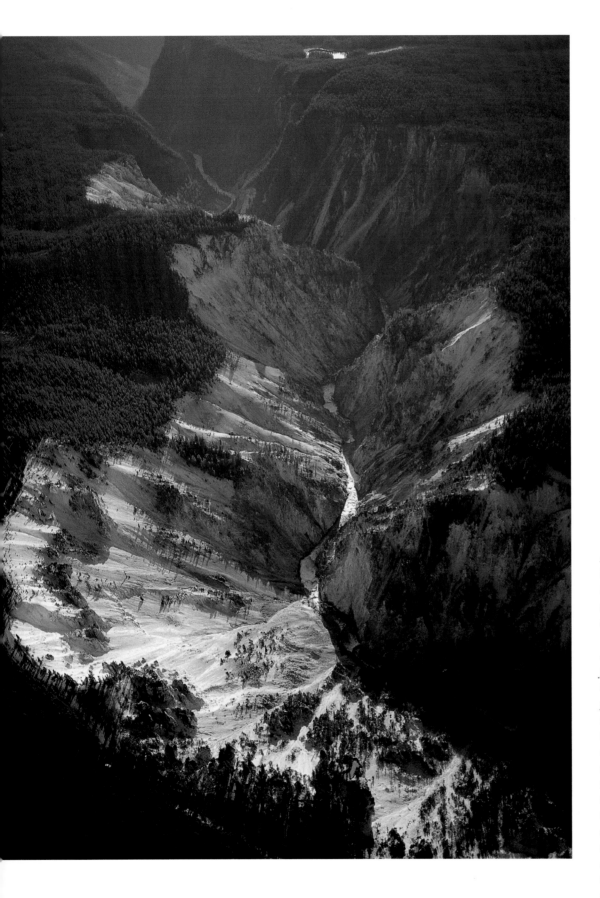

Left: The Yellowstone River in Wyoming has carved its own Grand Canyon in Yellowstone National Park, cutting down through thousands of feet of volcanic rock.

Right: Arizona's Little Colorado River, flowing in sunlight from right to left in the bottom of the picture, foams as it plummets over Grand Falls to the canyon floor 200 feet below, but this was not always the case. The canyon once ran straight up from the bottom of the picture, but thousands of years ago a lava flow (visible at the lower left) spilled into the canyon, dammed the river, and formed a lake. The lake filled until water flowed around the edge of the lava plug, creating Grand Falls and returning the Little Colorado to its former gorge, seen here in shadow. To its right, sunlight highlights an older, abandoned channel where the Little Colorado once flowed before carving its current, deeper bed.

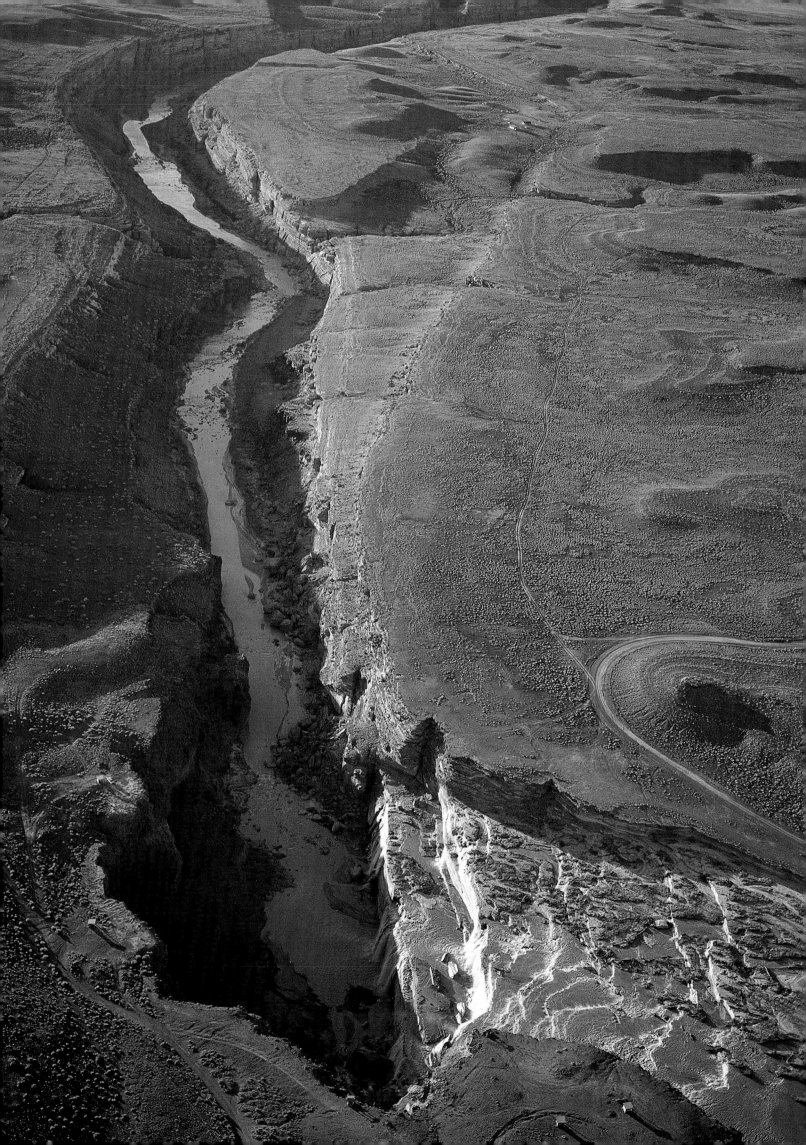

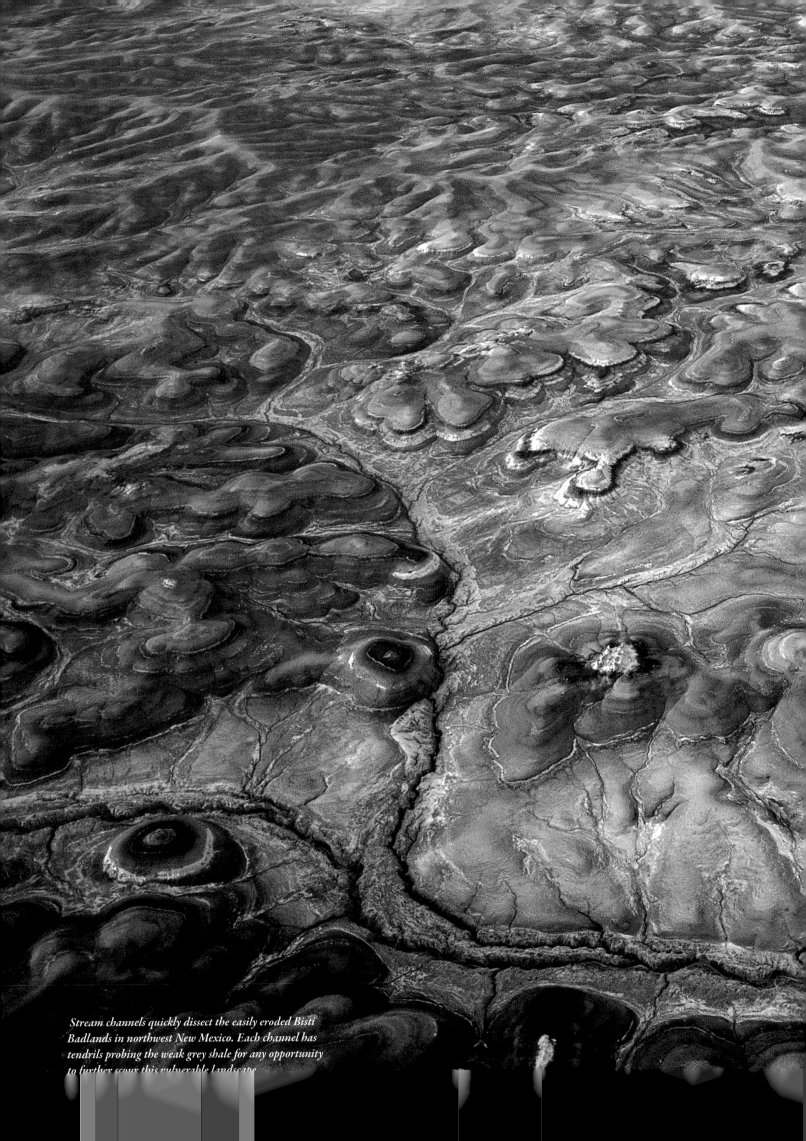

Stream channels quickly dissect the easily eroded Bisti Badlands in northwest New Mexico. Each channel has tendrils probing the weak grey shale for any opportunity to further scour this vulnerable landscape.

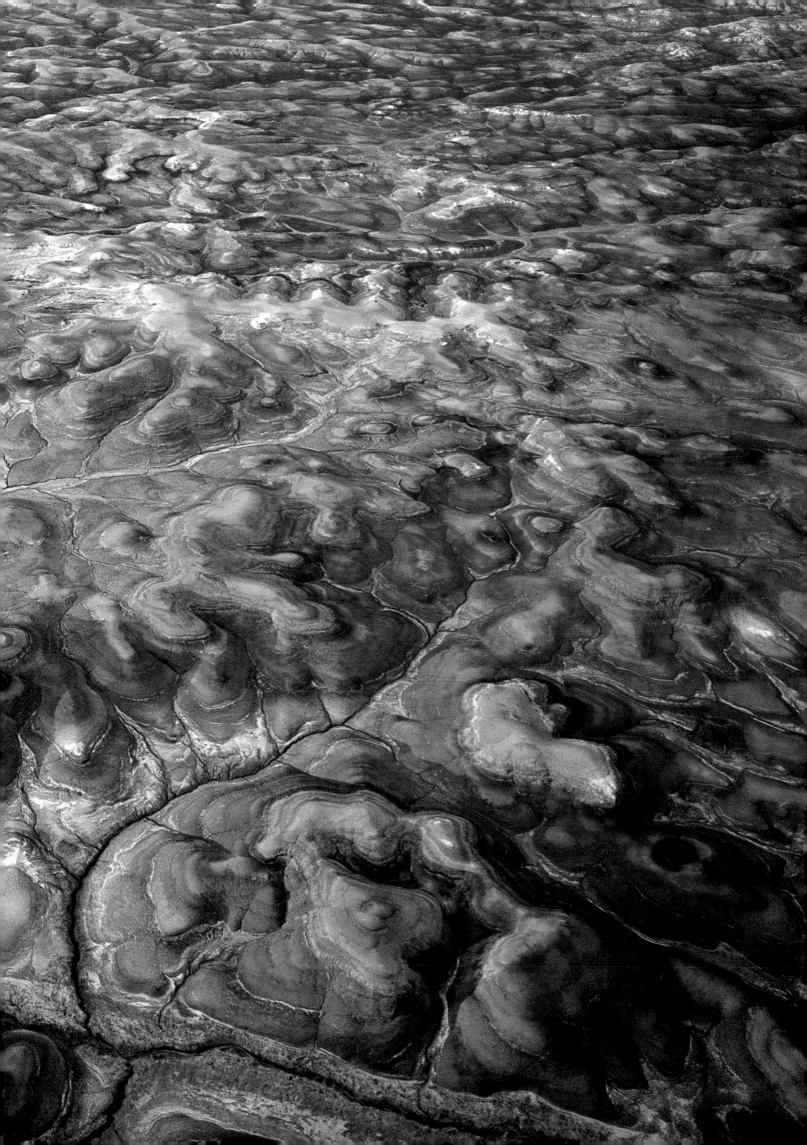

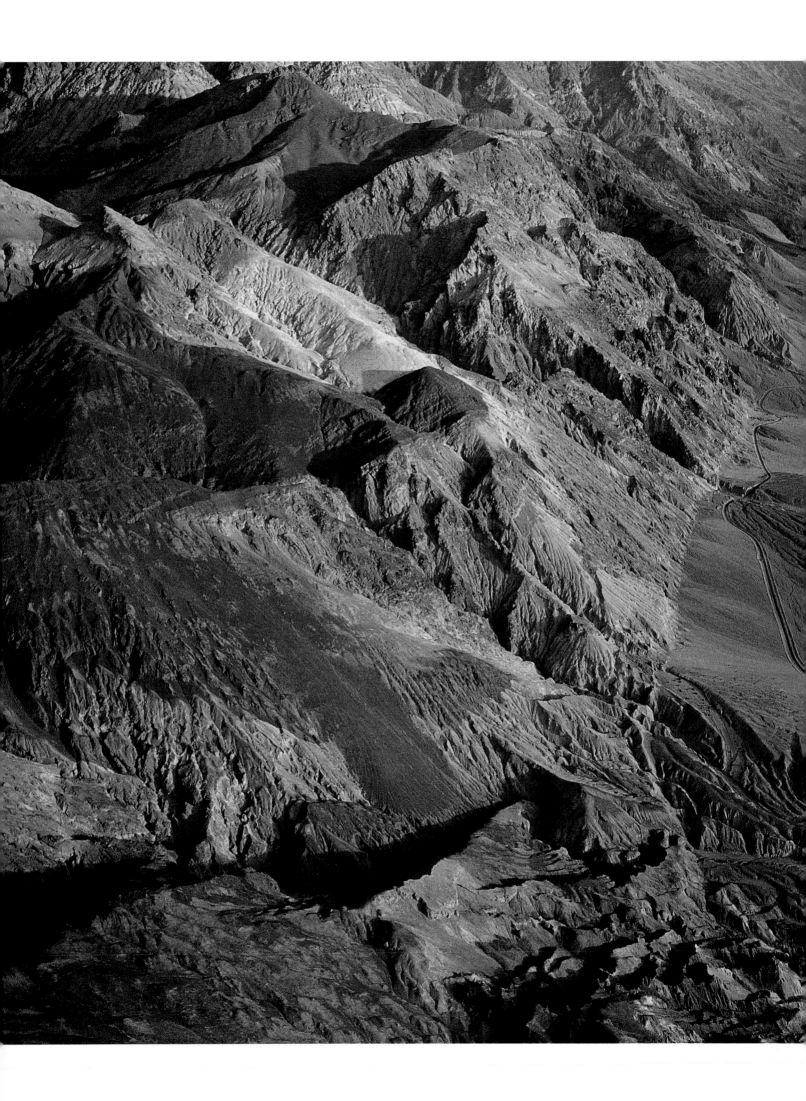

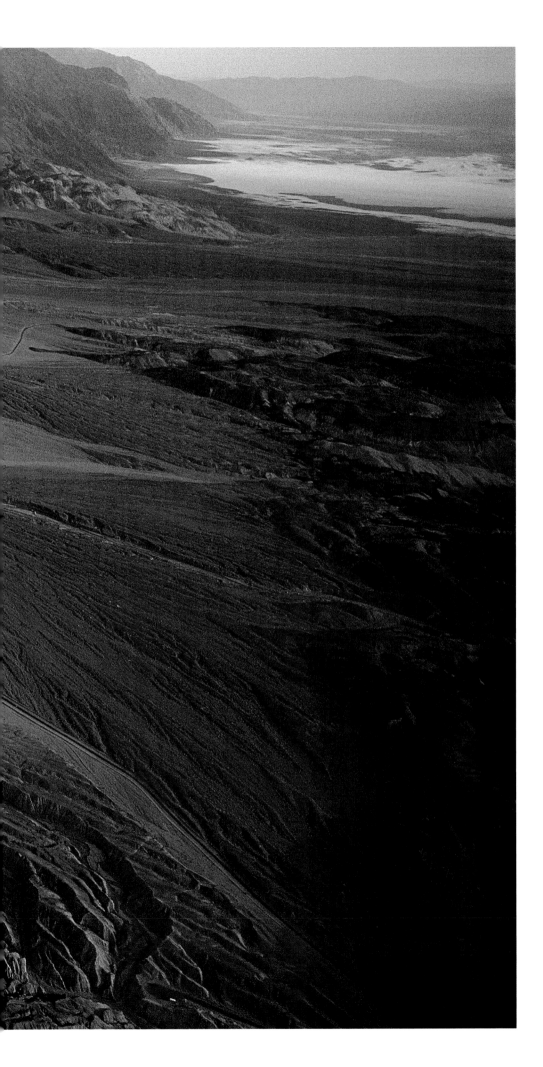

A bright line, separating the Black Mountains on the left from the smoother bajada on the right, marks the faulted surface along which Death Valley is sinking. In the upper right are white deposits of the Amargosa River which flows into this basin 282 feet below sea level.

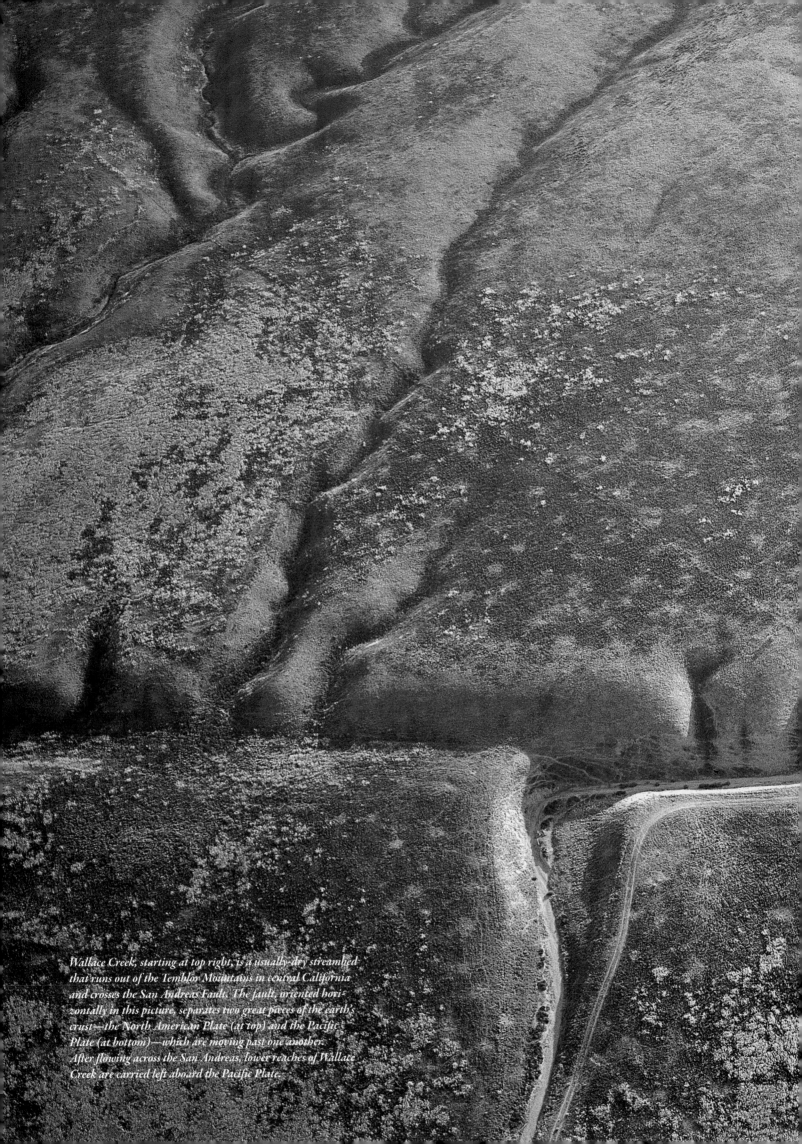

Wallace Creek, starting at top right, is a usually-dry streambed that runs out of the Temblor Mountains in central California and crosses the San Andreas Fault. The fault, oriented horizontally in this picture, separates two great pieces of the earth's crust—the North American Plate (at top) and the Pacific Plate (at bottom)—which are moving past one another. After flowing across the San Andreas, lower reaches of Wallace Creek are carried left aboard the Pacific Plate.

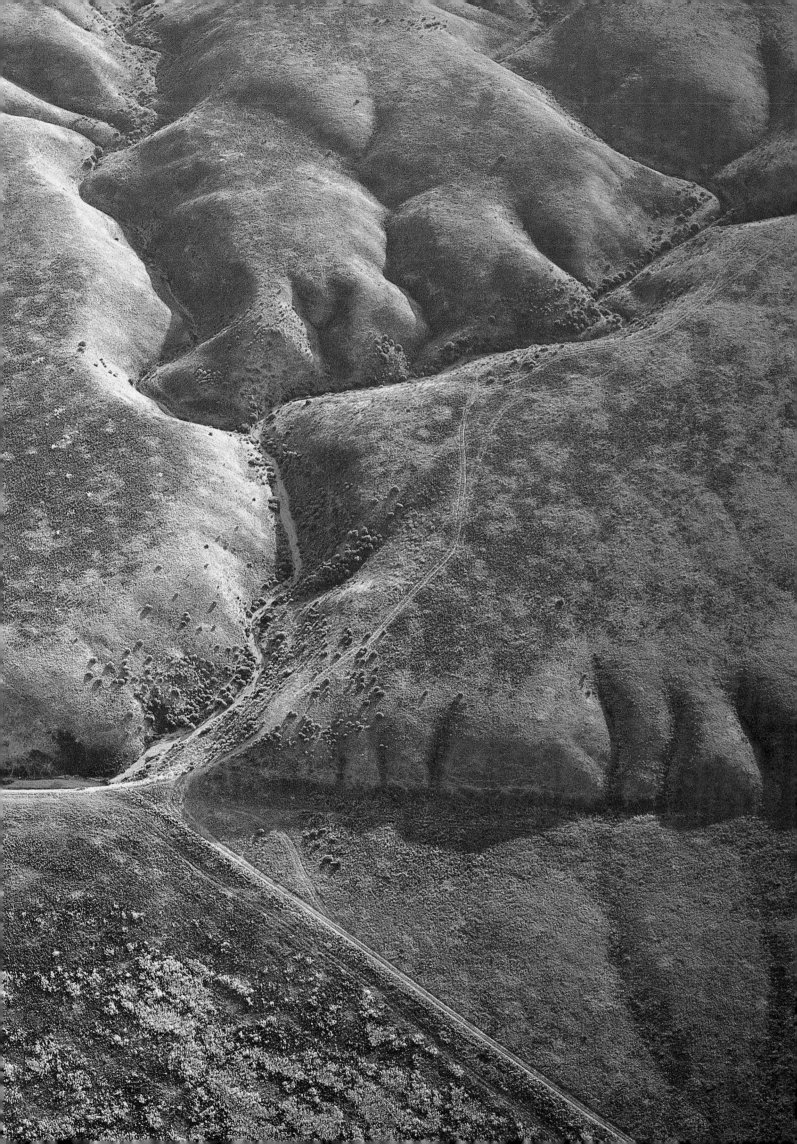

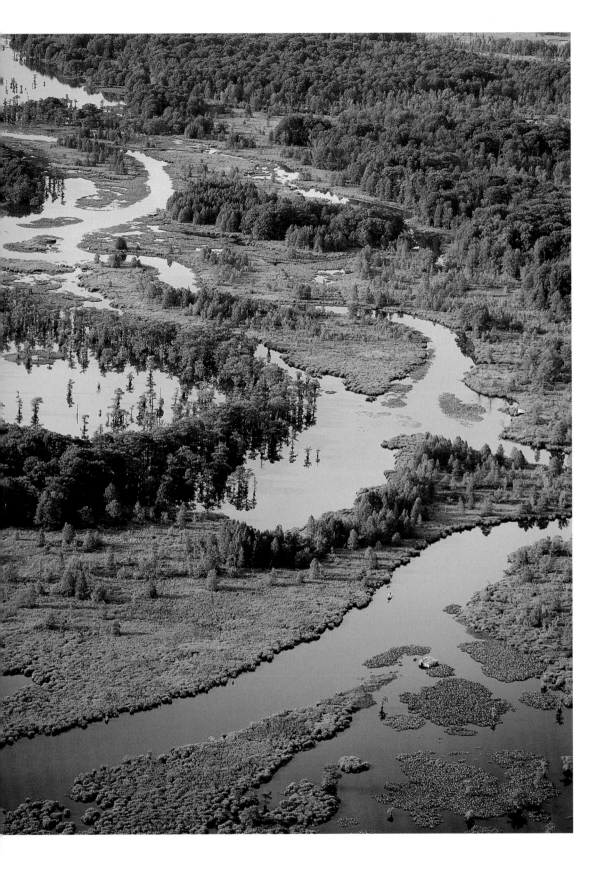

Left: Reelfoot Lake was created when the New Madrid Fault jostled north-western Tennessee and the rest of MidAmerica in 1812. Local uplift from the earthquake temporarily forced the Mississippi River to flow backwards to the north. The river subsequently shifted its course to the west, stranding the waters that have become Reelfoot Lake.

Right: Water is not the only fluid ever to flow down a riverbed. The Little Colorado River had established its course through cliffs of limestone in northern Arizona long before lava spilled into its channel. The hot and liquid lava, abiding by the same laws of gravity that govern water, flowed downhill along the riverbed. After the lava froze into basalt, the Little Colorado River resumed its flow over and around the resistant basalt. At first the river eroded along both right and left sides of the basalt, but eventually the left channel became dominant. The basalt stands now as a cast that preserves the mold of the old channel.

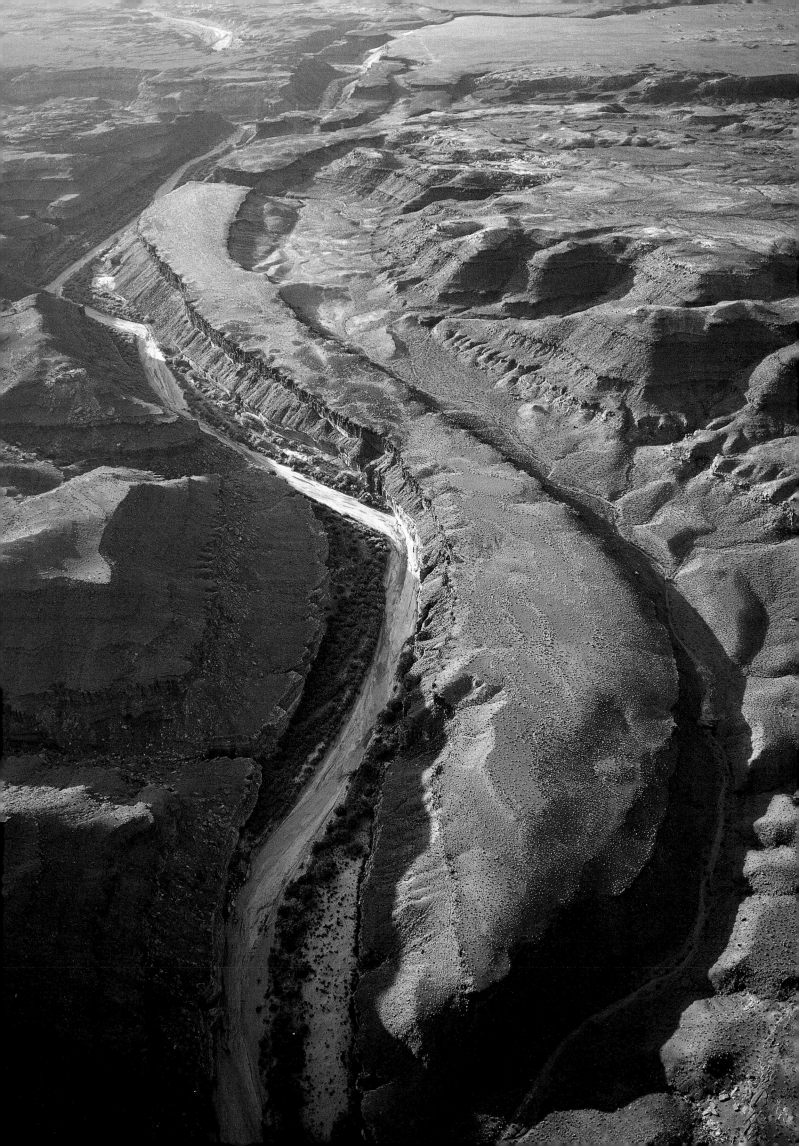

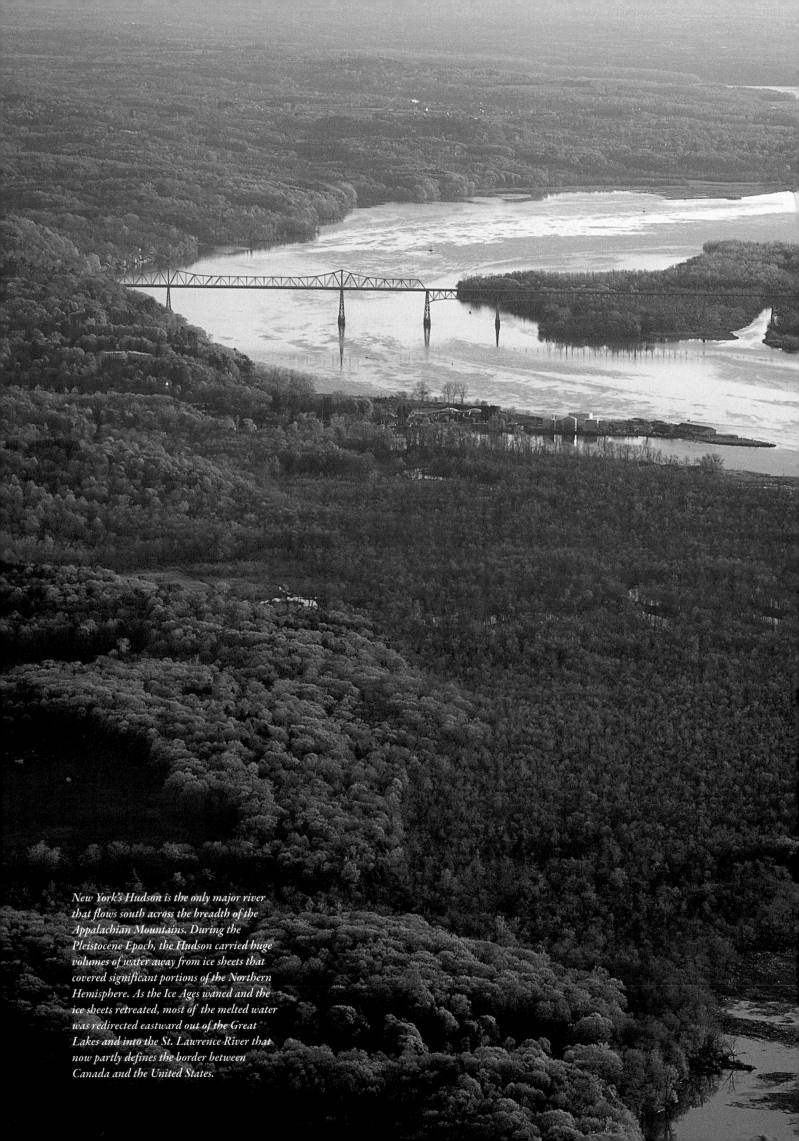

New York's Hudson is the only major river that flows south across the breadth of the Appalachian Mountains. During the Pleistocene Epoch, the Hudson carried huge volumes of water away from ice sheets that covered significant portions of the Northern Hemisphere. As the Ice Ages waned and the ice sheets retreated, most of the melted water was redirected eastward out of the Great Lakes and into the St. Lawrence River that now partly defines the border between Canada and the United States.

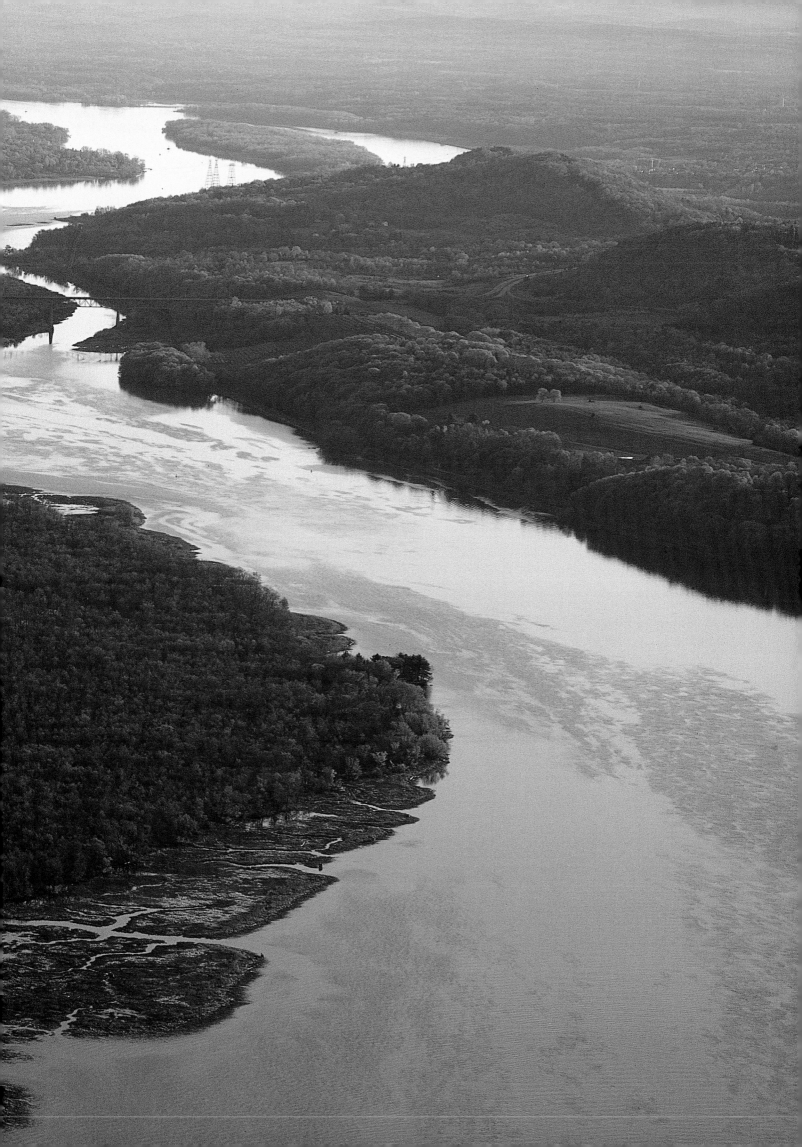

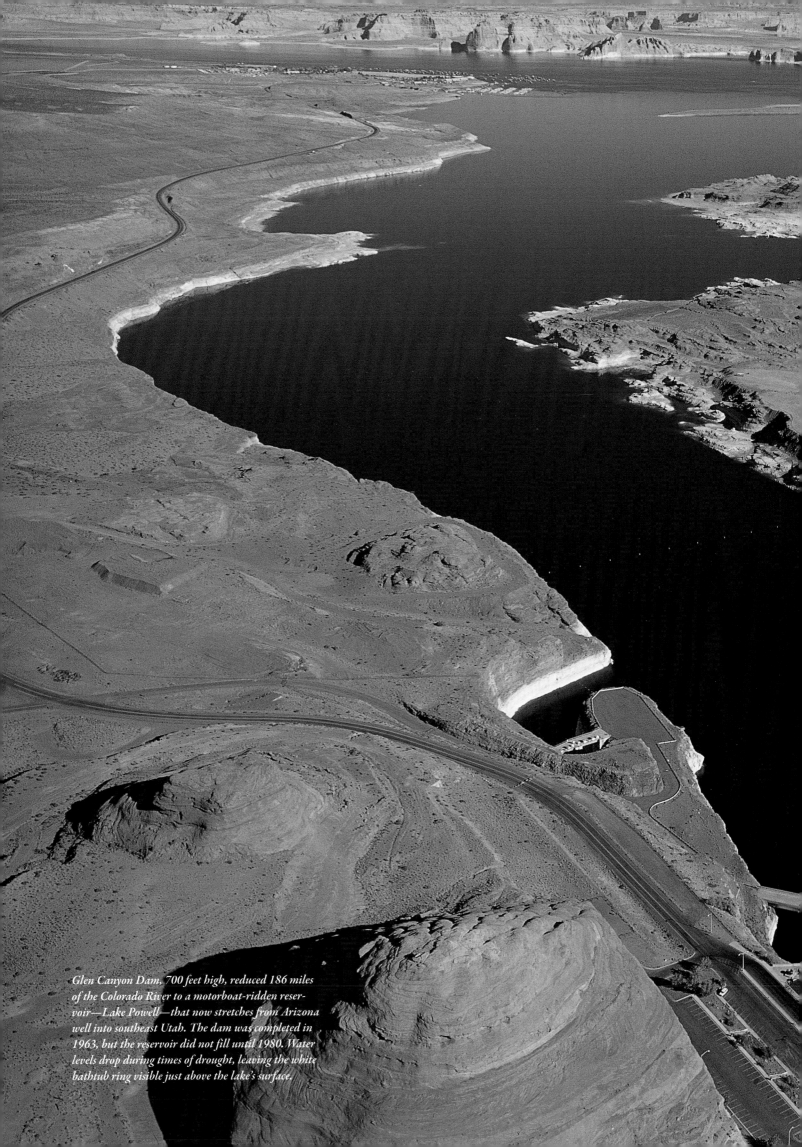

Glen Canyon Dam, 700 feet high, reduced 186 miles of the Colorado River to a motorboat-ridden reservoir—Lake Powell—that now stretches from Arizona well into southeast Utah. The dam was completed in 1963, but the reservoir did not fill until 1980. Water levels drop during times of drought, leaving the white bathtub ring visible just above the lake's surface.

THE HUMAN CONNECTION

arlan Hubbard, a painter, and his wife Anna, an unemployed librarian, started down the Ohio River aboard their homemade shantyboat in 1944. With few resources beyond their wits, the couple foraged for catfish and corn, taking seven years to reach Louisiana's bayou country near the Gulf of Mexico. They learned a watery way of life, spending each day according to the rhythms of the river. At night, with waves softly lapping against the sides of their boat, they played duets on violin and cello. In his wonderful book, *Shantyboat*, Harlan wrote that, "A river tugs at whatever is within reach." Rivers, I know, tug at their banks and beds, tug at low-hanging limbs and high-rising mountains. Rivers tug at my heart.

A few summers ago, I traced the Ohio River up from Cairo, past Paducah and the wrought-iron splendor of riverboat captains' homes in Evansville. I looked down on islands in the stream, on tugboats making their way up country, and on locks and dams that presumed to impede the river's progress. Above Louisville, I was delighted to discover the little grass airstrip at Lee Bottom where I could camp, and roam down by the water's edge. Across the Ohio, to my surprise, was Payne Hollow, where Harlan and Anna had returned to live out the rest of their lives after the shantyboat adventure. Here they cobbled together a home of salvaged wood and river rocks alongside a garden that would yield forty years of food. I hitched a ride across the Ohio and found, lying forgotten in a corner of their shed, a lyre strung from a forked piece of driftwood. The Hubbards had waltzed to homemade music and the melody of this beautiful Ohio River. Rivers, I realized, may forge landscapes, but they can also fashion people in their likeness.

We humans have a long, loving, and sometimes troubled relationship with rivers. We drew sustenance from Egypt's Nile. We built an empire with Roman aqueducts and lead-lined pipes that left us mad like a hatter. We engineered canals for our crops in the desert Southwest a thousand years ago. We hosed gold down from the foothills of the Sierra Nevada and clogged the rivers below with mud and greed. Over the entire earth, preindustrial rivers once carried nine billion tons of silt and sand out to sea annually; now, burdened with the sediment of human activity, rivers carry twice that load. We humans have become a geologic force; like mountains, like glaciers, we too shape rivers.

Three hundred years ago, 15,000 bear and deer hides were sent down the Ohio and Mississippi Rivers on their way to France. Since that first shipment, commerce has geometrically increased, and these days river cargo approaches a half billion tons a year. Barges the size of small towns carry oil, coal, fertilizer, and cement upstream, and corn, oats, wheat, and barley downstream. To many, the Mississippi is above all a working river. The U.S. Army Corps of Engineers is charged with maintaining its course and preventing floods. According to

the Corps, "This great river is, truly, one of the Nation's outstanding assets. Uncontrolled, it would be just as great a liability."

Flows within the Mississippi are too large, and its lower reaches too flat, to rely on dams for flood control. Locks and dams are used to aid navigation on the Mississippi, while the Army Corps has encased the last 1,600 of its 2,300 miles in manmade levees, in an ongoing attempt to restrict widespread flooding and prevent the channel from migrating. The Corps also relies on floodways that redirect portions of high flow into standby channels like the Atchafalaya River. The engineers cut through meanders to shorten the river and send floods downstream faster, and use dredges and dikes to keep the mainstem channel open to navigation.

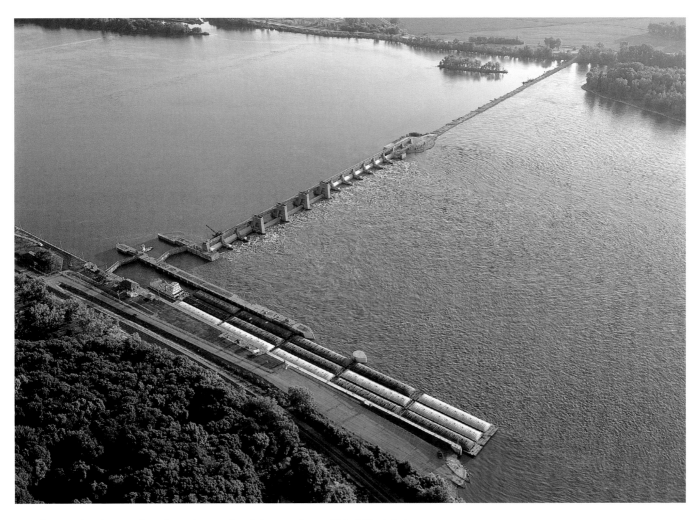

Diesel-powered tugboats pushing barges have replaced the steamboats of Mark Twain's day. Lock and Dam No. 22 here straddles the Mississippi River just below Monkey Run and Hannibal, Missouri. The U.S. Army Corps of Engineers maintains a network of inland waterways that branches out from the Mississippi with over 12,000 miles of navigable waterways.

"The Mississippi River is laden with the burdens of a nation. Wide at St. Louis, where I grew up, the river in my memory flows brown and heavy and slow, seemingly lazy but always busy with barges and tugs, always working—like my father—always traveling, always awesome and intimidating. I have watched this river since I was small, too young to realize that the burdens the Mississippi carries are more than barges loaded with grain and coal, that the river also carries sins and salvation, dreams and adventure and destiny."

Eddy Harris, *Mississippi Solo*

How we love to tinker with our waterways! Starting during the Great Depression, the Columbia River in Washington, Oregon, and British Columbia was harnessed by dams that held water upstream and salmon downstream. The benefits have been real—water for irrigation, hydroelectric power for cities and industry— but no less real than the drawbacks—a strangled ecosystem, a string of stillborn lakes where a living river once flowed. In the drier Southwest, the perceived benefits of dam construction are even more seductive because of the fitful flow of the region's rivers—highwater years interspersed with prolonged drought. The Colorado and its major tributary rivers are reined in by no fewer than 127 substantial dams, and countless smaller structures on the feeder streams. Water held in the reservoirs behind the two largest—Hoover and Glen Canyon Dams—is equal to four years of the Colorado's average flow.

Perhaps more striking than dams, though, are the ways in which water has been systematically drained from the Colorado River. The river's headwaters lie within the beautifully named Never Summer Range. Here, beneath Mount Stratus and Mount Nimbus, a canal called the Grand Ditch carves a 14-mile scar through Colorado's Rocky Mountain National Park, sucking 30 percent of the Never Summer's runoff east to Denver and beyond the Colorado River's reach. Farther downstream, canals of the Central Utah, Central Arizona, and San Juan-Chama Projects carry water away from the basin to the cities of Salt Lake, Phoenix, and Albuquerque. Las Vegas sticks a straw into Lake Mead amidst the cacophony of its motorboat marinas. Farther downstream the cities and farms of Southern California remove a lion's share of the river's annual flow via the Colorado River Aqueduct and All American Canal. Upon crossing the international border, the last few drops are wrung from this long-suffering river at Morales Dam for agriculture in Mexico. And then the river dies.

It would be impossible to subdue a once lovely river more drastically. Never large, the Los Angeles River is now reduced to a straight concrete storm drain, tethered down by lilliputian freeways, as it traverses Southern California's metropolitan sprawl on its way to Long Beach and the Pacific Ocean.

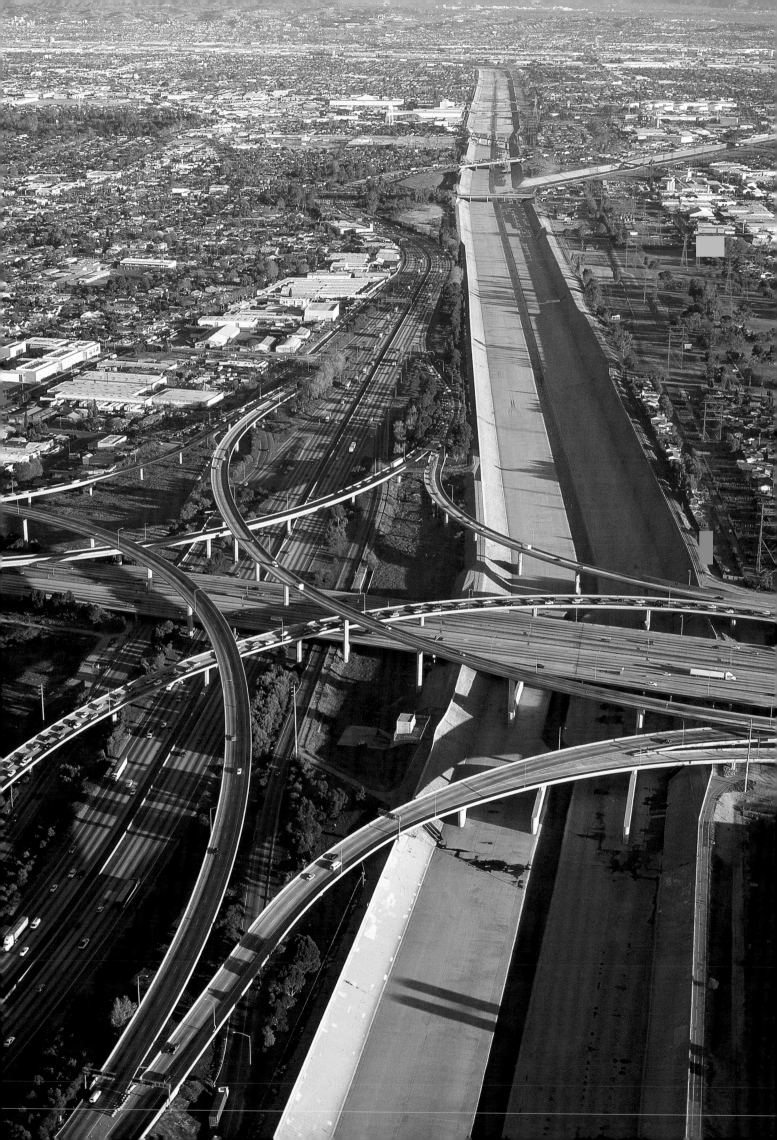

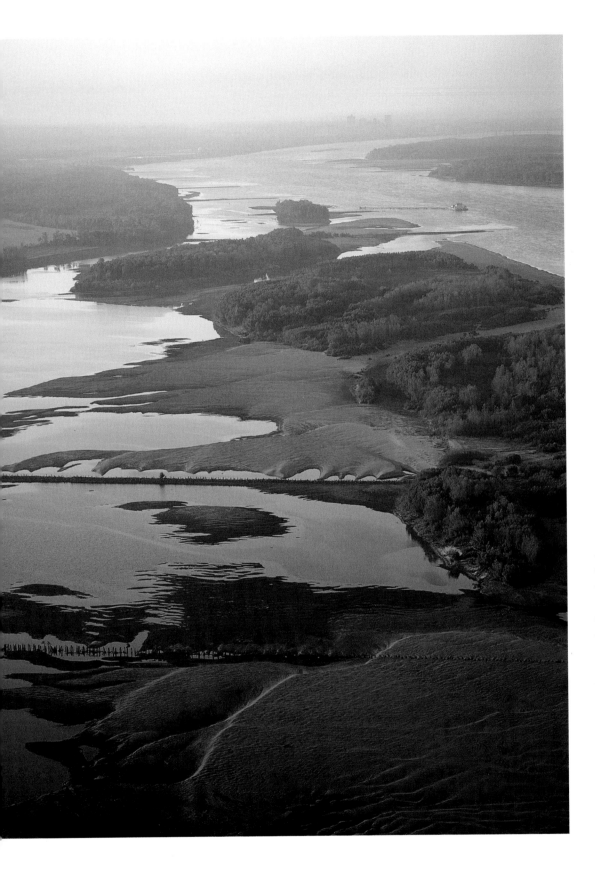

Left: Engineers have placed fence-like barricades across sections of the Mississippi River above Memphis, Tennessee. These sand traps inhibit the current and encourage deposition of sand into selected portions of the river's channel. If the engineers have done their homework properly, the sand traps should steer the Mississippi toward deeper parts of its channel, and thus enable navigation.

Right: Rivers can't help swaying their hips and feeling the rhythm. Sandbars are arranged alternately on one side and then on the other in this severely channelized section of the Rio Grande near Las Cruces, New Mexico. No river is content to flow in a straight line; all try to assume natural curving shapes based on their gradient, bed roughness, sediment, and volume. When engineers stop maintaining this artificial channel, the Rio Grande will eventually resume its natural sing-song course.

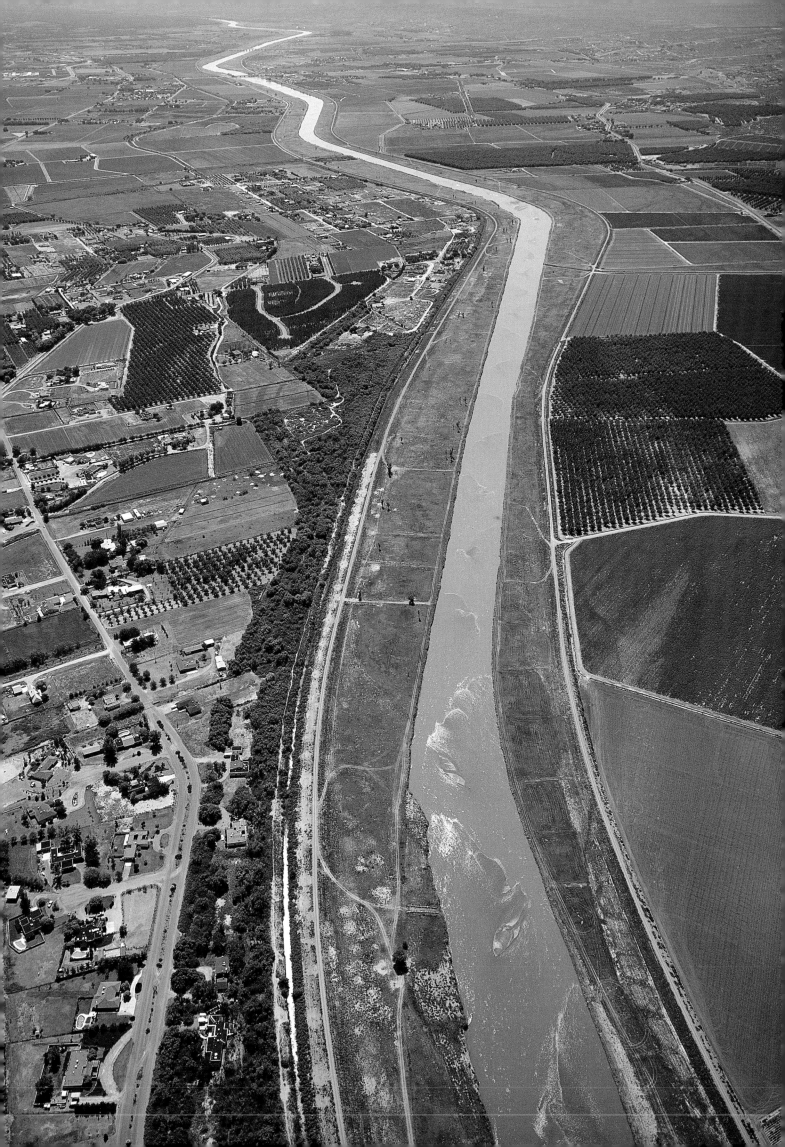

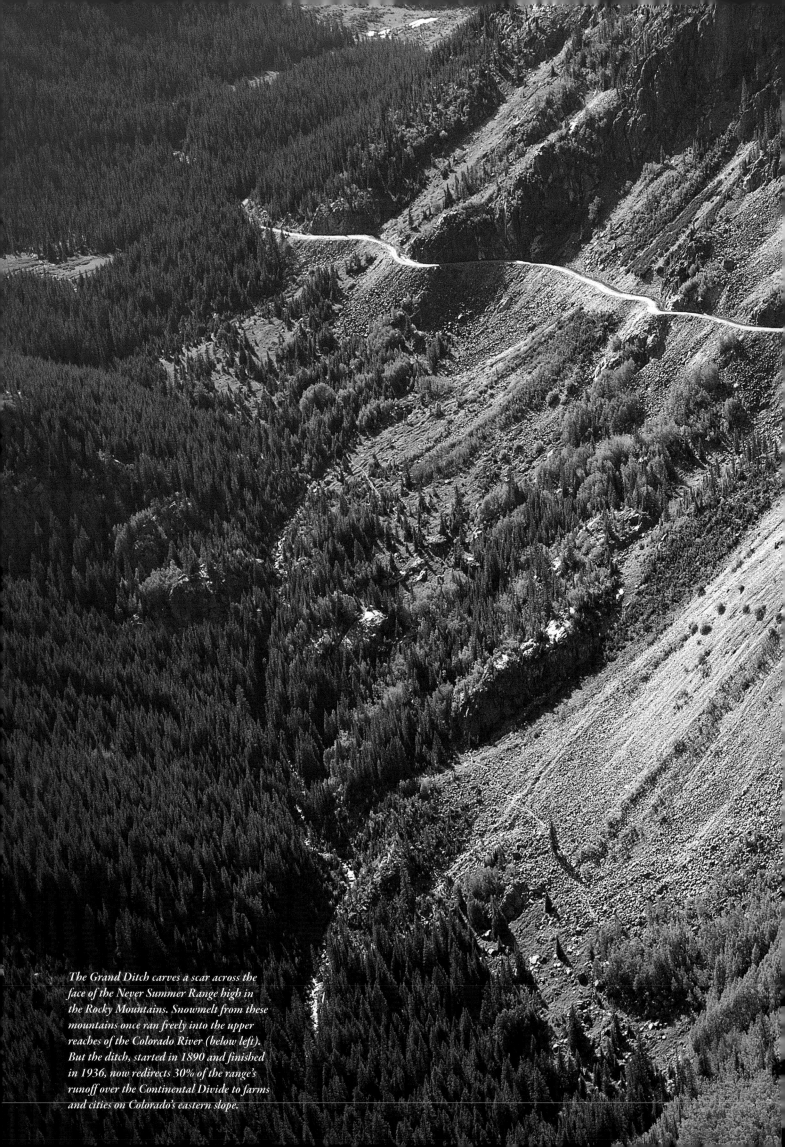

The Grand Ditch carves a scar across the face of the Never Summer Range high in the Rocky Mountains. Snowmelt from these mountains once ran freely into the upper reaches of the Colorado River (below left). But the ditch, started in 1890 and finished in 1936, now redirects 30% of the range's runoff over the Continental Divide to farms and cities on Colorado's eastern slope.

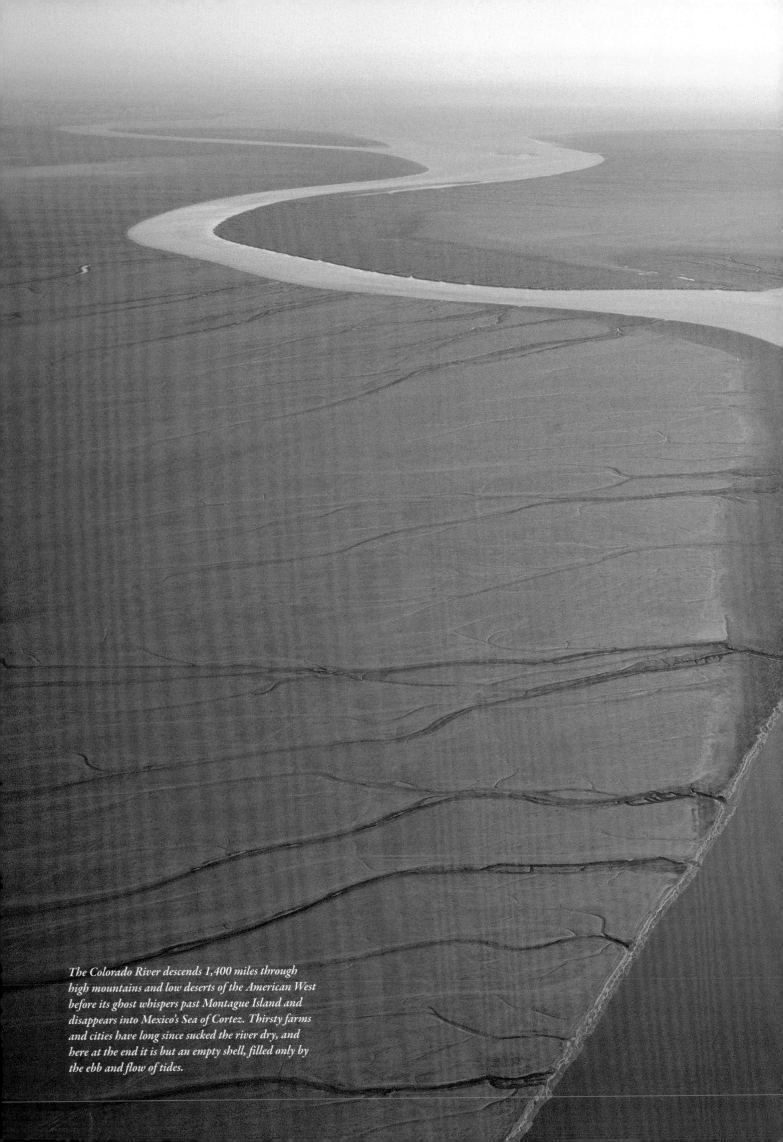

The Colorado River descends 1,400 miles through high mountains and low deserts of the American West before its ghost whispers past Montague Island and disappears into Mexico's Sea of Cortez. Thirsty farms and cities have long since sucked the river dry, and here at the end it is but an empty shell, filled only by the ebb and flow of tides.

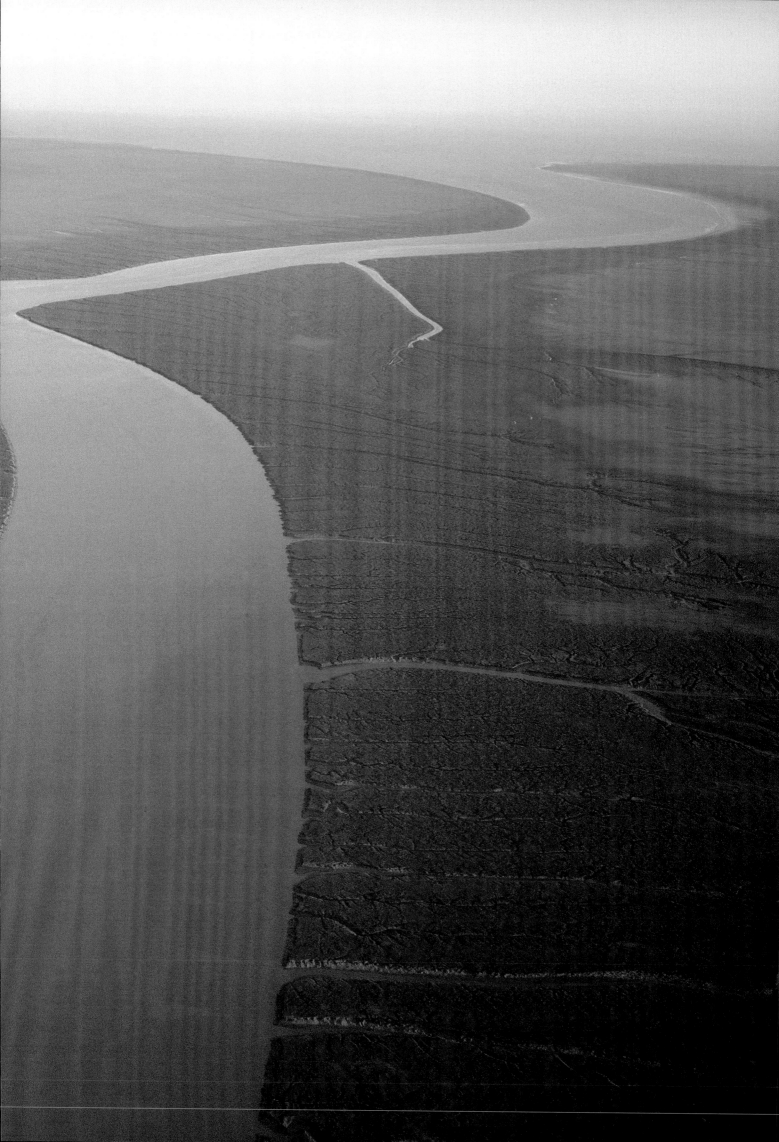

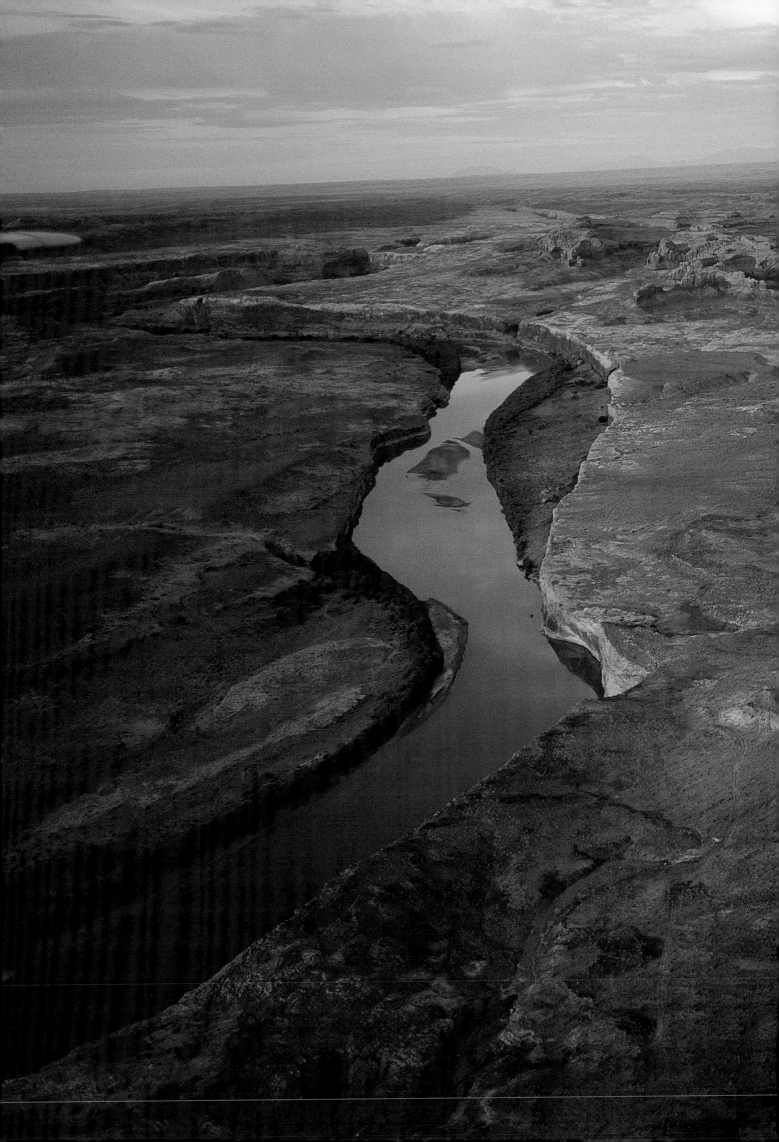

A SENSE OF MOVING WATER

Green River at the head of Labyrinth Canyon, Utah

I have learned that there's usually little sense in trying to take aerial photographs during the slack light of midday. Colors are flat and, in turbulent afternoon air, the cockpit feels like a gallon can caught in a paint mixer. A few years ago, I'd been following the Green River through the back country of southeast Utah. I was hot, tired, and in need of a bath. No amount of enthusiasm was going to wring even one good picture from this situation. So I landed alongside Lake Powell on the skinny, windblown runway at Hite, and spent an afternoon reading and snoozing when I wasn't swimming.

Hours passed and the sun worked its way west. Shadows lengthened and the sunlight began to soften. Time to get back in the saddle. I rubbed my plane under the chin and said, "Come on, Buzzard, we have work to do." We took off to the east. Lake Powell fell behind as I followed the Colorado upriver through Cataract Canyon in the heart of Canyonlands National Park. On the left was Waterhole Canyon, where friends and I had scrambled away from the frozen river during a winter trip decades earlier, returning three months later to retrieve our boats. On the right were gypsum "volcanoes" that have slowly oozed like toothpaste into Red Canyon. From the plane I could see how the walls of Cataract Canyon were sloughing into the river, peeling away in great rotated blocks that drop into the river and form this canyon's famous rapids—Brown Betty, Mile Long, and the Big Drops.

A few miles beyond Spanish Bottom, milky waters of the Green joined the darker Colorado at the confluence of these two great rivers. I could see that the two streams didn't immediately mix; instead they flowed side by side. The boundary between them corkscrewed left as the river curved right. A few hundred yards later as the river curved left, the boundary between the unmixed waters rolled back to the right. I had rarely seen such tangible evidence of the spiraling dynamics of river flow. Following the Green farther upstream, I looked down on sandbars below the incised canyons of The Maze and on the entrenched meanders at Unknown Bottom. Over the rock walls of Cleopatra's Chair, I saw how the river and its water are at once alien and integral to this dry, dry country.

I continued toward Mineral Bottom with its dirt strip tucked alongside the Green River. As I approached, friendly cliffs of Wingate Sandstone leaned out to brush the plane's wingtips; playful cottonwoods reached up to tickle its belly. The strip is plenty long—comfortably over 2,000 feet—but there's a patch of sand near the end that I had to power through. The Buzzard grinned back as we gee'd and haw'd toward our home for the evening. I put chockstones under the wheels and let her reins dangle untied—she wouldn't wander away during the night. The Green burbled just a few feet away. I walked over, sat on its banks, slapped a single mosquito, and listened to the always pleasant sound of thrown sticks splashing into the water.

Where had these waters been? What stories could they tell? I thought of the river's origin near Squaretop Mountain and the beautiful Green River Lakes within the Wind River range. I remembered hardscrabble ranches around Bronx, Wyoming, with their tiny irrigation ditches strung along the river where it was but a small stream. I could see brown mud swirling where the Duchesne, Price, and San Rafael Rivers joined the Green. I recalled little O's on the river's quiet surface made by the mouths of hungry fish in Desolation Canyon. I slapped another mosquito. The sticks I'd thrown were drifting out of sight. Yes, the ones out in the middle did travel faster. In my mind, I followed them around the corner to Upheaval Canyon.

Years before, I had pulled in, tied up my boat, and walked the four miles to Upheaval Dome. Some geologists think this might be a meteor impact crater, but others argue that it is a blister of upwelling salt from the underlying Paradox Formation. After trotting around its rim, I had drawn no conclusions and headed back to the river.

The rest of the river party had long since floated downstream to our agreed-upon campsite near Fort Bottom. I reached my boat at dark. Actually it was closer to O-dark-thirty. I clipped on a lifejacket, untied the bowline, and tentatively pushed out into the current. I knew there were no rapids but wasn't sure if I'd be able to see well enough by starlight to avoid the cottonwood snags. The nearest lamppost was not so much in the next county as in the next universe.

The night air was permeated with the cool smells of water and willows. I shipped both oars, and stars swayed gently as my boat rocked on the current. Once or twice the silence was broken by the sharp slap of a beaver's tail, indignant at my passage. With no horizon for reference, I was wholly absorbed by the overwhelming sense of moving water. The banks could have been ten inches or a quarter mile away from my outstretched hands; I could not tell. I rode wide-eyed, without seeing, on the back of this wondrous creature. I felt the river's every shrug and shift, listened raptly to its every chuckle and splash. I would have been happy to float on all night, but with regret I set oars to the water when my friends' lantern appeared on the right hand shore.

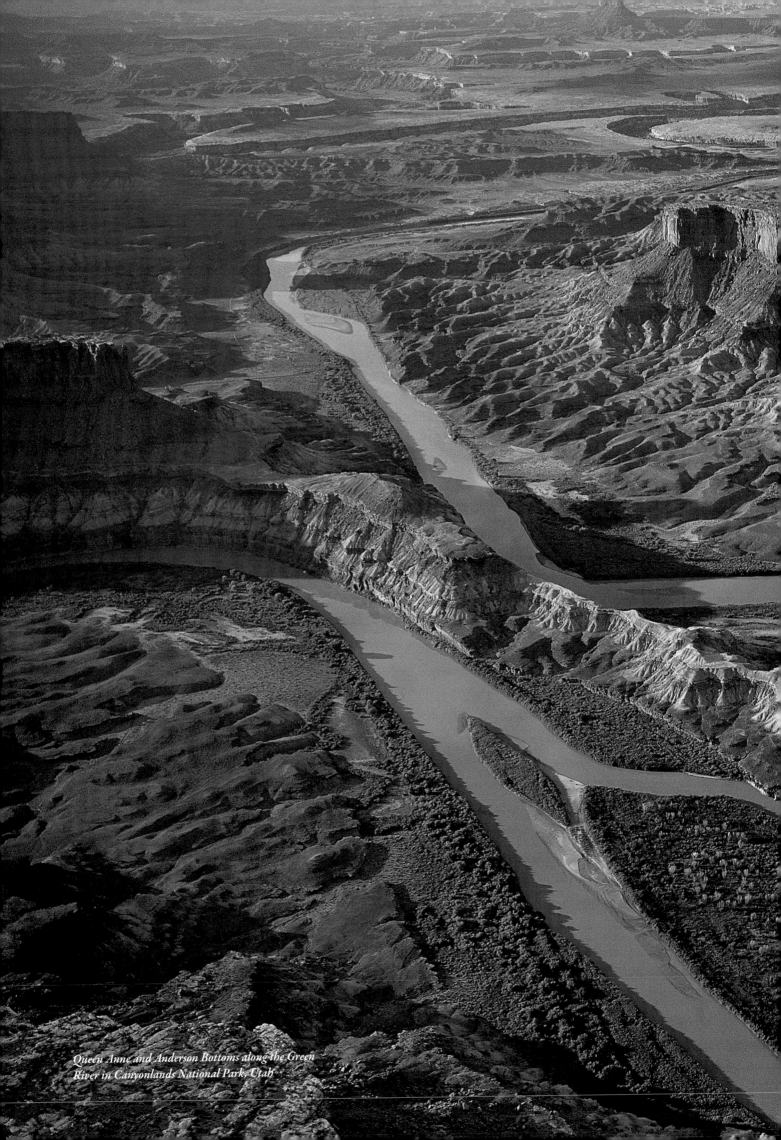

Queen Anne and Anderson Bottoms along the Green River in Canyonlands National Park, Utah

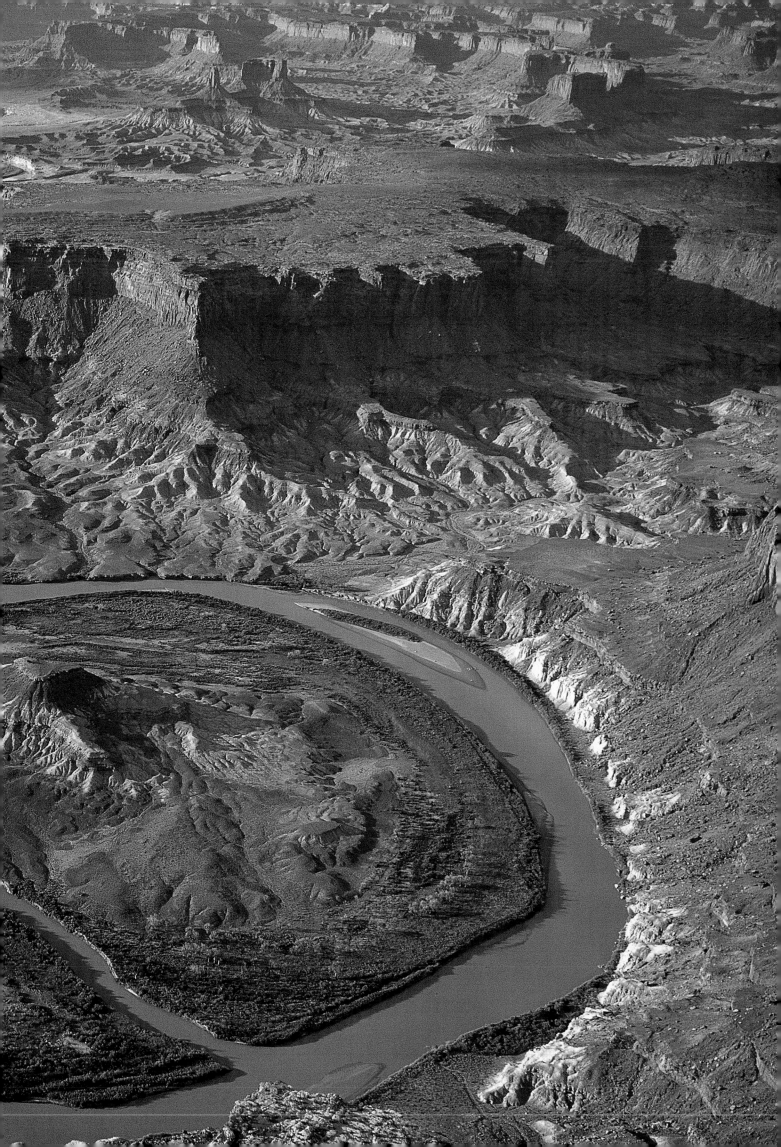

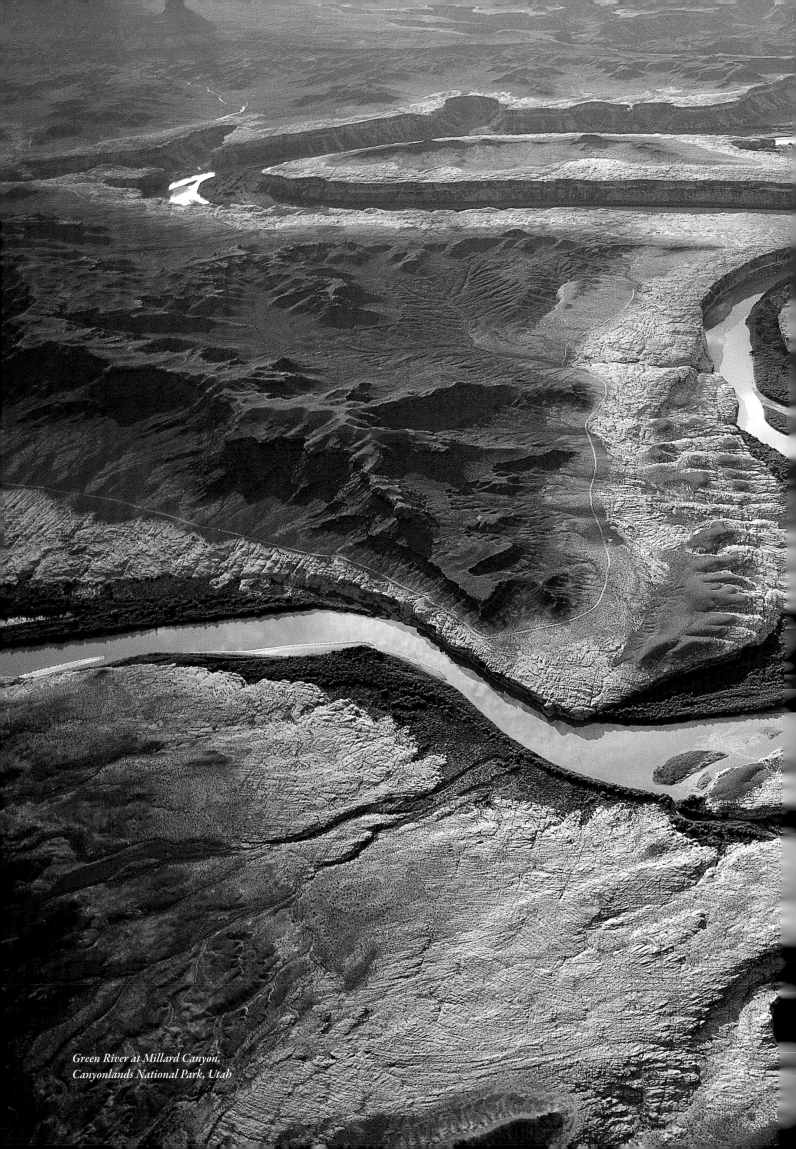

Green River at Millard Canyon,
Canyonlands National Park, Utah

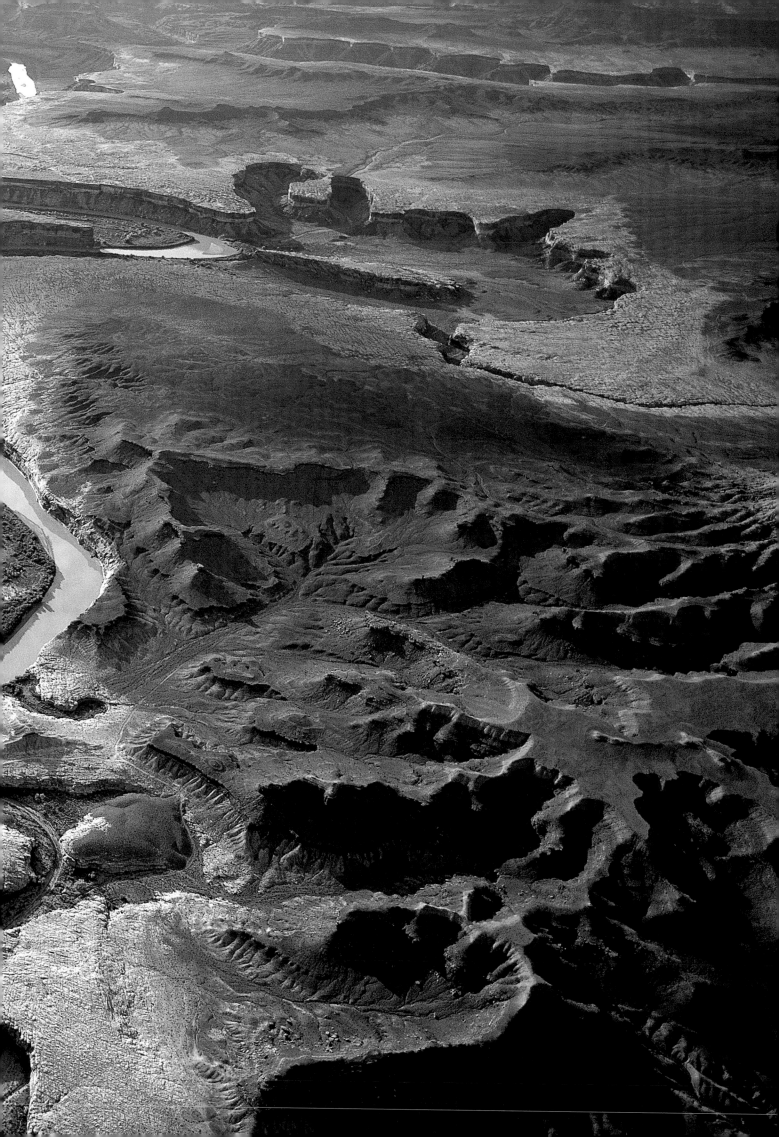

Photo Locations

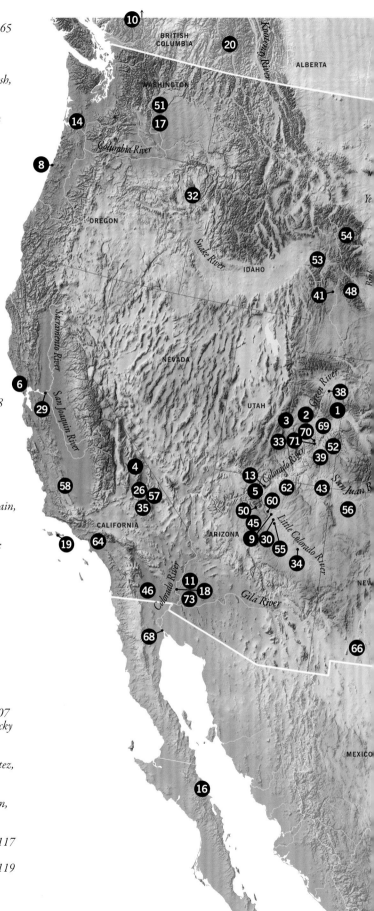

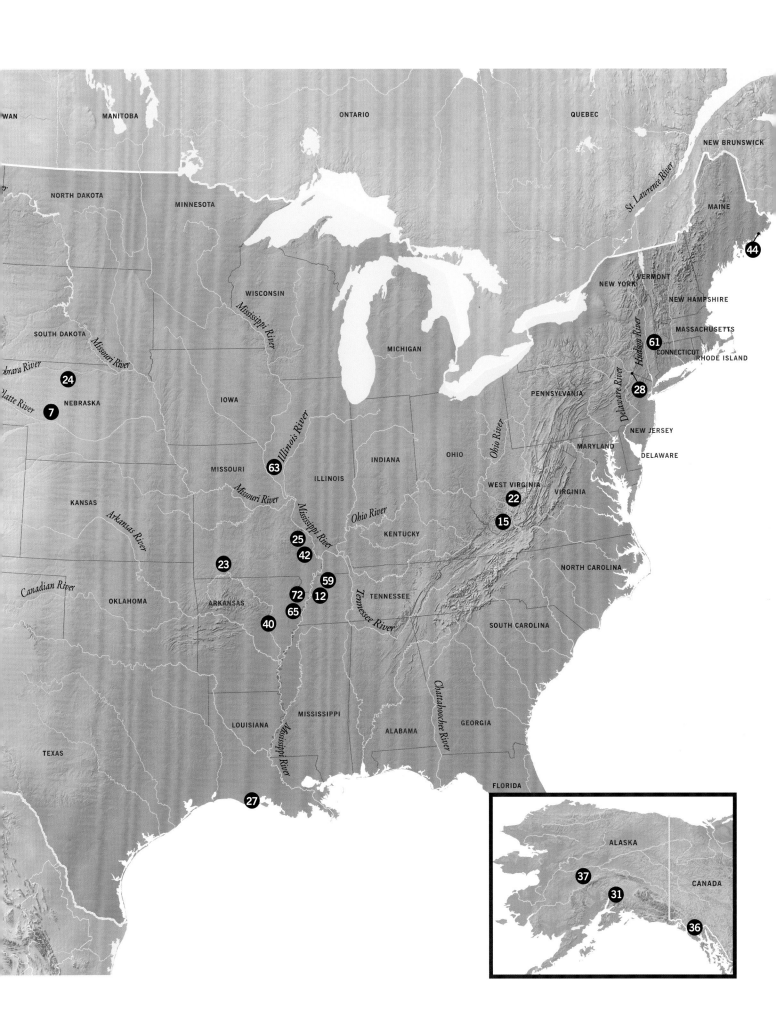

Recommended Reading

Barry, John M., 1997, *Rising Tide*, Simon and Schuster

Bartlett, Richard A., 1984, *Rolling Rivers*, McGraw-Hill Book Company

Hidore, John J. and Oliver, John E., 1993, *Climatology*, Macmillan Publishing Company

Hubbard, Harlan, 1953, *Shantyboat*, University of Kentucky Press

Leopold, Luna B., 1994, *A View of the River*, Harvard University Press

Moulton, Gary, ed, 1988, *The Journals of the Lewis & Clark Expedition*, University of Nebraska Press

Mount, Jeffrey F., 1995, *California Rivers and Streams*, University of California Press

Palmer, Tim, 1996, *America by Rivers*, Island Press

Pielou, E.C., 1998, *Fresh Water*, University of Chicago Press

*Paddlewheel steamer on the Mississippi
River above Memphis, Tennessee.*

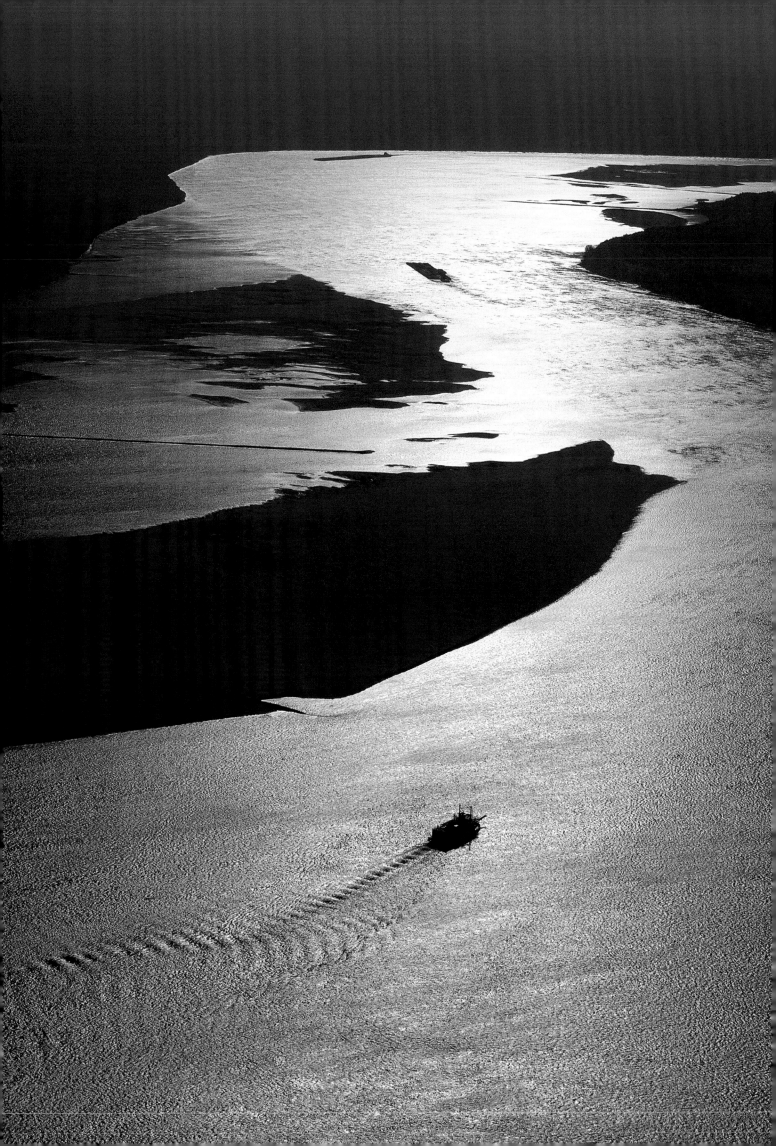

Glossary

Alluvial fan– *sediment deposited in a fan shape at the foot of a slope*

Aquifer– *underground body of permeable rock containing slowly moving water*

Bajada– *coalescent alluvial fans along the base of a mountain*

Base level– *level below which a stream cannot erode*

Basin– *area drained by a river*

Braided stream– *network of branching and reuniting channels separated by islands or bars*

Capacity– *upper limit of sediment that a stream is able to transport*

Cirque– *small mountain basin carved by a glacier*

Cutoff– *short stream segment created when a river cuts across the narrow neck of a meander*

Delta– *sediment accumulation where a river reaches its base level*

Discharge– *volume of stream water passing a point within a channel over a period of time*

Distributary– *divergent segment of flow leaving a stream's main flow*

Eddy– *current of water running contrary to a stream's main flow*

Erosion– *physical removal of rock fragments by wind, water, or ice*

Floodplain– *area adjacent to a river that can be inundated during a flood*

Gradient– *river's vertical drop over a horizontal distance*

Groundwater– *subsurface water within underground channels and the interstices of rock*

Headward erosion– *upslope extension by erosion of a river basin*

Hydrogen bonding– *faint attraction between atoms of two different molecules of water*

Laminar flow– *flow of a liquid in which stream lines remain parallel*

Levee– *floodwater deposit adjacent to a river just beyond its main channel*

Magma– *molten rock*

Mantle– *solid layer of the earth that extends from the base of the crust to a depth of about 1800 miles, consisting of dense iron- or silica-rich minerals*

Meander– *looping bend in the course of a river*

Moraine– *poorly sorted pile of coarse sediment deposited on the sides or terminus of a glacier*

Plate tectonics– *theory describing the earth's crust as an interactive set of crustal plates*

Playa– *flat bottom of an undrained basin*

Point bar– *sand and gravel bar that projects into a channel on the inside of a curve*

Rift– *region of crustal divergence*

Rill– *tiny channel first eroded by overland flow of water*

Saltation– *staccato movement of sediment particles in a series of short bounces*

Sheetwash– *unconfined flow of overland water*

Stream piracy– *capture by erosion of a portion of one stream by another from an adjacent basin*

Tarn– *lake perched in a cirque*

Terrace– *former floodplain surface that is now rarely if ever flooded, abandoned as a stream eroded downward*

Thalweg– *line of maximum depth within a channel*

Transpiration– *uptake and release of water by plants into the atmosphere*

Transverse dune– *long ridge of sand oriented perpendicular to the prevailing wind*

Turbulent flow– *non-parallel, erratic flow within a liquid*

Acknowledgments

Rivers run in my blood. During mineralogy class in 1976, Peter Winn turned around to ask in a stage whisper if I wanted to buy his kayak. "Yes," I whispered back, "What's a kayak?" I camped with Wesley Smith above Crystal Rapids in 1977 and worried all night about hurting a passenger; Wesley understood my fears the next morning when he said, "Make your prayers to the river and everything will go as it should." Chris Condit swooped into Grand Canyon in 1978 to air-drop good news from my graduate-school advisor. A small parachute blossomed as his Cessna roared by; the duct-taped plastic container splashed down near my raft. I rowed over, fetched it, and started whooping that I had a master's degree. A master's degree in SCIENCE!

With friends—Hugh Rieck, Curt Green, Roger Henderson—I explored rivers on private trips throughout the West. I rowed science trips through the Grand and on the Green with Larry Stevens, Jack Schmidt, and Bob Webb whose collective curiosity opened my eyes to a critical way of seeing the natural world. I worked for a few years on the Colorado, rowing with men and women who remain larger than life now in my memory: Dave Lowry, Lorna Corson, Dave Edwards, Don Briggs, Louise Teal, Drifter Smith, Becca Lawton and her brother Tim, and of course, Wesley. Each taught me about the fluid lives of rivers and people.

I've long since lost Peter's kayak and my once-trusty roll has turned rusty. These days I'm more likely to see rivers from a Cessna than a raft. The mechanics at Arizona AirCraftsman—Jay, John, Ron—tend to my plane and keep me alive. The generosity of the American Geological Institute keeps wind under my wings. I fondly remember Marcus Milling, and thank Ray Thomasson for introducing me to the AGI gang—Chris Keane, Ann Benbow, Abi Howe, and now Pat Leahy.

I often photograph alone, but books are are never done in a vacuum. Stu Waldman and Livvie Mann at Mikaya Press continue to be wonderful editors, publishers, and confidantes. I was enthralled when Stu showed me his Hudson River as we strolled along the edge of Greenwich Village. Lesley Ehlers brought her magic to bear again as she illustrated and designed this book. As always, all of my rivers roll toward Rose.

The Colorado River, separating California's Chocolate Mountains (left) from Arizona's Trigo Mountains (right), flows peacefully through the Imperial National Wildlife Refuge.

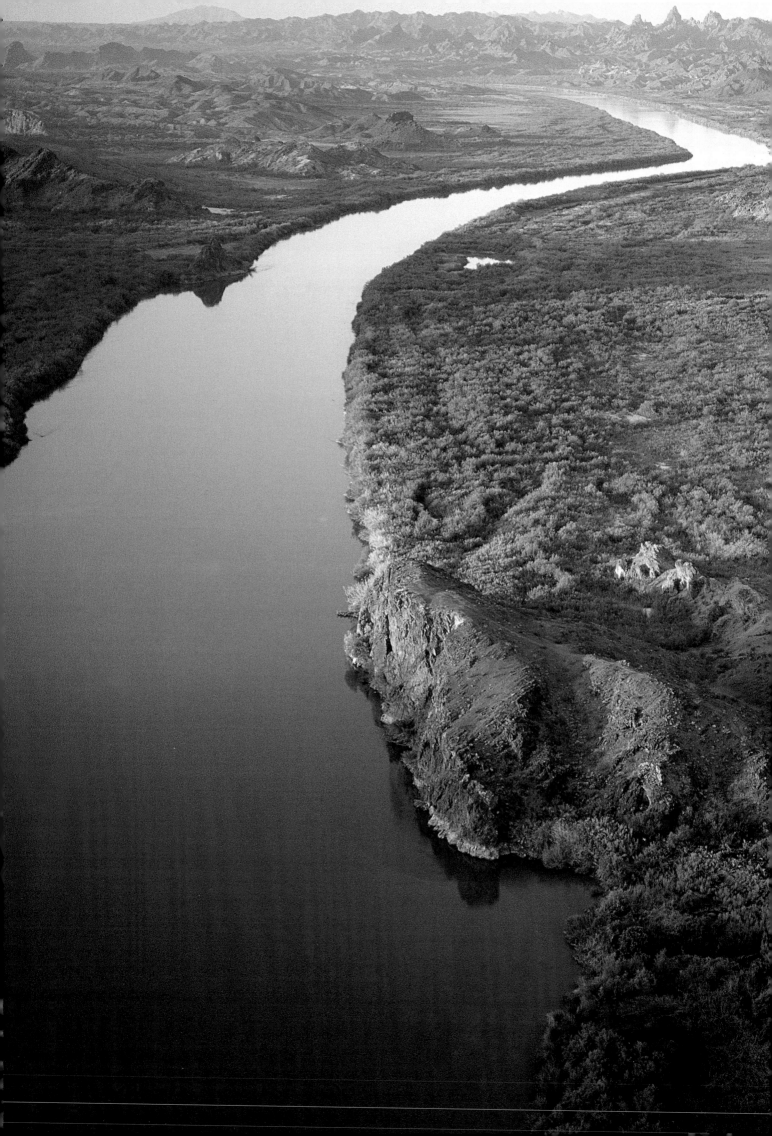

Index